WAYNE THIEBAUD

PAINTINGS

STEVEN A. NASH

WITH

ADAM GOPNIK

FINE ARTS MUSEUMS OF SAN FRANCISCO

Thames & Hudson

Published on the occasion of the exhibition
Wayne Thiebaud: A Paintings Retrospective

Fine Arts Museums of San Francisco
California Palace of the Legion of Honor
10 June–3 September 2000

Modern Art Museum of Fort Worth
24 September 2000–14 January 2001

The Phillips Collection, Washington, D.C.
10 February–29 April 2001

Whitney Museum of American Art
28 June–23 September 2001

The catalogue is supported in part by a grant from Sotheby's.

First published in the United Kingdom in 2000 by Thames & Hudson Ltd,
181A High Holborn, London WC1V 7QX

British Library Cataloguing-in-Publication Data
A catalogue record for this book is available from the British Library

ISBN: 0-500-09292-3

Printed and bound in Belgium

Frontispiece: Wayne Thiebaud, *River and Farms* (detail), Nan Tucker
McEvoy, 1996 (cat. 100)

Preface

Fifteen years have passed since the last major retrospective exhibition of the art of Wayne Thiebaud. Since then Thiebaud has continued to expand his work with new themes and stylistic expressions, reaffirming his position as one of the leading figurative artists in America today. This book and the exhibition that accompanies it—*Wayne Thiebaud: A Paintings Retrospective*—therefore provide an opportunity for the most comprehensive survey ever presented of Thiebaud's lengthy and productive career. In the early planning for this project, a calculated decision was made to focus the survey exclusively on the paintings —his oils, acrylics, watercolors, gouaches, and pastels—recognizing that Thiebaud's work in the various graphic media is a vast subject unto itself that warrants its own full retrospective.

Organized in this way, the exhibition can track the formal and thematic profile of Thiebaud's development as it concentrates on one of its primary strengths—his exhilarating use of color. It also aspires to bring together with many of his most famous paintings a selection of lesser-known but outstanding works, some of which have rarely or never been publicly exhibited, and to unite certain thematic groups for the first time. The result is both a rich visual experience and a historical record that provides deeper comprehension of the issues and ideas encompassed by Thiebaud's art.

It is particularly appropriate to mount such a survey in this eightieth year of the artist's life. It is also appropriate for the Fine Arts Museums of San Francisco to act as organizer. Comprised of the M. H. de Young Memorial Museum and the California Palace of the Legion of Honor, the Fine Arts Museums boast an outstanding collection of Thiebaud's work in different media, including over 300 works on paper and the famous paintings *Three Machines* and *Diagonal Freeways*. We also were among the first museums to introduce his work to the public, through an early one-artist exhibition at the de Young Museum in 1962 and several invitationals at the Legion of Honor in the early sixties. With Wayne Thiebaud we share a deep commitment to enriching the cultural life of the Bay Area.

Steven Nash, our Chief Curator and Associate Director, is the originator of this project and its primary organizer. He and Adam Gopnik, well-known critic and historian and our guest essayist, wrote the catalogue. Throughout the lengthy process of research, organization, and writing, Dr. Nash worked closely with Wayne Thiebaud, his sons Paul Thiebaud and Matthew Bult, the staffs of the Campbell-Thiebaud Gallery in San Francisco and the Allan Stone Gallery in New York, and numerous staff members of the Fine Arts Museums. All of these individuals contributed significantly to the project's success and we are most appreciative of their helpful and generous participation. We owe a special debt of thanks to the many collectors, public and private, who graciously agreed to lend to part or all of our exhibition tour, and to our sponsors, whose support made the whole project possible: the National Endowment for the Arts, Nan McEvoy, the Jon and Linda Gruber Foundation Family, and to Sotheby's for catalogue support. I also want to express gratitude to our partners in the exhibition tour for the understanding and foresight they showed in supporting the exhibition and their help in bringing it to wider audiences. It has been a pleasure to work with the staffs of the Modern Art Museum of Fort Worth, the Phillips Collection, and the Whitney Museum of American Art. Finally, on behalf of these partners and all the individuals who will enjoy the exhibition and its catalogue, we salute Wayne Thiebaud for his dedicated achievement. He is a remarkable person and a remarkable artist.

Harry S. Parker III
DIRECTOR OF MUSEUMS

Acknowledgments

It is a pleasure to acknowledge the many individuals who generously contributed their time and assistance to make the preparation of this exhibition and book a memorable and enjoyable experience. First among these is Wayne Thiebaud himself. From the onset of the project several years ago, Wayne has proved an ideal collaborator. He has given freely of his time and advice, frequently elucidating his views on art and his own work with clarity and enthusiasm and even allowing these conversations occasionally to continue onto the tennis court! We salute his achievement and thank him for all his help.

A similar debt of thanks is owed to the rest of the Thiebaud family. Paul Thiebaud was supportive from the very beginning. His help has been invaluable in numerous ways, from assistance with the selection and securing of loans to research into the history of various works and arrangements for conservation and photography. Matthew Bult provided ongoing collaboration with documentation for the catalogue, including considerable work on the chronology, bibliography, and exhibition history. During our many meetings at the Thiebaud home in Sacramento, Betty Jean Thiebaud was a tireless hostess, helping in so many ways to see that all went smoothly and supporting the project with her usual good cheer and sage observations.

Much assistance also derived from the staff of the Campbell-Thiebaud Gallery in San Francisco. Charles Campbell, Diana Young, Wendy Turner, and Julie Caskey all found themselves pulled frequently from their regular full-time duties to answer questions, help with loan requests, or hunt for photographs. Wendy Turner contributed importantly to the catalogue with help on the bibliography, exhibition list, and catalogue captions. To everyone at the Campbell-Thiebaud gallery, our most sincere thanks.

In the same spirit, the staff at the Allan Stone Gallery in New York provided yeoman support throughout the course of research and exhibition development. Allan Stone, Wayne Thiebaud's longtime friend and dealer, is the leading authority on the artist's work. We gratefully acknowledge all the time, effort, and advice that Allan, Claudia Stone, and Bo Joseph have devoted to the project. I am particularly appreciative of the help in researching the gallery's remarkable photo archive of Thiebaud's paintings.

Our director, Harry S. Parker III, helped conceive this exhibition many years ago at a time when the staff of the Fine Arts Museums were consciously expanding our programs in contemporary art. Harry joins me in acknowledging our partners in the Museums' tour of the show, who have lent enthusiastic support and in some cases, assistance with loans and organizational details. We wish to thank Marla Price and Michael Auping at the Modern Art Museum of Fort Worth, Jay Gates and Eliza Rathbone at the Phillips Collection, and Maxwell Anderson and Marla Prather at the Whitney Museum of American Art. Of course, the exhibition would not have been possible without the generosity of our many lenders, from public and private collections alike, who agreed to part with favorite works and share them with our museum audiences.

An exhibition and book with over 100 works covering almost fifty years of an artist's career is always a monumental undertaking. Without the help of the following individuals, the project could not have been realized with the same expediency and quality of results. We wish to thank: Helen Allen, Rebecca Bach, David Beck, John and Gretchen Berggruen and the staff of the John Berggruen Gallery (particularly Sheila Ferrari), David Bonetti, Frances Bowes, Sven Bruntjen, Gary Carson, Colleen Casey, Ralph Coe, Janice Driesbach, Patrick Dullanty, Karen Haas, Molly Hutton, Kate Johnson, Robert F. Johnson,

John Jones, Judy Kim, Gregory Kondos, Lawrence Markey, Sara Jane Miller, Carol Nash, Maureen O'Brien, Steve Oliver, Ira Schrank, Paul and Barbara Schurman, Alexander Ross, Katherine Ross, Joral Schmalle, Marjory Searl, Russ Solomon, James Soong, Karen Tsujimoto, John Van Doren, Charles Wilson, Bill Wolf, Richard Wollheim, James Wood, and Mary Zlot.

Many staff members at the Fine Arts Museums of San Francisco have assisted ably on this exhibition and catalogue. Their professionalism, dedication, and team spirit are deeply appreciated. In particular, I would like to acknowledge the following: Kathe Hodgson, Director of Exhibitions Planning, supervised many of the logistics of exhibition administration; Karen Kevorkian, Editor of the Museums' Publications Department, copyedited the catalogue and managed the myriad details of its production in collaboration with Ann Karlstrom, Director of Publications and Graphic Design; Exhibition Assistants Laurel Fredrickson, Victoria Muñoz, and Samantha Martin provided indispensable help with historical research, compilation of loan records and photographs, and manuscript preparation; Bill White, Exhibitions Designer, oversaw the exhibition installation, and Bill Huggins, Lighting Designer, installed the lighting; Therese Chen, Director of Registration, managed the assemblage of loans and tour arrangements, including details of shipping, couriers, and insurance; Allison Pennell, Librarian, and Louise Chu, Acting Librarian, tracked down many bibliographic references; Juliana Pennington, Graphic Designer, provided the exhibition graphics and designed various associated products; Vas Prabhu, Director of Education, helped organize the ambitious program of educational activities connected with the exhibition; Tony Rockwell and Tricia O'Regan, in the Paintings Conservation department, provided conservation examinations of the paintings and worked skillfully to return certain of the works in the exhibition to presentable condition; Barbara Boucke, Director of Development, with Gerry Chow and Anne-Marie Bonfilio of the Development Department worked on raising funds for the exhibition; Joseph McDonald, Photographer, provided new photography for the catalogue; Suzy Peterson, Secretary to the Chief Curator, in addition to assisting with the preparation of catalogue manuscripts helped in innumerable tasks connected with research and documentation; Carolyn Macmillan, Deputy Director for Marketing and Communications, with Andrew Fox and Linda Katona of the Media Relations Department, coordinated all public relations and advertising programs; Sherin Kyte, Legion Administrator, oversaw logistics at the California Palace of the Legion of Honor, where the exhibition took place in San Francisco; Michael Sumner applied his considerable graphic skills to the design of the catalogue, assisted by Melody Sumner Carnahan. The skills and high standards of all these individuals were clearly manifested in all aspects of the project.

Particularly high in our esteem are the exhibition sponsors who provided generous financial support. For its underwriting and the confidence it showed in our proposal, we are most grateful to the National Endowment for the Arts, a Federal agency. Other sponsors include Nan Tucker McEvoy, the Jon and Linda Gruber Family Foundation, and Sotheby's, for catalogue funding.

Steven A. Nash
ASSOCIATE DIRECTOR AND CHIEF CURATOR
FINE ARTS MUSEUMS OF SAN FRANCISCO

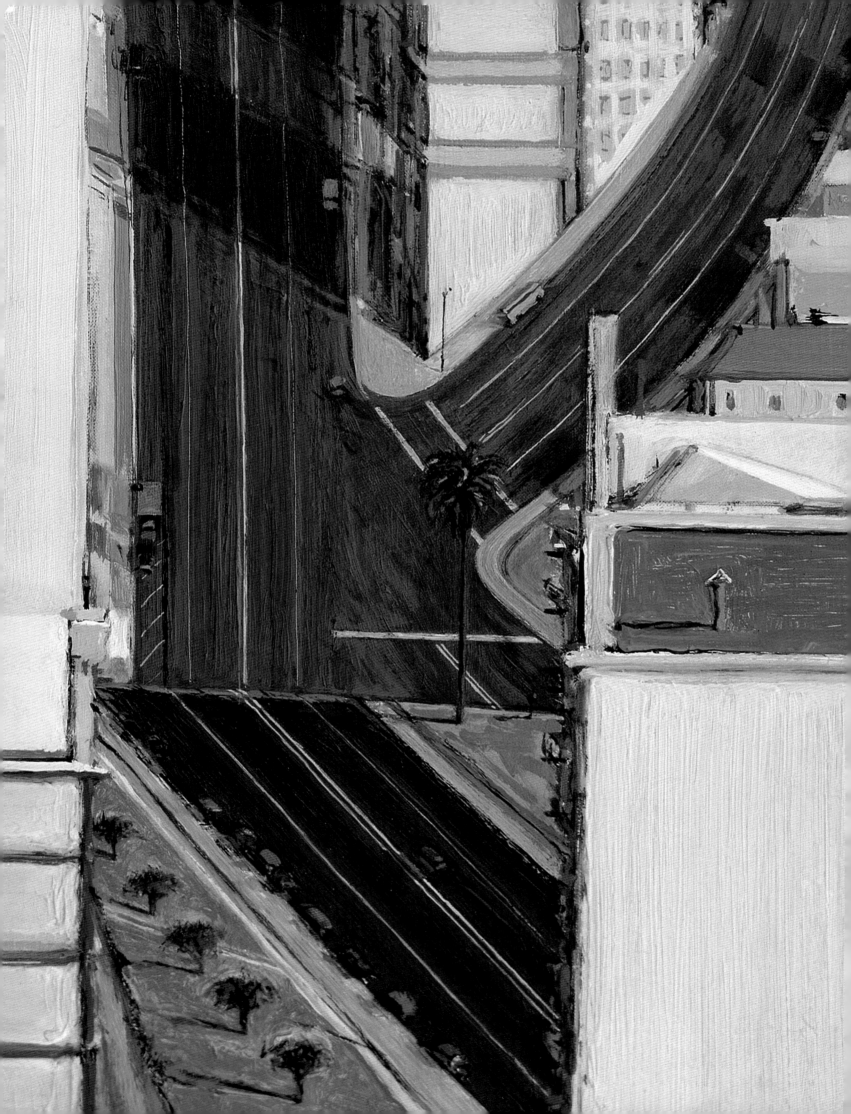

Unbalancing Acts:
Wayne Thiebaud Reconsidered

STEVEN A. NASH

With all the modern mechanical aids, with the cinema, with film, and everything else, how are you going to trap reality, trap appearance without making an illustration of it? The painter has to be more inventive. . . . He has to reinvent Realism. —FRANCIS BACON, 1985

I think we have barely touched upon the real capacity of what realistic painting can do. —WAYNE THIEBAUD, 1968

FOR TODAY'S ARTISTS, Realism is a risky option. Faced with so long and rich a visual tradition and challenged by strong modernist pressure towards the nonobjective and conceptual, how is it possible to sustain and also reinvigorate basic Realist values? Wayne Thiebaud found his own way. For over forty years he has worked prolifically in a variety of media to define a figurative idiom whose individualism lies very much in his ability to balance apparent opposites: representationalism and abstraction, seriousness and wit, immediacy of touch and rigorous compositional control. His work has a unique look. In its focus on the here and now of consumer goods and deli cuisine, portraits of friends and associates, grand landscape views near his Northern California home, and the improbable geometries of the San Francisco cityscape, it tells a colorful story of popular culture and aspects of the world around us. Although the connections often drawn with Pop Art are overstated, it does share with that movement a fascination with brash Americana. For all of its bright modernity, however, Thiebaud's art depends heavily on tradition. He readily pays homage to a long genealogy of favorite artists, including such diverse figures as Hopper and Mondrian, Chardin and Sargent, Morandi and Diebenkorn. As Thiebaud himself put it, "I'm very influenced by the tradition of painting and not at all self-conscious about identifying my sources. . . . I actually just steal things from people that I can use—just blatant plagiarism."[1]

Curved Intersection
(detail)
1979 cat. 69

This admittedly larcenous interest in the past is just one of the factors that make Thiebaud's art more complex than is sometimes assumed. His development over the past forty years has been gradual and sustained, not marked by dramatic shifts of style but inflections of handling and expression arising from a steady examination of recurring themes. He has gone in his own direction with little concern for broader artistic trends, and at age eighty is working with as much vigor and inventiveness as ever. For all of Thiebaud's accomplishment, however, a certain critical ambiguity continues to surround his work, from the early confusion of his still-life paintings with the Pop Art movement to the surprise and uneasiness elicited by his recent landscapes with their jarring blend of abstraction and Realism. Critical and historical assessments of his work often seem to trip over the quandary Just Where Does He Fit In? It has been too easy to dub Thiebaud with respectful humor the "Chardin of the cake shops" and pigeonhole his work as "California Pop."[2]

FIG. 1
Wayne Thiebaud, *Rocks and Sea*, 1948. Oil on canvas, present location unknown.

On the occasion of the most complete retrospective of his paintings ever organized, it is particularly appropriate to review Thiebaud's development and identify those qualities that make his art distinctive, giving it depth and lasting impact. Certain issues require examination. To what degree, if any, does Thiebaud's work partake of the social criticism fundamental to most Pop Art? He has long described his art as a merger of the perceptual and the conceptual. What is the nature of the abstract-figurative dialogue that fortifies the best of his imagery? What historical relationships have been the most meaningful for his development, and what, if anything, can be identified as truly "Californian" about his work? Such inquiry may get us closer to the heart of Thiebaud's art and let us better understand its perspective on the topographies, natural and cultural, of American life.

Thiebaud was a late starter. Out of his school-age experience with cartooning, theatrical productions, and poster design came an ambition to pursue a career in commercial art, whether as advertising designer or cartoonist, and a number of

FIG. 2
Wayne Thiebaud, *River Scene*, ca. 1955. Oil on canvas, destroyed.

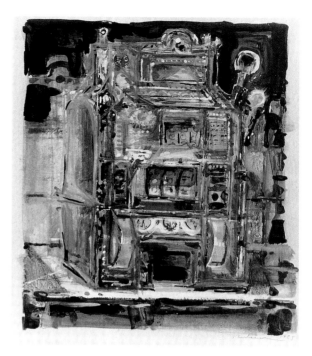

FIG. 3
Wayne Thiebaud, *Slot Machine*, 1958. Watercolor on paper,
11¾ × 9½ in. Private collection.

positions he held as a young man called upon his talents in these fields.[3] As is often
noted, he even worked in the Walt Disney Studios, although briefly, and he still
holds today a high regard for animation and cartoon artists. To this background
can be traced predilections of draftsmanship and composition—for example the
tendency towards a reduced, stereotypical essence of form; the clean layout of
objects against a blank background; and strong lighting effects derived from the-
atrical spotlighting—that stayed with him. It was not until he was almost thirty
years old, however, that the notion of becoming a painter struck home, in large
part under the encouragement and inspiration of his friend and fellow artist
Robert Mallary.

To obtain formal art training and a teaching certificate, Thiebaud enrolled
under the GI Bill first at San Jose State College and then at California State
College in Sacramento, where he received a teaching appointment at Sacramento
Junior College in 1951 while still in graduate school. As he worked on his graduate
degree and then began his teaching career, he experimented widely with different
media and stylistic approaches. The review of a range of his earliest paintings,
most of which have never been published, suggests an earnest if tentative search
for a personal and somehow progressive means of expression (figs. 1–3).[4] Through
Mallary and Thiebaud's involvement in several art exhibitions in Los Angeles he

met a number of that city's most prominent artists, but in Sacramento he found himself far removed from major art centers, which he eventually remedied by organizing a series of trips to the East Coast. The impact of European modernism so strongly felt during the 1940s in New York was much less direct and immediate in the West, and Thiebaud's exposure to modernist trends came mostly through the work of artists such as Lyonel Feininger, Eugene Berman, and Rico Lebrun, translated into his own early efforts as mild doses of Cubism and Expressionism. Ambitiously interested even at this early period in different avenues of work—from printmaking and theater design to sculpture, public murals, and film—Thiebaud began to build a regional reputation through exhibitions in and around Sacramento and San Francisco and by an energetic pursuit of whatever opportunities came his way, including a number of design commissions for performing arts productions and even the organization of annual exhibitions at the California State Fair and Exposition.

With the growing hegemony during the 1950s of Abstract Expressionism as a force in American painting, Thiebaud was not able to resist the pervasiveness of its influence. During travels to New York, he met and made friends of several of its leading proponents, but even before this, his paintings manifested several of its trademark stylizations, including rapid-fire lacings of thick brushstrokes, strong chords of color, and even the use of reflective metallic paints (which also ties to his early interest in Islamic and Byzantine art). *Ribbon Store* from 1957 (cat. 3) is one of the boldest and most nearly abstract works Thiebaud produced during this period. With a heavily charged brush and wide strokes, he built up a mosaic-like pattern within which the basic, simplified motif of a shop window practically dissolves into the pure dynamic of energetic form and color. In works such as *Cigar Counter* of 1955 and *Pinball Machine* of 1956 (cat. 1, 2), a flickering play of brushwork and light absorbs the subject, although the breakdown of solid form is much less complete. It's as if certain mannerisms were being applied *over* the underlying structure, and the artist's interest was actually stronger in what lay underneath. Indeed, in subsequent years the objects that had first shown up in these Expressionist thickets—such as pinball machines, soda bottles, one-armed bandits, and food dishes—came pushing forward, embodied in a different set of formal concerns. About this transformation, Thiebaud has noted that he found himself "clarifying large areas" and moving towards "an isolation of the object and much more of an interest in . . . objective painting."[5]

UNBALANCING ACTS

Then at the end of 1959 or so I began to be interested in a formal approach to composition. I'd been painting gumball machines, windows, counters, and at that point began to rework paintings into much more clearly identified objects. I tried to see if I could get an object to sit on a plane and really be very clear about it. I picked things like pies and cakes—things based upon simple shapes like triangles and circles—and tried to orchestrate them. [6]

Thiebaud's paintings of food and consumer goods, which first emerged in mature form in 1961–62, have become such a familiar part of our art historical landscape that the risks they first posed can easily be taken for granted. As already seen, the inclination towards depictions of commonplace objects from middle-class America—decidedly "blue collar" subjects in the hierarchies of still-life painting—began to emerge for Thiebaud in the mid-1950s, well before the romance with similar iconographies that characterized the Pop movement. Thiebaud's choices may gesture backwards to such precedents as Stuart Davis's Odol bottle, Gerald Murphy's safety razor, or even Marcel Duchamp's urinal, but they mostly embrace objects that happened to be close at hand and that impressed him as interesting in character or presence. Also important in this development was his experience in advertising design and, for example, his layouts of simple objects in drugstore ads.

It was the cafeteria-type foods, of course, the cakes, pies, ice creams, hamburgers, hotdogs, canapés, club sandwiches, and other staples of the American diet—all of which have a stereotypical this-can-be-found-any-where-in-the-country-but-only-in-*this*-country quality—that brought Thiebaud most of his early notoriety. He described the almost giddy feelings he experienced with his first daring paintings of these subjects:

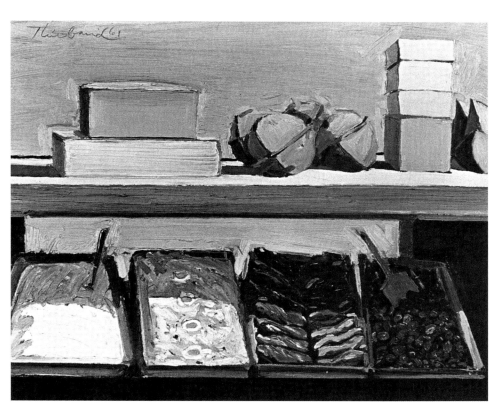

FIG. 4
Wayne Thiebaud, *Delicatessen Counter*, 1961. Oil on canvas, 27 × 34 in. Collection of The Oakland Museum of California, Gift of Concours d'Antiques, Art Guild of The Oakland Museum Association.

When I painted the first row of pies, I can remember sitting and laughing—sort of a silly relief—"Now I have flipped out!" The one thing that allowed me to do that was having been a cartoonist. I did one and thought, "That's really crazy, but no one is going to look at these things anyway, so what the heck."[7]

With this concentration on simple objects or groups of objects came simultaneously a much clarified means of representation—the "isolation of the object" and "interest in objective painting" to which Thiebaud had referred—the rapid development of which can be traced by comparing the Oakland Museum of California's fine *Delicatessen Counter* of 1961 (fig. 4) with the *Delicatessen Counter* from 1962 in the Menil Collection (cat. 14).

Already by the time of the earlier work, Thiebaud was pressing his subjects forward against the picture plane, simplifying the objects into basic formal units, and aligning them in strictly ordered progressions. A possibly coincidental relationship exists here with the comparably architectonic ordering principles seen in work by the turn-of-the-century American Realist John Peto (fig. 5), with whom Thiebaud also shares a love of vernacular objects. Undoubtedly more direct was the influence of still-life paintings by Giorgio Morandi, long admired by Thiebaud for their contemplative quiet, the palpable sense of protracted looking that they convey, and their delicate, varied effects achieved with seemingly minimal means (fig. 6). Not only is the basic organizational structure of such works germane to Thiebaud's paintings, but also their use of modulated light and discrete, slow-moving strokes to model the forms.

Between the two delicatessen paintings under consideration, a process of even greater rationalization took place. In the Oakland Museum's picture, the alignment of forms is not as rigid as it would soon become. The positioning of the different objects—the trays, containers, and cheeses—is still slightly loose, the countertop

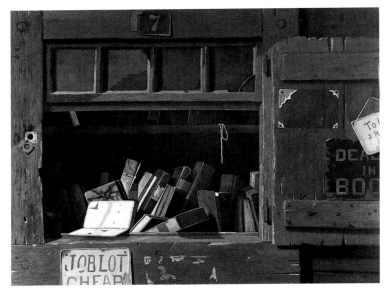

FIG. 5
John Peto (American, 1854–1907), *Job Lot Cheap,* after 1900. Oil on canvas, 30 × 40 ¼ in. Fine Arts Museums of San Francisco, Gift of Mr. and Mrs. John D. Rockefeller 3rd.

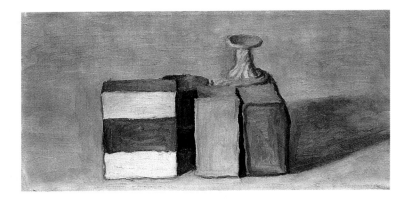

FIG. 6
Giorgio Morandi (Italian, 1890–1964), *Still Life,* 1953. Oil on canvas, 8 × 15 ⅝ in. The Phillips Collection, Washington, D.C.

UNBALANCING ACTS

and bottom of the counter's window are angled slightly downward as they cross the picture plane, and the definition of individual shapes is somewhat rough and irregular. By the time of the Menil painting, these relationships had tightened considerably. The shelves and counters reach out now to grip the sides of the painting, forming a resolute, Mondrian-like grid. (Perhaps "*Mondrian* of the cake shops" is an equally valid epithet!) The brushwork is highly viscous but individual forms are nevertheless defined with increased clarity, and the colors also have brightened compared to the slightly grayed palette in the Oakland example.

This signature style of Thiebaud's paint handling—the rich, smooth dragging of paint across a surface or around a shape in a way that both proclaims the luscious

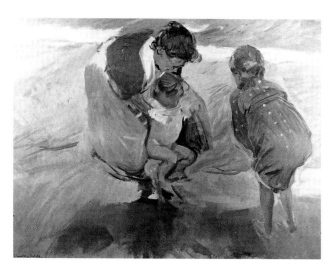

FIG. 7
Joaquín Sorolla y Bastida (Spanish, 1863–1923), *On the Beach*. Oil on canvas, 32 ½ × 41 ½ in. Fine Arts Museums of San Francisco, Gift of Archer M. Huntington.

texture of oils and often transforms itself into the very material being depicted, from frosting or whipped cream to metal—is referred to by the artist as "object transference."[8] Its origins can be traced not just to Morandi but also Thiebaud's interest in the bravura effects of such artists as Joaquín Sorolla (fig. 7), clearly apparent in the transitional *Beach Boys* of 1959 (cat. 4), the work of Willem de Kooning, and the Bay Area Figurative painters Richard Diebenkorn and David Park. Thiebaud's mature style had crystallized rapidly. The enthusiasm that greeted his still lifes when exhibited in New York at the Allan Stone Gallery in the spring of 1962 and later that year in San Francisco at the M. H. de Young Memorial Museum reflect their strength and appeal (fig. 8).

A great deal has been written about the possible meanings these still-life subjects held for Thiebaud beyond their purely visual delights and the problems in formal composition that they posed, though Thiebaud himself has warned against reading too much into their symbolism. "The symbolic aspect of my work is always confusing to me—it's never been clear in my mind. . . . I tend to view the subject matter without trying to be too opaque with respect to its symbolic reference, mostly from the standpoint of problematic attractions—what certain aspects of form offer."[9] Nevertheless, he has also indicated that the foods he returned to again and again did hold an emotional or poetic resonance relating to the demotic Americanism of

his boyhood memories. These paintings were made from memory, from mental images, not from actual setups of food or other objects:

> *Most of [the objects] are fragments of actual experience. For instance, I would really think of the bakery counter, of the way the counter was lit, where the pies were placed, but I wanted just a piece of the experience. From when I worked in restaurants, I can remember seeing rows of pies, or a tin of pie with one piece out of it and one pie sitting beside it. Those little* vedute *in fragmented circumstances were always poetic to me.*[10]

Thiebaud has also pointed out many times that his foods were always processed and prepared, not raw, "which mostly . . . has to do with some sort of ritualistic preoccupation. . . that interest in the way we ritualize the food, play around with it."[11]

Thiebaud's personal associations with the objects in his paintings, part of the personal voice he has spoken of trying to attain and open to others,[12] reflect back upon family picnics with tables full of home cooking, his work in restau-

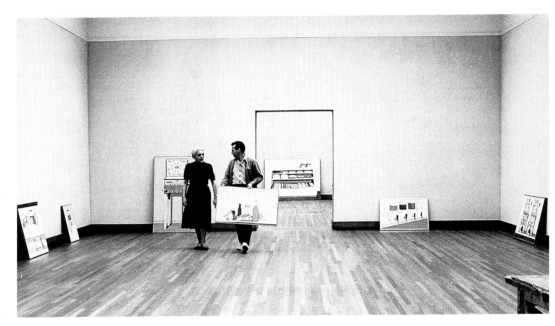

FIG. 8
Wayne Thiebaud installing exhibition at the M. H. de Young Memorial Museum with curator Ninfa Valvo, July 1962. Photograph courtesy of Allan Stone Gallery.

rants and small stores, and the displays of food and consumer goods he admired in drugstores, bakeries, and hardware stores. Distinctly different from the imagery in Pop Art, which simultaneously draws upon and satirizes consumer society, mass production, and advertising, his work relates an honest, Thornton Wilderesque appreciation for aspects of American experience that for decades have slowly disappeared:

> *[My subject matter] was a genuine sort of experience that came out of my life, particularly the American world in which I was privileged to be. It just seemed to be the most genuine thing which I had done.*[13]

UNBALANCING ACTS

Thiebaud's language can be decidedly low-key and limited in its formal agendas, but even then, his objects say a lot about the people who make them and enjoy them. They also comment on the abundance that is part of American society and the longing or desires that go with it: desserts lined up in rows stretching far into the distance like trees in a landscape but held separate from the viewer by the glass of window or case. The tone, however, is celebratory, not negative.

> *Commonplace objects are constantly changing, and when I paint the ones I remember, I am like Chardin tattling on what we were. The pies, for example, we now see are not going to be around forever. We are merely used to the idea that things do not change.*[14]

Unlike the Pop artists, irony was not one of his strategies.

How much did Thiebaud know of these contemporaneous developments in New York when he began his series of still-life paintings? Magazines in the early 1960s kept him aware of the work of most of the artists loosely joined in this movement, and while he admired the paintings of Jasper Johns in particular and also the work of Claes Oldenburg, the graphic stylizations of others who aped the languages of commercial art left him cold. "I really wasn't interested in what they were doing," he has said. "I had too much respect for commercial artists. I appreciated how skilled they really are."[15] At any rate, Thiebaud's homespun iconographies were actually born in paintings executed as early as the mid-1950s, well before Warhol, Lichtenstein, and others adopted similar subject matter.

Thiebaud's fondness for objects could sometimes verge on the sentimental, as with certain charming paintings of trinkets or goofy toys and cakes. The rigorous process of construction to which he subjects his imagery, however, generally counteracts tendencies in this direction. In this way, he stands sentiment on its head, as in the masterful *Toy Counter* of 1962 (cat. 21), in which the disarming collection of cuddly teddy bears takes on a slightly sinister note through the forceful structuring of the composition into compartments that have a confining, cagelike quality. Thiebaud thinks of each picture very much as a problem in form: How can a given subject be most fully realized within the demands of its particular pictorial context, in a way that does justice to its own character or "thingness" and that gives it a confident structure that will hold up over time? He has noted about Realism that an artist "can enliven a construct of paint by doing any number of manipulations and additions to what he sees," which makes it possible for representational art to be

"both abstract and real simultaneously."[16]

Thiebaud approaches these "constructs" as basic formal units, to be integrated and related in a clear dialogue that draws to a surprising degree on the abstract worlds created by such artists as Malevich and Mondrian with their tersely geometric concordances. In a composition such as *Pastel Scatter* (fig. 9), where the sticks of pastel seem randomly strewn across the surface, we can actually see at work a structural principle of geometric organization not at all unlike ones made famous by the Dutch *De stijl* artist Bart van der Leck (fig. 10). Rather than abstract blocks of color, Thiebaud deals in recognizable objects that he has con-

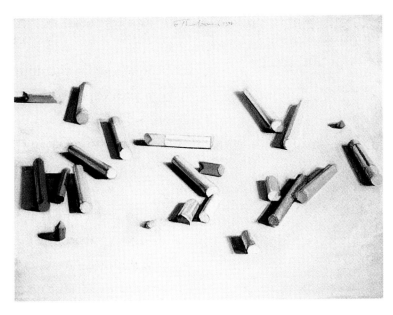

FIG. 9
Wayne Thiebaud, *Pastel Scatter*, 1972. Pastel on paper, 16 × 20 ⅛ in. Private collection.

siderably simplified. In his well-known painting of *Five Hot Dogs* (cat. 8), each sandwich, slightly different from the others in color, shape, and angle of placement, not only provides an emphatic notation on popular culture, but also plays a part in the choreographic give-and-take between regimentation and variation. The ground plane is indicated by a thickly brushed layer of white pigment and is solid enough to accept the shadows created by a strong light, but, on the other hand, it seems to dissolve into nothingness like the brushy white spaces in one of Malevich's Surprematist paintings of the cosmos. Thiebaud noted that he was interested in the possibilities of the background forming both negative and positive spaces simultaneously so that "form both emerges from and is part of the background," which becomes "both flat and planar-metrically illusionistic. . . , projecting or recessing, and even sometimes alternating, depending on your perception."[17] The frontal screens in *Four Pinball Machines* (cat. 17) pay homage directly to geometric abstraction. In place of the normal advertising and scoring readouts, we find totally nonobjective patterns of grids and concentric squares and circles.

Or consider the equally well-known *Three Machines* from 1963 (cat. 33). The glass globes here are wire-thin halos bursting with the densely packed round atoms of color inside. Barnett Newman told Thiebaud when he first saw one of these works displayed in New York that he thought they represented a truly American idea: "All those globes of colored beauty, and for a penny, out comes something sweet and wonderful!"[18] The machines are modeled with deft, form-giving brushstrokes and variations of hue and value that imply three-dimensionality, but they

UNBALANCING ACTS

appear coequally as cutouts flattened at calculated intervals across the picture plane. The whites of the background and what we presume to be a countertop and front are closely matched so that these three rectangles lock vertically into a flat screen that moves both back in space and forward. Also typical of Thiebaud's working methods are the juxtapositions of warm and cool tones and outlining of shapes or edges with lines that are divided into two or three different colors, intensifying color and producing that vibration of contour that has come to be known in his paintings as halation. These lines started as a kind of accident but later were used with full understanding of their relation to color theory and the laws of simultaneous contrast and take on a vivid life of their own.[19] In Thiebaud's working out of formal problems, tangible reality and abstraction intermix as one.[20]

While the first exhibitions of Thiebaud's pies and cakes and other food paintings at the Artists Cooperative Gallery in Sacramento and the Arts Unlimited Gallery in San Francisco in 1961 drew little attention from critics or collectors, his first show at the Allan Stone Gallery in New York in 1962 was a huge success, marking the beginning of a close relationship between the artist and dealer that has lasted until today. The exhibition sold out, with numerous museums and prominent collectors acquiring works and accolades rapidly appearing in several national publications. The degree of the response, a bit overwhelming for Thiebaud, was due in part to the automatic associations made by many with the burgeon-

FIG. 10
Bart van der Leck (Dutch, 1876–1958). *Study for Composition 1917 no. 3 (Donkey Riders)*, 1917. Gouache on paper, 25 ½ × 60 in. Private collection.

ing Pop movement. It encouraged him, nevertheless, to further explore the stylistic directions newly opening. A number of ambitiously scaled still-life paintings date from 1962–63 (for example cat. 13, 17, 18, 25, 26, 28), and Thiebaud continued to work on still-life themes for the rest of the decade and, indeed, periodically ever since, spiraling back to this subject as he has to other favorite themes throughout his lengthy career.

In general, the still lifes from later years followed familiar stylistic paths, reinterpreting earlier motifs and also introducing a number of new subjects, including piles of books, brightly colored ties (cat. 57), eyeglasses, and paint cans. Most often light in mood, these works could, however, suddenly turn dark. A group of particularly lugubrious compositions date from around 1983–84, including *Black Shoes*[21] and *Dark Candy Apples* (cat. 74). In the former, a pair of worn dress shoes that invoke Van Gogh's famous, highly autobiographical *Pair of Shoes* stand symbolically

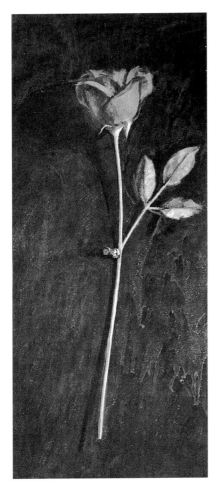

for the artist himself, casting him in an uncharacteristically melancholic light. Thiebaud's *Pinned Rose* of 1984 (fig. 11) is especially funereal, and his *Boxed Rose,* also from 1984 (cat. 76), is a simultaneously grim and attractive analogue for a body in a casket. Similar images threaded their way into Thiebaud's development from time to time, contributing a chill to the usually warm emotional temperature of his work.

Not long after the triumph of his New York show of 1962, Thiebaud changed direction and began to aggressively tackle a relatively new subject, the human figure. He had always found the figure challenging, calling it the most fundamental and also the most difficult art theme. This reordering of thematic priorities came as a needed break from the still lifes, though it also undoubtedly reflected the influence of the Bay Area Figurative movement championed by David Park, Elmer Bischoff, Richard Diebenkorn, and others, with which Thiebaud was familiar since the mid-1950s:

Actually, while I was doing still lifes I was at the same time trying to do figures, but very unsuccessfully. I was doing them concurrent with my food paintings in 1962, but in 1963 I decided to concentrate on figures for a while. I think an artist's capacity to handle the figure is a great test of his abilities. [22]

In many ways, the figure paintings are direct extensions of the still lifes. In both cases, Thiebaud attempted to objectify as fully as possible the basic subject. He situated figures in the same abstract, open spaces that engulfed the still lifes, flooding them with the same intense illumination, and constructing them with a similar materiality of paint. When joined in combinations, they display a regimented seriality like that commonly found in the still lifes. *Revue Girl* from 1963 and *Five Seated Figures* from 1965 provide good examples (cat. 35, 44). In the former, the stiffly posed entertainer is personally remote and slightly unreal, analyzed as substance,

color, and light, and lacking the inner voice that makes the show girls of Walt Kuhn, an obvious precedent, such emotionally ambivalent representatives of their trade (fig. 12). Thiebaud presents his entertainer, however, with so much obvious delight in the basic act of painting that we do not begrudge the missing personality. Thickly applied strokes push and pull around her contours, giving her a decidedly sculptural presence. High-keyed colors, intensified by the lighting, become even stronger through reinforcing combinations, such as blues dragged through whites for a Sargent-like brilliance, or reds and greens woven together in surrounding outlines. The figure's simple, frontal placement contrasts with the opulence of her painterly realization. We are not far from the treatment of objects in such luscious still-life paintings of the era as *Around the Cake* (cat. 11).

Still-life precedents also come to mind when Thiebaud's figures are multiplied, as in his *Five Seated Figures*. Typically, a basic pose is repeated and permutated in much the same way that a piece of pie or cake is examined from different angles in one of the many paintings of bakery displays.

In a big difference from the still lifes, the figures are almost always painted from models, not memory. Thiebaud has frequently commented on how difficult he finds this task, and how hard it is to note, absorb, filter, and reconstitute the complex information that comes from a close study of the human form:

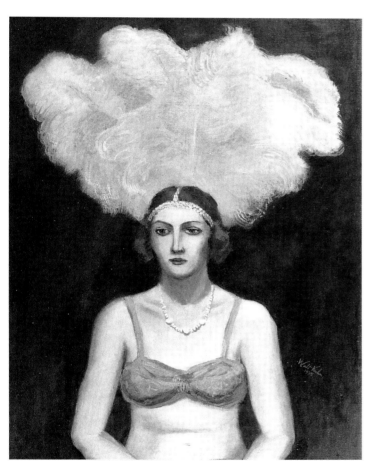

FIG. 12
Walt Kuhn (American, 1880–1949), *Chorus Captain*, 1935. Oil on canvas, 40 × 30 in. Thyssen-Bornemisza Collection.

I started out painting the figure from memory, with disastrous results. I just didn't know enough about the figure and still don't. It's very difficult for me. So I have people pose, and I just keep on trying. [23]

In these paintings, he looks for static and neutral poses that tell nothing about the sitter. He strips figures down to the essential details and eliminates settings: rarely is an object or attribute included that might add narrative interest. As one author put it, Thiebaud insists on "limiting the figure to itself, its own objectness. [Just] the

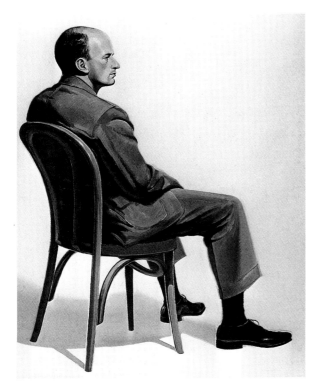

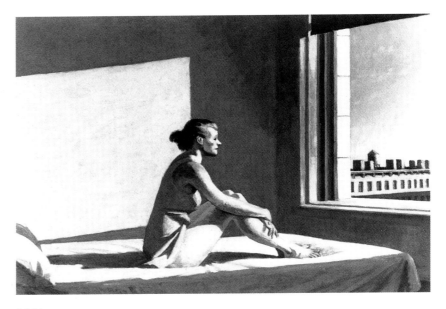

FIG. 14
Edward Hopper (American, 1882–1967), *Morning Sun*, 1952. Oil on canvas, 28 ⅛ × 40 ⅛ in.
Columbus Museum of Art, Ohio, Museum Purchase, Howald Fund.

FIG. 13
Wayne Thiebaud, *Man in a Blue Chair,* 1964.
Oil on canvas, 60 × 48 in. Private collection.

facts, please."[24] This effort to avoid expressiveness can often yield an effect of mute isolation that in itself becomes expressive. In this regard, comparisons have been made between his figures and those of Edward Hopper, an artist Thiebaud greatly admires. *Man in a Blue Chair* from 1964 (fig. 13), for example, can be compared in spiritual as well as formal terms with the woman in Hopper's *Morning Sun* of 1952 (fig. 14). Certainly they share the same sense of lonely introspection, even if Hopper tells us much more about his subject's personal situation. Another less commonly recognized analogy for such works exists with the portraits and figure studies by Thomas Eakins. Both the basic pose and moody, rather sullen expression in *Betty Jean Thiebaud and Book* from 1965–69 (cat. 54) call to mind Eakins's *Miss Amelia Van Buren* (fig. 15). And several of Thiebaud's studies of men, including the *Standing Man* of 1964 (fig. 16), relate at least distantly to such works by Eakins as *The Thinker* (fig. 17). In the latter comparison, the neutrality of the setting in both cases focuses attention on the stiff immobility of the figure and the inner concentration highlighted by each man's knit brow. Through Hopper and Eakins a line is drawn to other nineteenth- and early-twentieth-century artists concerned with the lack of human mutuality and communication as a theme of modern life.[25]

UNBALANCING ACTS

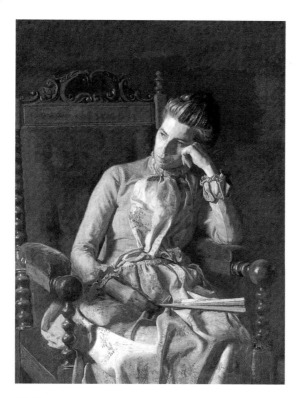

FIG. 15
Thomas Eakins (American, 1844–1916). *Miss Amelia Van Buren*, ca. 1891. Oil on canvas, 45 × 32 in. The Phillips Collection, Washington, D. C.

Clearly, many of Thiebaud's figures—including such colorful icons of the 1960s as *Revue Girl* and *Girl with Ice Cream Cone* (cat. 32)—do not share these properties, although the chic of the *Girl in White Boots* (cat. 41) fits easily enough with the sense of deep reverie she projects. To some degree the expressive qualities alluded to are by-products of other of Thiebaud's artistic intentions, but the prototypes provided by the work of such favored artists as Hopper and Eakins must have played a role. Perhaps even more to the point are the formal similarities with Hollywood publicity photographs of the type that Thiebaud himself helped to produce while working for Universal-International Studios as a poster artist and layout designer in the late 1940s. The altered state of reality in such works (fig. 18), created by the spatial isolation of the figure, the strong side-lighting, and the frozen poses and facial expressions, is strikingly similar to the staged effects in many of Thiebaud's figural essays.

Still-life paintings and figure studies continued to alternate in Thiebaud's oeuvre through the remainder of the 1960s, but towards the end of the decade he shifted focus again to yet another theme, the rural landscape. Embodied in one way or another—as direct plein-air studies, modern cityscapes, or grand, formalized panoramas—the landscape theme remained basic to his art and recirculated through his development from that time onward.

Thiebaud painted a number of beach scenes in the 1950s and early 1960s (cat. 4, 30), and starting around 1963 he produced a series of small, richly brushed landscape studies, such as the beautiful *Hillside* of 1963 (cat. 29), that extend into nature the stylistic terms of the contemporaneous still lifes. In the rural landscapes that began to emerge around 1966–67 a stylistic shift took place (cat. 50–52). Often worked up from small studies drawn or painted in situ, these large-scale compositions display

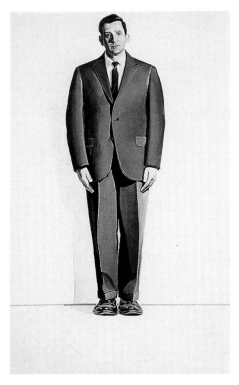

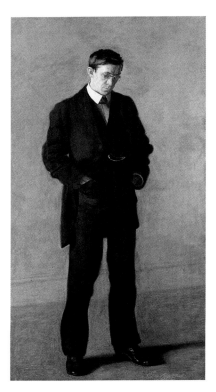

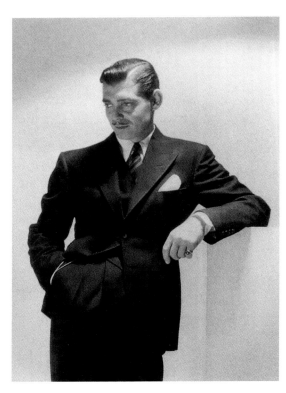

FIG. 16
Wayne Thiebaud, *Standing Man*, 1964. Oil on canvas, 60¼ × 36 in. Photograph courtesy of Allan Stone Gallery.

FIG. 17
Thomas Eakins (American, 1844–1916), *The Thinker (Portrait of Louis N. Kenton)*, 1900. Oil on canvas, 82 × 42 in. The Metropolitan Museum of Art, Kennedy Fund, 1917.

FIG. 18
Harvey White (American, active 1930–40s), *Portrait of Clark Gable*, 1930s. Photograph. Private collection.

an odd assortment of geological features—steep ridges, bulging cliffs, balloonlike lakes, and solid, confectionary clouds—generally presented in flattened, abstracted formats. Many have a cartoonish quality, replete with miniature trees, buildings, and animals, but as strange or fanciful as they might seem, they are grounded in fact. As Thiebaud has explained:

> *[One critic] thought, as many people think, that they're invented forms, that they're esoteric, or even arcane surrealists' references; but they're not that at all. They're painted right on the spot. I think people aren't used to seeing things cut from corner to corner so rudely or crudely, and maybe it's upsetting or seems unfulfilled in the sense of space. It's something, nonetheless, that fascinates me. It came about by driving across the country and actually going through those canyons. Those imposing structures seem to just fall in on you and make such a nice visual shape that I can't resist doing them.*[26]

Common in the foothills of the Sierra Nevada mountains not far from Thiebaud's home in Sacramento are cliffs and bluffs with the clean, plunging profiles seen in his paintings, small farms stuck on hillsides, and the types of round yet fluffy clouds

UNBALANCING ACTS

he often paints, so that driving through this country the landscape constantly draws you to see it through the predisposition of Thiebaud's gaze.

Despite the true-to-life nature of many of these paintings, the issue of abstraction in Thiebaud's work again surfaces. In a work such as *Diagonal Ridge* of 1968 (cat. 52) with its square format divided so resolutely from corner to corner, we find a conscious invocation of the hard-edged geometry in compositions by Ellsworth Kelly or perhaps more pertinently Kenneth Noland. The thin veils of color that distinguish the handling of acrylics in *Diagonal Ridge* or *Coloma Ridge* of 1967–68 (cat. 51) or even the lovely pastel entitled *Study for Bluffs* from 1967 (cat. 50) relate directly to the stain techniques employed by Noland and Morris Louis in works from around this same time. On the one hand, Thiebaud seems to have borrowed from color-field painting the means for a particular texture and translucent coloration for his flattened and massive land formations. These shapes unfurl with the same billowing quality as Louis's well known veils (fig. 19). On the other, the similarities of technique and composition show Thiebaud enjoying a little tongue-in-cheek parody of one segment of the East Coast art establishment and its pursuit through reductive abstraction of the supposedly fundamental truths of painting.[27]

It was not long before Thiebaud redirected his analysis of rural landscape towards the natural and constructed strangeness of the San Francisco cityscape. In 1972 he bought a small house as an extra residence and studio in the Potrero Hill section of San Francisco, an old working-class neighborhood in the steep hills south of the city's financial district. Close to his front door are some of the

FIG. 19
Morris Louis (American, 1912–1962), *Broad Turning*, 1958. Acrylic on canvas, 7 ft. 6 ⁹⁄₁₆ in. x 12 ft. 7 in. Dallas Museum of Art, Gift of Mr. and Mrs. Algur H. Meadows and the Meadows Foundation, Inc. © Morris Louis.

nosedive streets, perchlike intersections, and rows of blocky architecture clinging to the sides of roadways that are so famous a part of the San Francisco cityscape (fig. 20). The alterations of perspective, foreshortening, and standard pictorial space that such scenes offered fascinated Thiebaud, as did the play between abstract geometric structure and the realities of a living, working city, as improbable as these interactions may seem. By liberally juggling the building blocks of form that surrounded him he was able to construct complex urban visions that seem suspended someplace between pure fact and pure fantasy.[28]

The earliest of his paintings and drawings in this new mode date from 1971. At first he liked to work outdoors directly from his subjects, as seen in such a relatively straightforward example of visual reporting as the *Street Arrow* of 1975–76 (cat. 63). Consider, for example, the faithful relationship between the early *Chestnut Street near Hyde* and the actual scene on which the painting is based (figs. 21–22). Before long, however, Thiebaud began working on the cityscapes mostly in his studio, relying on memory and imagination more than on visual observation. With increased freedom of invention came greater complexity of composition. Sometimes he used a telescope that he trained on a distant fragment of the city. In such instances, the optics of the telescope lenses flattened and slightly distorted the view, exaggerating the given spatial dynamics. *Curved Intersection* from 1979 (cat. 69) is a good example of the resulting mosaic effect of tightly manipulated shapes and colors.

As often pointed out, Thiebaud's street scenes in general owe a major debt to Richard Diebenkorn's cityscapes from the mid-1960s, such as *Cityscape I* of 1963 (fig. 23). Diebenkorn's patchwork compositions of faceted, interlocking planes of light and color manage to convincingly describe his topographies of hilly landscape with steeply ascending streets and rows of houses, while verging at the same time

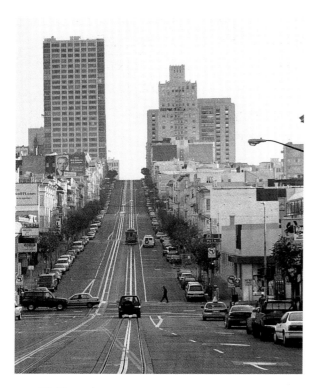

FIG. 20
San Francisco streetscape.

UNBALANCING ACTS

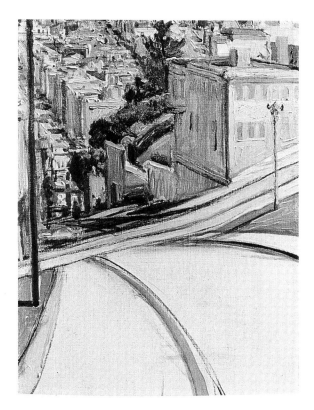

FIG. 21
Wayne Thiebaud. *Chestnut Street near Hyde,* 1971.
Oil on canvas, 14 × 10 in. Private collection.
Photograph courtesy of Allan Stone Gallery.

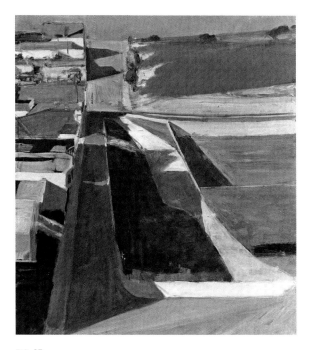

FIG. 23
Richard Diebenkorn (American, 1922–1993), *Cityscape I,* 1963. Oil
on canvas, 60 ¼ × 50 ½ in. San Francisco Museum of Modern Art.
Purchased with funds from trustees and friends in memory of
Hector Escobosa, Brayton Wilbur, and J. D. Zellerbach.

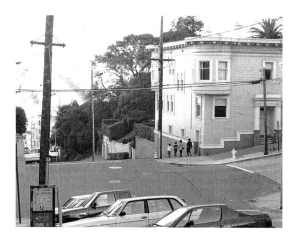

FIG. 22
Looking down Chestnut Street near Hyde.

on pure abstraction through the collapse of perspective and simplification of form into semi-independent color masses. Thiebaud's forms in his cityscapes are almost always more crystalline and clear as well as more solidly colored than Diebenkorn's, but nevertheless answer to a similar duality of purpose. The sides of buildings straighten themselves into flat squares or rectangles of creamy, light-struck color. Streets become dark vertical stripes, slicing diagonal ribbons, or pathways that swoop from under our feet into a wild intersection of different planes and angles. Poles, trees, electrical lines, and roadway stripes provide sharp linear accents. Shadows take on a life of their own in an orchestrated play of light and dark values and warm and cool tones. Everything in Thiebaud's cities of the mind is constructed according to the needs of the picture first and descriptive function second.

Comparisons also could be drawn between these works and the utopian city views of the Precisionist movement in American art during the 1920s and 1930s, when artists such as Charles Sheeler, Louis Lozowick, and even Georgia O'Keeffe sang the praises of American industrial might and urban expansion through their abstracting interpretations of the built environment (fig. 24). The towering verticality of skyscrapers, highways as giant arteries of communication, and the exciting congestion of urban spaces were themes then as they are again for Thiebaud. While he does not share in the heroicizing of social progress and new building technologies

typical of this earlier body of work, he does communicate an honest, wide-eyed amazement at the audacity of architecture and engineering inherent in the San Francisco streetscape.

Thiebaud continued these explorations into the 1990s, making some of his largest and most striking compositions in the past decade. Over their thirty-year history, the cityscapes have shown considerable variation of format and formal character and have even varied quite a bit in expressive mood. The verticality so distinctive to many of the paintings, with vertiginous drops down steep streets or hillsides (cat. 67, 69, 90), contrasts with horizontal formats sometimes broken abruptly by strong diagonals (cat. 78, 89) or with the use of long, slow curves as the main organizing principle (cat. 72, 80), sometimes combined in the same work (cat. 88, 112). Compositions are generally built up with meaty strokes of paint, although flat applications can intermix with combed textures or roughened, choppy brushwork, the directionals of texture always playing an important compositional role. In some passages, thinner, translucent washes of color recall Thiebaud's skills as a watercolorist and also his earlier work with the staining techniques of color-field painting (cat. 88, 89). The wryly complex thickets of urban freeways seen in a number of paintings (cat. 70, 71) stand as a subtheme, as do the close-up views of traffic congestion on urban roadways (cat. 82).

In general, the cityscapes' neutrality of viewpoint eschews social comment. Color and movement keep the mood light and humor frequently intercedes. We can identify, for example, with little characters in cars that seem as if they are about to peel off a nearly vertical ascent, and we are often drawn into the minutiae of infrastructure and human habitation that Thiebaud loads into the pictures with much the same relish that we find in the crowded details of many folk art townscapes (figs. 25–26). But as with the still lifes, somber expressions also arise, particularly in the night scenes. The darkly glowing *Resort Town* of 1995 (cat. 94) is almost apocalyptic in its foreboding sense of some unknown, threatening event. For all their concentration on formal ingredients and devices, the cityscapes also tug at human instincts and emotions that may be difficult to pinpoint exactly but nevertheless play an important poetic role. The memory world of the artist is relevant again, connecting

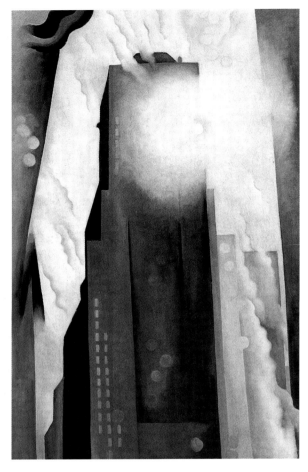

FIG. 24
Georgia O'Keeffe (American, 1887–1986), *The Shelton with Sunspots*, 1926. Oil on canvas, 48 ½ × 30 ¼ in. © The Art Institute of Chicago, Gift of Leigh B. Block (All Rights Reserved).

UNBALANCING ACTS

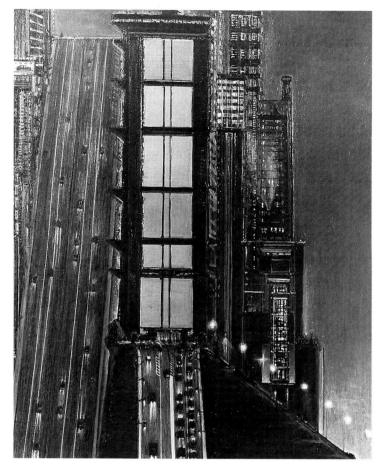

FIG. 25
Wayne Thiebaud, *Night City,* 1980. Oil on canvas, 60 × 48 in. Private collection.

FIG. 26
Attributed to Jurgan Frederick Huge (American born in Germany, 1809–1878).
Composite Harbor Scene with Volcano, ca. 1875. Oil on canvas, 25 ½ × 40 ⅛ in. Fine
Arts Museums of San Francisco, Gift of Edgar William and Bernice Chrysler Garbisch.

the cityscapes with recollections of his uncle Lowell, a rough-and-tumble road builder who first interested Thiebaud in highways and cars and who taught him to drive at age twelve.[29] Thiebaud has noted that he "remained interested in the city as a human enterprise, and the pile of human tracks it contains and the byways of living and moving,"[30] that is, the city as a powerful signifier of modern life. Although he assiduously avoids any hint of the melodramatic, either in his work or his descriptions of it, Thiebaud is open about certain empathetic qualities in the cityscapes: "Some have to do with longing and yearning for something unattainable, the urge to reach heights and build a fantasy world, and some have to do with dirt and grit and the loneliness of the streets." Highways can connote "headlong action," and there is sometimes a "bright pathos" to the most sunny of scenes.[31] These may be qualities that he thinks about *after* the picture is complete, he is quick to point out, but they are somehow there, even if deeply and unconsciously embedded.

Thiebaud often sticks with a particular theme until he begins to lose interest in it, choosing a new subject for a fresh start and frequently drawing ideas from his own paintings or works on paper from the past. In the mid-1990s, another of these switches took place as his concentration on cityscapes began to shift to California rural landscapes, but landscapes much different from those dating from twenty-five years earlier. These works were introduced to the public in an exhibition at the Campbell-Thiebaud Gallery in San Francisco in November 1997, where they had a mixed impact, surprising many followers of Thiebaud's work by their new and rather daring direction, but also drawing praise from regional art critics.

The series of paintings in question, one that he

continued to develop to the present, centers on the flat farmlands of the Sacramento River Delta, a fertile alluvial plain that stretches along the river as it flows westward from Sacramento to the San Francisco Bay. Not only is the color more intense in these works than at just about any other time in Thiebaud's development, with sharp tones of purple, yellow, red, and blue predominating and an overall citric bite to the palette, but the compositions also tend to be large in scale and cacophonous in their brilliant, disorienting play of different patterns and perspectives. It is as if Thiebaud were pushing the spatial dynamics he conquered in the vertical environment of the San Francisco cityscapes into the flat planes of his new farmscapes.

River and Farms from 1996 provides a particularly fine and representative example of the kind of pictorial ploys that characterize this new departure (cat. 100). The landscape fills the picture plane like a giant tapestry, with no horizon at the top for orientation or to help register in the mind's eye the extent of depth in the picture. A wide riverbed zigzags its way from top to bottom. A touch of color is pulled into the river's silver-white waters for modulation and to help give a sense of spatial progression from foreground back into depth, though it still reads primarily as a flat ribbon of light cleaving to the painting's surface. To either side, brightly colored fields lock together in a syncopation of irregular shapes. That we aren't dealing here with a traditional Renaissance system of spatial organization and single- or-double-point perspective immediately hits home. Although we are led to feel that our bird's-eye vantage point connects us visually with a long, flat vista, we sense that the whole composition tips up to the picture plane and that the many blocks of color are dipping and twisting in different directions, producing an optical landscape that is physically impossible to map. The many painted shadows imply at least two different positions for the sun. The large clump of trees in the foreground seems to pop out of a bank that descends in a steep diagonal path towards the water, although everything else in that zone says that the bank should be relatively flat. The patterns of tilling in the fields and the different rows of planting race along in several directions, sped by the jarring contrasts of color and the different techniques of marking with the brush, so self-consciously displayed. A compendium of two or three different seasons is created by the range of foliage coloration. Disparities of scale between, for example, the trees in the foreground and the tiny houses in the distance are immense, and the homey narrative touches of small boat, houses, and figures seem slightly wacky in the context of so grand and ambitious a rethinking of nature's forms.

As Thiebaud noted ironically about the complexity of these pictures, "In the desperation of trying to get them to look like something, I guess I'm willing to try about anything." He then elaborated:

> I was intrigued by what I could do to try to get some kind of image or self relationship which I hadn't seen so much. . . . As a consequence, I tried to steal every kind of idea—Western, Eastern—and the use of everything I could think of—atmospheric perspective, size differences, color differences, overlapping, exaggeration, linear perspective, planal and sequential recessions—and to do that with the kind of vision I talked about before with as many ways of seeing in the same picture—clear forms, hazy, squinting, glancing, staring, and even a sort of inner seeing.[32]

As usual with Thiebaud, personal experience and formulations learned through earlier paintings and drawings deeply condition acts of looking and seeing. In the case of the Delta paintings, he drew upon small oil sketches and numerous sketchbook studies but also a fund of vivid boyhood memories of life on his grandfather's farm in Southern California and his family ranch in Southern Utah:

> I plowed, harrowed, dug, and hitched up teams . . . and planted and harvested alfalfa, potatoes, corn. . . . and I loved it. . . . It was a great way to grow up. These paintings have something to do with the love of that and in some ways the idea of replicating that experience.[33]

Despite the internal tension in these works, Thiebaud managed to keep their different visual elements in register, so that we see each picture as a unified whole. For historical precedents, one might invoke Cézanne's analysis of landscape through shifting planes of color and light, the brilliant improvisations on nature by the Fauves, the planar distortions and spatial disruptions of early Cubist landscapes, or, for the use of multiple perspective, the great tradition of Asian landscape painting (fig. 27). Like all of these possible sources, Thiebaud negotiates a push-and-pull between representation and abstraction. His work is no less daring for embracing most fully the former.

These large and boisterous paintings are another chapter in what might be called the "unbalancing acts" of Thiebaud's different thematic and stylistic shifts. Never a strategic thinker in terms of directing his career to curry sales or critical favor, he

has always been concerned with keeping his work fresh and occasionally stepping off stride in order to challenge himself and try something new.

Along these lines, it is interesting to note that Thiebaud has always made small abstract paintings, undertaken as amusements and exercises but kept strictly to himself.[34] His deep knowledge of past tradition and extensive technical skills might well have allowed further exploration in this direction had not his attachment to representational modes dictated otherwise. When asked about these convictions, he is self-deprecating about his own efforts at pure abstraction but also very clear and reasoned in his defense of Realism. He admires tremendously the accomplishments of de Kooning, Mondrian, Arshile Gorky, and Franz Kline, but also feels that these artists pursued their particular formal and expressive issues to final resolutions that are difficult to build upon. Artists such as Diego Velázquez and Jan Vermeer, to mention just two of his favorites, opened doors through which generations of later artists passed. "We have been feasting off these painters ever since," notes Thiebaud. "They cannot be exhausted. As much as I admire Mondrian, whether early or late, I just don't think he is up to the level of Vermeer."[35] He feels strongly that everything he is trying to say about the nature of painting, about different states of perception, and different emotional states can best be said in Realism.

Thiebaud's ability to follow his own pathways in modern art, to stand apart from the tow of art world fashion, certainly owes something to his geographical location, a factor in the assessment of what is truly "Californian" about his work and career. The cityscape of San Francisco and the landscape of Northern California are obvious thematic ties to place and provide a geographical identity to the work. A romance with popular culture typical of the state's modern history stands behind his still-life subjects and also his figure paintings. One could hypothesize that the vivid luminosity and color in his work, in its different embodiments, derive to some extent from the distinctive clarity of Pacific coastal light. Geography plays a role in both iconographic and stylistic ingredients. But it is also clear that Thiebaud's life in California, spent largely in the unpretentious surroundings of his home in Sacramento, his studios, and the classrooms of the University of California at Davis, has given him distance, physical and intellectual, from the rest of American culture. This distance reinforces the personal independence that is a highly important factor behind his development and reputation. He especially credits his teaching and the constant dialogues with students and fellow faculty members with his ability to keep an open mind about artistic issues and ideologies, to approach them

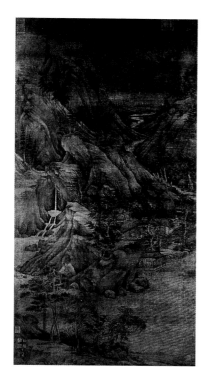

FIG. 27
Attributed to Dong Yuan (Chinese, active 930–960s), *River Bank.* Hanging scroll, ink and color on silk. 87 × 42⅞ in. Ex-collection, C. C. Wang Family. Promised gift of Oscar L. Tang Family. The Metropolitan Museum of Art.

from different perspectives and with healthy skepticism.

Thiebaud's work adds a separate chapter to the history of Bay Area Figurative painting, but it is difficult to identify more precisely his place in the wide spectrum of contemporary Realism. Comparisons can be made with the work of numerous other artists, including David Hockney, Frank Auerbach, Alex Katz, and Richard Estes; but in all cases, the differences far outweigh any similarities. It is actually within the context of earlier twentieth-century artists such as Morandi, Hopper, and even Balthus that Thiebaud feels most at home and against whom he most wants his work to be judged. What, then, best characterizes his contribution to contemporary American art?

Andy Warhol remarked famously that his art was mostly "about liking things." With the things in Thiebaud's work—the household goods, people, roadways, or mountain cliffs—we feel the empathy of the artist, but other attributes as well. Thiebaud's are deeply reasoned paintings that still allow instinct and emotion to thrive. His objects are nuggets of nostalgia, encoding fond memories from his youth but also aspects of American life meaningful to a great many of us. Even the cityscapes and landscapes are vehicles of subtle symbolic content, as much as Thiebaud distrusts any foregrounding of such content. His works are object lessons in looking hard and thinking about the processes of perception, recollection, and the transferal of form into two dimensions. They immerse us in the magic by which paint transforms itself into the things being described and back again into raw substance. For all their topicality, they achieve permanence that raises them beyond the moment and the region. In this way, Thiebaud forcefully answers Bacon's call for modern reinventions of Realism.[36] We may not be able to describe fully the artistic alchemy involved, but we can enjoy the fruitful intersection of observation, memory, and painterly manipulation that his art represents. He has established his own vantage point in contemporary culture. In many ways he is the prototypically American artist, but with old-master, international savvy.

Notes

1. Wayne Thiebaud, interview by Dan Tooker, in "Wayne Thiebaud," *Art International* 18, no. 9 (November 1974): 24.

2. See, for example, Paul Richard, "Luscious Realism: Thiebaud, Making the Mouth Water," *Washington Post,* 16 December 1992: "[Thiebaud's] solid, creamy pictures pay a dual homage—to California dreamin' and to the great tradition of the European still life. He's the Chardin of the cake shops, the Morandi of the malls." The history of critical response to Thiebaud's work over the years is a complicated story that could form the subject of a separate study. It is linked very much to issues regarding the place of Realism in contemporary art history, regionalism, and East Coast attitudes towards West Coast artists. Respect for Thiebaud as one of the masters of modern American art is reflected, for example, in a huge literature on his work and development, including articles, reviews, interviews, and catalogue essays; steadily rising auction prices for his prints, drawings, and paintings; and his inclusion in recent surveys such as the Whitney Museum of American Art's two-part encyclopedic exhibition *The American Century* (23 April 1999–13 February 2000) and Michael Kimmelman's anthology of interviews with selected contemporary artists entitled *Portraits: Talking with Artists at the Met, the Modern, the Louvre and Elsewhere* (New York: Random House, 1998). On the other hand, he has received over the years a fair amount of the critical cold shoulder, which has to do in part with the traditionally difficult times that West Coast artists have in East Coast media and also with ingrained modernist biases against Realism per se. Thus, despite the steady evolution evident in his career, he has not participated in such surveys as the Carnegie International, the Whitney Biennial since 1967, and Documenta since 1972, and his post-sixties work is, with very few exceptions, almost unrepresented in East Coast public collections. If he is seen as something of a maverick presence in contemporary art, he readily accepts the acknowledgment. But to counterbalance this perception of "otherness," it is all the more important that his remarkable output receive a careful reading and assessment.

3. For surveys of Thiebaud's early development, the best general sources are Karen Tsujimoto's introductory essay in the exhibition catalogue *Wayne Thiebaud* that accompanied a retrospective at the San Francisco Museum of Modern Art in 1985, and Gene Cooper, "Thiebaud, Theatre, and Extremism," in the exhibition catalogue *Wayne Thiebaud Survey 1947–1976* (Phoenix: Phoenix Art Museum, 1976).

4. A few early works are published in Tsujimoto, *Wayne Thiebaud,* 23, 26, 28, 32; and Cooper, "Thiebaud, Theatre, and Extremism," fig. 4.

5. Tooker, "Wayne Thiebaud," 22.

6. Mark Strand, ed., *Art of the Real: Nine American Figurative Painters* (New York: Clarkson N. Potter, 1983), 188–89.

7. John Arthur, *Realists at Work* (New York: Watson-Guptill, 1983), 120.

8. A. LeGrace, G. Benson, and David H.R. Shearer, "Documents: An Interview with Wayne Thiebaud," *Leonardo* (January 1969): 70.

9. Tooker, "Wayne Thiebaud," 22.

10. Arthur, *Realists,* 120.

11. Stephen C. McGough, "An Interview with Wayne Thiebaud," in *Thiebaud Selects Thiebaud: A Forty-Year Survey from Private Collections,* exh. cat. (Sacramento: Crocker Art Museum, 1996), 8–9.

12. Ibid., 9.

13. Ibid., 9. Thiebaud has been asked many times if his food paintings are meant as social commentary on the monotony of mass production or middle-class consumption habits, and he invariably answers in the negative. In one particularly trenchant repudiation of any social or political agenda in his work, he noted, "What makes a good painting or a bad painting has nothing to do with social comment. At least for me, whether or not an image relates to the human condition, to the existential dilemma or any of those proposals, though interesting in themselves, in terms of painting they are not stimulating for any kind of primary premise." Coplans, "Wayne Thiebaud: An Interview," 28.

14. LeGrace, Benson, and Shearer, "Documents," 70.

15. Wayne Thiebaud, interview by author, Sacramento, 26 August 1999.

16. Strand, *Art of the Real,* 192.

17. Jan Butterfield, "Wayne Thiebaud: 'A Feast for the Senses,'" *Arts Magazine* 52, no. 2 (October 1977): 136.

18. Wayne Thiebaud, interview by author, Sacramento, 20 December 1999.

19. Thiebaud has commented many times on the vibrant chromatic outlining found in many of his forms. To one question about where his "rainbowed line" had come from, he replied, "I think it showed up accidentally at first as a way of drawing. I started with a very light color to draw with [on the canvas], and then began to draw with yellow and orange and then with cadmium, and green and two blues, and each drawing that I would make on the canvas was usually a correction of one drawing over the other. When I began to paint, some of that would be left, and it looked good, and so I began to put it other places. It was only afterwards that I made some identification of it in the fullest coloristic sense in terms of simultaneity and codification of contrast, or optical properties of painting. The color interested me, and then I began to try to use it in order to get the painting to be richer, or to have more vibrancy." Butterfield, "A Feast for the Senses," 137.

20. The blending of abstraction and representation is a vital aspect of Thiebaud's work and a recurrent subject in his own discourses on art and art making. He has noted, for example, "The kind of painting that I admire, in the tradition of representational painting, comes from the painters who are able to combine perceptual manifestations and conceptual enterprises. For instance, take Degas, who seemingly is very interested in representing the figure but always interjects abstraction. There's a mysterious series of constructs which drives the painting into a language and grammar unique to the work." Meredith Tromble, "A Conversation with Wayne Thiebaud," *Artweek* 29, no. 1 (January 1998): 15.

21. Tsujimoto, *Wayne Thiebaud,* pl. 38.

22. John Coplans, "Wayne Thiebaud: An Interview," in *Wayne Thiebaud,* exh. cat. (Pasadena: Pasadena Art Museum, 1968), 34. He also noted, "I guess I've always been very much interested in the figure, either as a research unit, or as actual subject matter. . . . I have a continuing respect and a deep involvement with both teaching figure painting and doing lots of figure painting. . . . I think the figure is the basic measuring device . . . it's the *most* important study there is and the most challenging." Tooker, "Wayne Thiebaud," 22.

23. Arthur, *Realists,* 124.

24. Quoted in Steven Steinberg, "Wayne Thiebaud: The Concept of Realism, the Notion of Inquiry," *Southwest Art* 15. (February 1986): 52. Thiebaud has pointed out that he wanted to give his figures a "sort of neutral environmental stance," and, instead of the convention of depicting figures engaged in some activity, was interested in a figure "that is about to do something, or has done something, or is doing nothing, and, with that sort of centering device, try to figure out what can be revealed, not only to people, but to myself." Tooker, "Wayne Thiebaud," 22.

25. Thiebaud from time to time made very conscious references to old-master paintings in his figure studies. His *Woman in Tub* (cat. 43), for example, is based directly on Jacques-Louis David's *Death of Marat,* and the *Supine Woman* of 1964 (see *Wayne Thiebaud,* exh. cat., Pasadena Art Museum, 1968) is a quotation of Edouard Manet's *Dead Toreador.*

26. Tooker, "Wayne Thiebaud," 25.

27. For discussion of these double-edged references to color-field painting, see Tsujimoto, *Wayne Thiebaud,* 122–23, and Steven A. Nash, "Nature and Self in Landscape Art of the 1950s and 1960s," *Facing Eden: 100 Years of Landscape Art in the Bay Area,* exh. cat. (San Francisco: Fine Arts Museums of San Francisco; Berkeley, Los Angeles, London: University of California Press, 1995), 106.

28. Thiebaud reported, "I was fascinated by those plunging streets, where you get down to an intersection and all four streets take off in different directions and positions. There was a sense of displacement, or indeterminate fixed positional stability. That led me to this sense of 'verticality' that you get in San Francisco. You look at a hill, and, visually, it doesn't look as if the cars would be able to stay on it and grip. It's a very precarious state of tension, like a tightrope walk." Susan Stowens, "Wayne Thiebaud: Beyond Pop Art," *American Artist* (September 1980): 50.

29. See the interview of Thiebaud by Richard Wollheim, in *Wayne Thiebaud Cityscapes,* exh. cat. (San Francisco: Campbell-Thiebaud Gallery, 1993), n.p.

30. Ibid., n.p.

31. Wayne Thiebaud, interview by author, Sacramento, 20 December 1999.

32. Victoria Dalkey, "Wayne Thiebaud's Rural Landscapes," in *Wayne Thiebaud: Landscapes,* exh. cat. (San Francisco: Campbell-Thiebaud Gallery, 1997), n.p.

33. Dalkey, "Rural Landscapes," n.p. Thiebaud has spoken often about different levels and types of perception as reflected in his work and the different factors that condition perception. He notes, for example, "A problem that I think is a continuing one is attempting to distinguish between objective, perceptual information and the attempt to distill or codify or symbolically refer to it, as opposed to memory, fantasy, and a lot of other kinds of references. Our minds are filled with conventions, which means convenient ways of doing something, or a cliché, which is probably the same thing. . . . When you look at an object in comparison with these conventions, you're faced with a real dilemma, one which I propose is unending, because you can never see everything that's there." Thomas Albright, "Wayne Thiebaud: Scrambling Around with Ordinary Problems," *Art News* 77, no. 2 (February 1978): 86.

34. Thiebaud said, when asked if he continued to make abstractions, "Yes, but fortunately for you, I never show them. . . . My own abstract paintings don't come up to the level of emotional involvement I would like." Interview by author, Sacramento, 26 August 1999.

35. Wayne Thiebaud, interview by author, Sacramento, 26 August 1999.

36. Bacon's admonition that "the painter has to be more inventive. . . . He has to reinvent Realism" derives from an interview by David Sylvester in the film *Francis Bacon and the Brutality of Fact,* Michael Blackwood Productions, Inc., 1985.

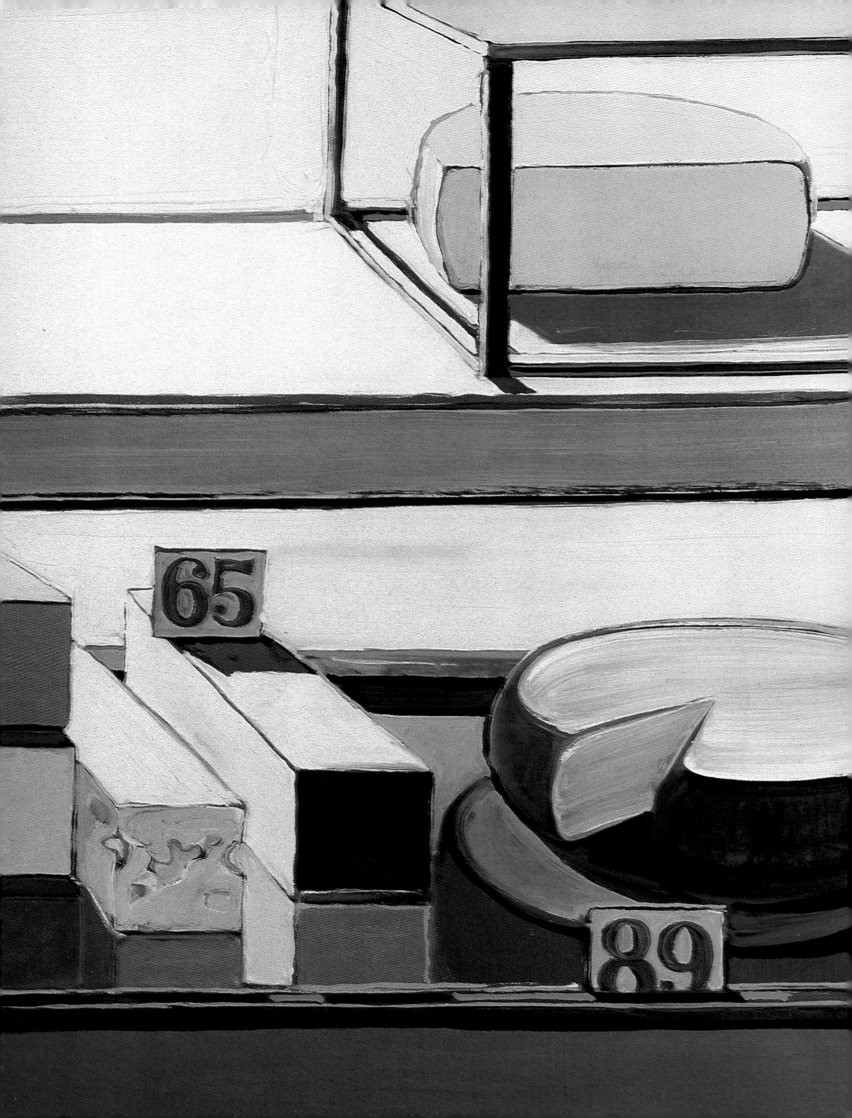

An American Painter

ADAM GOPNIK

A poet's hope:
To be like some valley cheese
Local, but prized elsewhere.
—W.H. AUDEN

WAYNE THIEBAUD IS AN AMERICAN PAINTER whose work carries
a long way. On a chilly November day in Paris, for instance, with the branches
outside trembling and the sky not even gray but dirty school-paste white, with
the leaves brown and the buildings stone and all the color rising from three
street lights, two red umbrellas, and a single yellow bicycle, an American
writer—given the role that his son, a circus-lover, calls being "the pronouncer,"
the ringmaster of the event, tooting his kazoo and announcing the acts—looks
at a bright pastel of two cakes in a window in afternoon light and wonders why
he cares for them so much.

For four years these two cakes, drawn as a pastel by Thiebaud in the 1990s,
have been a comfort, a joke, a talisman, a reminder of all left behind. One cake
is a pink Valentine's day cake, the other an angel food cake with a circular center
and eight or nine or ten streams of chocolate icing spilling over it. They are
small, almost discreet, set back in space on their typically Thiebaudian pedestals—
those high spindly plates that recall to us the display cases of delicatessens and
diners, though in fact they are, as our grandfathers would have said, like noth-
ing seen in nature or even in cheap culture—too large and too high. The cakes
cast long, lollipop-shaped shadows behind them, which glow intensely.

Delicatessen Counter
(detail)
1963 cat. 28

Across the room a Manet watercolor—not the real thing, of course, pronouncer's fees being what they are, but an aquatint copy made back in the twenties, not bad at all—pictures another simply shaped food, a green apple. It has the same spareness, the same intensity of observation, the same love of a plain thing seen plain. Yet to look at it is to feel in touch with a classical contemplative tradition. The apple has a dapper dapple, a comfortable shimmer that suggests looking as a completely satisfying way of living. Gazing at transient things in the French tradition, the Manet apple seems to say, is in itself a way of making them last. Looking at transient things in the American tradition, the cakes seem to imply, creates a melancholy little comedy of longing and exclusion. You feel lured in and then you feel left out.

The emotional truth, or anyway the local feeling, hits. The French apple, though it points no moral, is in every sense composed. The two American cakes, though all dressed up as if for their own birthday party, seem by contrast plaintive—longing. The apple is calm; the cakes are sad. Not just sad, but *nationally* sad, familiarly sad. They radiate a peculiar emotion that we have sensed before in such lovely areas of American paint as those fruit bowls in Hopper's restaurant or the children's building blocks in Eakins—a note of yearning, a melancholy undercurrent of aspiration implanted even in things of pleasure that we recognize more easily than understand. It is a yearning that can seem as big as the longing of the artist for self-realization, or as small as the longing of the kid staring in the candy store window for the candy. The little picture is about shopping and sadness, to put it in the plain language of the Woolworth counter. Or, to dress the same thought up for the window of Saks, the little picture is about desire and disappointment, a big American subject, maybe the biggest.

Wayne Thiebaud is an American painter. "Painting is more important than art," he has been known to announce with only a hint of deadpan humor. "Art—art we don't know *what* the hell it is—though we think we do, or try to do. Whenever one of my students says he's off to do his art, I say, Not so fast." He is and has been identified as many other things, too, of course: a California artist, a peerless teacher, a still-life painter in the tradition of Chardin, a popular illustrator of cookbooks and poems and, by reputation, a tennis player of

eccentric game developed on public park courts, with a wicked backhand. But before he is any of these things he is an American painter—someone who paints for a living and whose subject, for all its formal perfection, is what we are to make of American abundance, a poet of the risks and joys of window shopping.

One rushes to say that his subjects run far wider than the cakes-in-windows that have made him famous. Few American empirical painters have a wider range. He has painted vertiginous cityscapes and nudes and eye-in-the-sky landscapes and bow ties and lipsticks and pinball machines. Yet they all have a feeling in common—democratic abundance seen in aristocratic isolation. *Too Many Things* is a decent title for his collected works, so much so that the pictures have even sometimes been seen as satiric.

Thiebaud's commitment to painting—not to "expression" or "conception" or even to tradition, but to *painting,* the act of applying sticky colors to canvas and making them look like something—is the probity of his art. Once at a lecture he said—and the note of disdain and even contempt that this mild and charming man achieved as he said it was startling—"People say painting's dead. Fine. It's dead for you. I don't care. Painting is alive for me. Painting is life for me."

He *is* a virtuoso painter. His composite whites, his varied "tempi," the halos that surround his objects, are not like anyone else's. But he would never want to be used as a club with which to beat conceptual art or untutored art or any other kind of art. The first-rate technician recognizes the limits of technique, and no one speaks more admiringly of painters of limited craft and real vision. The advantage that being good at something gives to him is primarily the daily discipline it offers. Unlike many more self-consciously poetic painters, he is grounded in a practice in the most literal sense: he wakes up every day with something to do. This has given his art a kind of cheerful industry, a next-thing-to-doishness that has saved him from visible slumps. (No one gets saved from daily discouragements.) This strikes one as distinctly the inheritance of the lower-middle-class children of the Great Depression, grateful for the work.

His modesty has enabled Thiebaud's career, for all its appearance of being almost too placidly well-charted and self-contained, to rock and then hold fast amid two great revolutions. First, the revolution of Abstract Expressionism in the forties and fifties, which made any Realist enterprise, no matter how modestly

undertaken, into a defensive, *retardataire,* dubious position—a revolution which, as revolutions will, made seeming reactionaries out of honest men and defenders of the faith out of those who merely wanted to practice in their own chapel. And then, hard on its heels, the Pop Art coup d'etat—it would be too much to call it a revolution—which meant, in a brutal accompanying irony, that anyone who *did* take on the things of the American world as a subject was assumed to be engaged in one or another kind of ironic or mocking activity. This double-whammy—"Sure, he's a good painter, but, honestly, he just paint cakes," to, "Hey he paints cakes, but doesn't he paint them just a little bit too honestly?"—would have beaten, worn down, or depressed a man with a less resilient core. (That he doesn't exclusively or primarily paint cakes anyway hardly helps the problem; this is America, where a man becomes his hit.)

The modesty of his ambitions can make his admirers at times overreach in their praise. There is a natural inclination among those of us who love his work to try to make of him either the Last Honest Painter—a Chardin or Fantin-Latour-like figure—or else to insist that his work is not as comic and charming as it looks and find in it elements of the transgressive, the difficult, the contradictory, or the just plain ornery. (After all, no postmodern puritan has ever looked more precisely at the way that American goods are packaged by its merchants, and if the theme of these sunny and rapt pictures has to be summed up in a phrase it would be "commodity fetishism.")

To follow this line, though, is to betray, if not the artist, then our own response to him. It is to allow the forms of forensic pleading, as they are practiced in the catalogue essay, that summing-up before the bar, to take precedence over the actual leaps of the heart in response to things seen. Thiebaud is without a school, an obviously radical innovative style, a "breakthrough." And if these things seem to limit the way we write about his pictures, perhaps the trouble lies not with the pictures but with the way we write about them. If we ask the pronouncer to abdicate, for a moment, the seat of fussy historical placement— if we are true to our actual experience of the pictures, rather than to the things we ought to speak, if we say what we feel, not what we ought to say— then our thoughts may turn away from a hidden plot in history, of which Thiebaud might be made the hero, towards the things that make people

happy (and sad) when they look at his pictures.

Thiebaud paints cakes and valleys and bow ties and San Francisco streets; his paintings give pleasure, and the pleasure then conveys complicated truths about California and American life. Rather than evade that pleasure, maybe the job is to define it more closely, to particularize the exact kind of pleasure he brings and where, exactly, it ends. Love calls us to the things of the world, Richard Wilbur wrote. But having been called to them by the poet, it is the painter who is left to show us *exactly* the way they look that makes us love them. "Now: close your eyes!" the small boy instructs his audience when he comes to the tricky part of the magic trick. The painter says to open them, just as the trickiest part begins. If we look hard the trick is on the table. How do such simple things affect us so deeply? What's the recipe? The trick may be not that the pictures are more complicated than they look, but that the act of looking may be more complicated than it feels.

———————

WAYNE THIEBAUD WAS BORN in Arizona in 1920 and raised in California, though as so often in American lives, that last phrase is an over-simplified précis for a childhood spent lurching from places as different as the Southern Utah flats to Long Beach Junior College. His father was, by turns, a mechanic, an inventor, a mechanical administrator, a rancher, and a milkman. (Having a dad like that is a good way to learn resilience.) Thiebaud's first attraction was to cartooning at a time when American cartooning was in its jaunty, black-and-white George Herriman and Krazy Kat heyday. (To this day, Thiebaud can do an uncanny pastiche of Herriman's Jazz Age manner.) Cartooning was an available art form, something real people really did. One of Thiebaud's uncles, for instance, was a coffee salesman who also worked on Happy Hooligan. (A coffee salesman *and* an artist.) Thiebaud established himself when a teenager as a cartoonist—he still often draws a cartoon a day, though he doesn't like to show them—and even worked briefly as an apprentice animator at the Disney studios. (He was said to be able to draw Popeye with both hands simultaneously.)

His first coherent and logical ambition was to be a commercial artist, an illustrator—perhaps to someday have a commercial art studio of his own. This wasn't in any way a compromised or timid or tentative aspiration. For a boy of limited means growing up in California in the Depression, it was "commercial art"—a general term that brought together illustrators, cartoonists, engineers, and designers, the men who made you laugh in the *Saturday Evening Post* and the men who made you long for an unobtainable Studebaker—that shone with glamour and promise, while the fine arts were still a dusty rumor of old Catholic madonnas with rolling eyes. John Updike, another poet of American abundance and isolation, notes:

> *In the Thirties and Forties when I was growing up, the cartoonist occupied a place in the cultural hierarchy not far below that of the movie star or inventor . . . a cartoonist partook of this process [of limitless mechanical printing] at the tentative, scratchy, inky outset, and then was swept up and glorified by a massive, ponderous miracle of reproduction. To get a toehold in this mighty metal world that was my ambition, the height of my hope.*

While there was a popular-surrealist side to commercial art, evident in the extravagant simplifications of Krazy Kat or the quick stenographic gags of Blondie, it also offered a love of truth, a modestly proclaimed but heartfelt faith that the world and everything in it was describable. As Bruce McCall would observe of his own attraction to commercial art at the identical time (well, actually ten years later in Canada, the same thing), what illustration showed you was that "the point and pleasure in drawing was in getting it right, trapping the truth on paper, demystifying another piece of the world." His early immersion in commercial art—and until the mid 1940s, when Thiebaud was already a grown man with a young family, "the last thing in the world you would have imagined of me was aspiring to the museums"—remains central to his work. What he got from that immersion was less a style than a habit of being unintimidated, an urge to demystify the world and art, too. When he first came upon the work of Edward Hopper, for instance, who would continue to inspire him in his seventies, "I thought of it as a kind of illustration," Thiebaud notes today.

AN AMERICAN PAINTER

Yet the thing that impressed him most, as he went to work at design studios in Los Angeles, was the commercial artist's reverence for the high art of the museums—a reverence made more impressive for being technical and practical rather than rhetorical and academic. Michaelangelo and Rubens knew how to do stuff. They knew how to render a biceps or the selling bit of a woman's thigh, and these tricks, imitable if not reproducible, were in themselves affecting. "What I couldn't get over was that all the illustrators and commercial artists I admired most were crazy about the old masters," Thiebaud says today. Where the old curse on American art appreciation meant that art had to be good *for* something—to teach a moral or improve a social position—Thiebaud was lucky to experience the old masters as guys who were good *at* something and who got good by practicing.

With this education came a kind of mildly puritanical distaste for splashing ideas around and for art as a means of "self-expression." Like Joseph Mitchell in New York writing for the *World* and sensing that flat-American newspaper style was actually closer to the style of *Dubliners* than the slick stories in the *Saturday Evening Post,* Thiebaud grasped that the lower ranked activity of commercial art had in it some direct contact with the real distinguished thing. He got the old masters as guys who might potentially have occupied the next drafting table—which, if not the only way to get them, is certainly better than getting them as pawns in a game of metaphysical chess played by professors.

Thiebaud also admired and took part in a more narrowly local tradition—the growing and just burgeoning tradition of California art. In California painting of the twenties and thirties, Thiebaud's youth, there was at least one first-rate talent with a circle around him, whose work in many ways uncannily anticipates some of Thiebaud's. That was Selden Gile, the founder of the Society of Six, the Oakland-centered group that failed to triumph because the surrounding soil seemed too thin to nourish it. Gile and the group around him who became the Six were outdoor painters in bright color. Curiously, they looked like disciples of the Fauves, though they had seen very little Fauve painting. All of them were in search of a "local" style, high-keyed and expressive and unmediated. But Gile alone among them went beyond anything he could have seen in his use of wild, pure color, right-out-of-the-tube color, which looks like nothing seen again in

American art until the 1940s. Most of the Six still adapted French schemata to Northern California scenes, but there is nothing French in feeling about a picture like Gile's *Open Window* of 1927, which, in its play between saturated intensity and simplified shape-making, seems directly to anticipate some of the spirit of Thiebaud's art. Even the insistence in the "Manifesto" of the Six on painting as simply "the joy of vision" and the remark, "We do not believe that painting is a language . . . we have much to express, nothing to say," seems impatient with over-theorizing in a way that Thiebaud would always be.

Thiebaud has commented enthusiastically on Gile's masterpiece, *The Red Tablecloth,* in Nancy Boas's fine book on the Six, praising its "goofy kind of juxtaposition of variable points of view" (goofy is a complimentary adjective in Thiebaudese) and as "a marvelous indication of the range of Gile's inquiry." What seems prescient of the "Thiebaudian" in Gile's painting is the sense of a picture made to a "classical" model—with a lucid, almost pedantically straightforward, clear geometric order underlying the image—but with the paint laid on in fireworks and frosting, directly and intense. Thiebaud's admiration for Gile is strong, but in his memory his experience of Gile's art was retrospective rather than formative. He saw later that someone else had been on the same track. At a minimum, Gile remained a vague example of What Could Be Done Right Here if you had the courage—goofy courage, perhaps—to stay and do it.

More than any of these "influences" and examples, there was the effect of what the artist saw without thinking about what he was seeing. Thiebaud grew up in the land of bleached light and windows. He did counter time. He seems to have been stirred not by the already intact Southern California iconography of ersatz "events" and palm trees and girls like ice cream sundaes, but by a lower, more commonplace lingua franca of American display. The soda fountain, the cosmetics counter, the hardware store—that entire world in which things seem to have been over-ordered, given more display value than the demands of buying and selling strictly demanded, "fetishized" beyond the intrinsic need to allure people in to buy glasses or bow ties or hammers and nails. He saw a world in which display had become a reflex and a habit, even in a sense a kind of cargo cult: if we keep the goods in perfect order, the customers will come. It was not the big, grand manner of billboards and Hollywood open-

ings, but the small manner of the nervous luncheonette: segment the grapefruit with a serrated knife, set the cakes spinning in their refrigerated case (we call them "homemade"; they came this morning from the big commercial bakery on Main . . .), put out the hair lotion and the suntan lotion and the sunglasses. He saw a world, to use a lovely abandoned Americanism, of *notions,* laid out as if by the hand of God. This was Thiebaud's primal landscape and it stuck with him. "I can walk for hours in a city staring at the windows of the little stores," he still says today.

————————

YET IF THE MATERIALS LAY NEAR AT HAND, the alchemy to turn them into art had to come from another place. The illustrative had no terror for him, but the anecdotal did. Although he had made a commitment to painting by the 1950s, and was already making a reputation as a teacher, the few paintings of the period that survive, or anyway that get displayed, seem surprisingly unsure apprentice-work. There are very few prodigies in modern painting, and curiously it is the hedonists, the painters of what seems like happily unmediated sensation, who can take the longest time finding themselves. (Matisse was a long time stumbling into his sensuality.)

But there was an extra difficulty. As Thiebaud sought to find himself as an American painter, American painting was in the middle of a revolution so large that it seemed to leave little room for a California Realist with a gift for descriptive drawing and an attachment to the light and order of the American scene. By 1946 he had taken a trip to New York and, wandering around the galleries, had gone into the Guggenheim Museum gallery of "Non-Objective Art." He had been impressed by some of what he saw, mostly European painting, though he still had a deep resistance not so much to the art itself but to the in-group atmosphere that surrounded it. "It seemed to me that [abstract painting] was what people meant by Fine Art—work that looked like the *signs* of art, flourishes and obscurities." Greta Garbo had walked into the gallery though, and, like a good American boy, he had walked out to follow her down the street, interrupting his education for several years.

By 1949, though, when Thiebaud returned to school to get a "teaching credential," the new abstract painting coming out of New York was becoming hard to avoid or miss—you only had to open the art magazines to see that something big was going on—and then in the next seven years it became impossible to ignore. With his quick instinct for good painting and his ability to see past what's said about a picture to what's actually there, Thiebaud became, as he remains today, a passionate and discerning admirer of the abstract painting of Willem de Kooning.

The path from de Kooning into Thiebaud is both so surprising and yet in another way so typically American—a high transcendental style turning in a single twist of the imagination into a precise, empirical, descriptive style—that it deserves a look. "De Kooning," Thiebaud observes, "had something to do with commercial art," and by this Thiebaud meant not that de Kooning was in any sense trying to sell anything, but that there was "something close to Ingres in it; he had an immense concentrated knowledge of painting. What I saw in it wasn't the painting of a wild man, but a succinct reductiveness that appealed to me immediately. Like any admirable artist, he seemed to me to work form-first, with an immense vocabulary."

Thiebaud came to admire de Kooning even more when, on a sabbatical in 1956, he went to meet the master in his Tenth Street studio and they talked comfortably about painting. Famously allergic to theorizing about his own art, the familiarity with which de Kooning talked about painting impressed Thiebaud nearly as much as the painting did:

He was dismissive of his critical admirers, and he talked so easily of so many kinds of painters: Rembrandt and Soutine, Fairfield Porter and Elias Goldberg—his talk was so full of people, rather than theory. It made me pretty suspicious of that kind of operation. I had been put off by the churchy feeling of a lot of New York painting, and I saw that de Kooning was, too. He disabused me of it, and, as much as anyone, suggested to me that painting was a lot more important than art.

De Kooning supplied a living instance of the way that a painter could make up his own pedigrees and alliances, without caring over-much about schools or

manifestos. But de Kooning's influence went far deeper, to the very basic grammar of the painting that Thiebaud would attempt and achieve in the next twenty years. It took a quiet, dry confidence, and even a certain kind of comic insight, to see in de Kooning's painting of the fifties, as Thiebaud did, a possible model or at least an inspiration for a new kind of descriptive painting. For 1956 was the high-water mark of the unthinking acceptance of Harold Rosenberg's brilliant, wrong-headed reading of de Kooning as an "action painter"—an existentialist in action, flinging a pot of paint in the face of Big Brother, a painter of pure heat and motion.

Thiebaud, instead, saw in de Kooning's actual practice not abandon and the renunciation of inherited form, but that "succinct reductiveness." Thiebaud, with the X-ray vision of the outsider, the guy from Krypton, saw that, so far from being a renunciation of figural painting, de Kooning's achievement had been intuitively to reduce the old forms of life drawing to a few stenographic hooks and scrawls—"all the armature of life drawing, the shorthand you learned in European art school for joins and transitions, was still there, only in simplified form."

Light more than heat was what Thiebaud saw in de Kooning. "He had a kind of Holbein-like sense, a very Dutch sense of how light worked—that he could use it as a means—reflecting in a brushstroke a whole atmosphere." Thiebaud particularly admired a quality that would become a touchstone of his own work, which was de Kooning's ability to "light a picture from within"—to engage, as Richard Wollheim has put it, in "the creation of a light that, in contrast to the light of reality which plays on objects, producing highlights and shadows, seems to come out of the objects [or in de Kooning's case, the pure brushstrokes] themselves."

De Kooning seemed able to sum up an entire condition of illumination in a single twisting, dolphin-leaping brushstroke, and in this way it was intimately tied to the next thing Thiebaud admired in his work, and that was de Kooning's sense of "tempo." "Tempo" is a very Thiebaudian word, and by it he means the implied rhythm of the brushstrokes in a picture—what he calls, wonderfully, the "brush dance" of a picture. "Each distinctive painter has his own brush dance. Seurat, surprisingly, has a kind of fox-trot, Manet a waltz. Berthe Morisot

you might say is almost a figure skater, skating and jumping and twirling. De Kooning includes almost *every* tempo—very slow and very fast, very happy and very blue, all within a single picture." This range of tempi, this variety of brushstrokes not put entirely at the service of description but intended to create a visible rhythm of its own, this jumpy unevenness in the much more concentrated, chamber-music format of Thiebaud's own work became one of its most distinctive features. His stillest pictures are never still-born. They swing.

It was his firsthand experience of de Kooning in 1956, both the man and the artist, that would release Thiebaud's mature style. What looks at first like the radical empiricism of Thiebaud's art—nothing but pies, pies, pies—turns out to have its origin in a form of abstract absolutism: nothing but paint, paint, paint.

———

IT WOULD TAKE FIVE YEARS for the mature Thiebaud style to emerge, made from this strange alloy of de Kooning and the five-and-dime, and it did at last in 1961. His first paintings of cakes and pies, which begin to appear then, are still mostly "anecdotal" in feeling, richly painted but without the concentration that later Thiebaud gives you. It would be in the next year that the first "signature" Thiebauds—the *Delicatessen Counter* (cat. 14), *Four Pinball Machines* (cat. 17), or *Toy Counter* (cat. 21)—announced the essential Thiebaud aesthetic: highly simplified geometric forms, squares and cylinders and rectangles and cubes, taken from the most unpretentious vernacular form and painted with a dense, textured, dancing richness.

It is really only towards the end of 1962 and then throughout 1963 that Thiebaud found himself, particularly in *Salad, Sandwiches and Dessert* (cat. 18)— the names alone are fun to write down—*Cake Counter* (cat. 25), and the great *Cakes* (cat. 26), now in the National Gallery of Art in Washington, D.C.

Critical reaction as well as popular taste have made of Thiebaud the great American pieman, and the variety in his work thereby overlooked is vast enough for the pieman to feel even more strongly than piemen usually do that his critics are Simple Simons. The real leap for Thiebaud was not into a subject but into a manner of presenting it. Bow ties or lipsticks, cold cream jars or seated

people, Thiebaud's mature style is independent of a single theme. Yet if the critical eye can be lazy—there's lots more than just cakes—popular judgment is not entirely wrong here. Images become iconic because they contain the most succinct expression of an idea, and the cakes and pies are as much the best as Johns's flags are the best of his. The superiority of the cakes and pies as subjects for Thiebaud's endeavor derives essentially from the sly audacity with which they work. They are reductive, diminutive, repetitive, and derivative—and make each of these "faults" into high-hearted comic virtues.

They are, first of all, reductive in the sense that they offer forms that are simpler and more regular than the shapes of pinball machines and scales and hanging salamis can be. The cakes, without being anything like the traditional *signs* of art, have an immediate likeness to the *materials* of art: they are the art teacher's cubes and cylinders and cones, come to life in a "found" form. They are diminutive, too—just plain small—and this makes them the right material for mock-epic grandeur. Compare *Salad, Sandwiches and Dessert,* for instance, to *Four Pinball Machines* of the same year. Although the pinball machines are presented as an endless row, our built-in knowledge suggests that the row will end. With the small desserts there is a hint of foreverness—they *might* just go on indefinitely, march out to infinity, and this seems to contain a poetic rather than a merely descriptive comment. There is no *end* to these sweet things, it announces, or at least it would be nice to think so.

The cakes and pies are small enough and their "found" manner of display uniform enough for the pictures to build around exact, or exact-seeming, repetition. Variation is an "art" mode, but repetition is the natural comic mode— think of Chaplin turning himself into an automaton in the assembly line in *Modern Times* or Keaton responding with the same deadpan blink and apologetic lift of the straw hat to anything that happens, a pretty girl passing by or a house falling down on his head. It is comic repetition that structures Thiebaud's dessert paintings—this sandwich, and then this sandwich again, and then the *same* damn sandwich again; this pudding with whipped cream on top, and then the same pudding with the same whipped cream; this avocado ad infinitum. The joke, as in Chaplin tightening bolts in *Modern Times,* lies in treating a mechanical task conscientiously, a mindless task mindfully—it lies in the

willingness to do the same thing over and over again, just as seriously each time. It is in this willingness to use comic repetition as a complete order that Thiebaud breaks most radically from the still-life tradition to which he in some ways belongs. From Chardin to Cézanne, the point has been to compose the objects through elegant variation. Thiebaud just connects them up with "ands."

The cake paintings are also derivative in the sense that part of their wit lies in their subjects' being already honest vernacular paintings of a kind. There is a built-in play between frosting and painting in them; these paintings, made with thick, sticky stuff to be appealing to the eye, are things that are already made of thick sticky stuff to be appealing to the eye. The yo-yos and bow ties that Thiebaud also began to paint have the same neat shapeliness and the same nostalgic overtones, but they lack the built-in joke of being already painted.

In *Cakes,* for instance, Thiebaud jokingly plays the part of confectioner—smearing thick brown paint to duplicate chocolate frosting; in other places the paint surface couldn't be more unlike what it represents. The two adjoining angel food cakes that stand dead center in the picture (and which are the only repeated cakes) are painted prismatically, as a composite of orange and beige and sky blue and putty. In every sense, he is giving these cakes a second coat.

Another part of Thiebaud's wit, too, and part of the special success of the cake pictures, is that like a good comedian he touches on knowledge so deep we hardly knew we had it. We know about these cakes, the way a nineteenth-century Englishman knows about rain clouds. We know them by name and can recite them: Boston cream pie, chocolate layer, coconut layer, angel food. And then, though they are sweet, they are not cloying, or even particularly ingratiating. The cakes are complete in themselves and wait for no buyer. (A joke in itself, for surely these are the kinds of American cakes that have always succeeded more as furniture than pastry—those four- and five-layer towers that spin gravely in their cases at the Route One diner and seem, from day to day, untouched.)

Yet if the cake pictures draw on our existing knowledge, they do it in an idealized form. Although the principle of design throughout draws on a plain American observation—this is the way food is actually shown in commercial counters—it makes of the ordinary cake counter an almost Platonic abstraction —Socrates' coffee shop (there really is such a place in New York). The pictures

AN AMERICAN PAINTER

are meant to be transporting, not reassuring, to evoke an "Oh—look!" not an "Oh, yeah." In *Cakes* or *Pies, Pies, Pies* (cat. 10) the perspective is "wrong": the plane of the pictures is improbably tilted up, like the tables in Cézanne still lifes, so that the perfectly circular tops of the cakes are completely visible, as though each dessert were rising on tiptoe to bow at the viewer. His relation to his appropriated styles of window display is like that of a jazz musician to the standards he plays. Thiebaud can transform a standard shop window arrangement simply by spacing it in a new way, pulling it apart, letting it breathe.

The pictures may be about abundance, but there is no glut in their arrangement, which is decisive and severe. The cake pictures' resonance lies in the tension between the dense and sensual excitement of Thiebaud's descriptions and the austerity of the means employed to discipline them—in the way the cake stands have improbably tall and attenuated spindles, so that each cake is mounted high enough to cast a perfect shadow on the aqua ground, or in the way that each cake has been pushed just off center on its plate, so that the simple repeated circles are set off by an undercurrent of ellipses. The effect of looking at all thirteen cakes in *Cakes* one after another is like listening to a whole-note scale struck lightly on a vibraphone. The cake pictures are varied, too, in mood and effect. In *Cake Counter*, for instance, the joke lies less in pure repetition than in the kind of masculine-feminine dialogue between the white wedding cakes up on high, as unreasonably pleased with themselves as the girl in her first communion dress, and the plebeian workaday cakes below. Another day, another cheesecake, they sigh.

If it is the shapes and the surfaces, and their double existence in the worlds of Euclid and Betty Crocker, that make Thiebaud's pictures charming, it is the light within and the light between the cakes that make them haunting. Each cake is shadowed. The shadows they cast seem at first as familiar as the cakes themselves, made of a chalky, melancholy light that got bottled sometime in the 1930s in a small midwestern city and has been spilling into American painting since. It is a composite light—exactly the summed-up light of a painter who has gone from California to the Midwest and back again. The shadows suggest the light of late afternoon—window-gazing time—and make the cakes into things seen on a long walk home or while playing hooky.

And then each cake in each picture is haloed, outlined with rings and rainbows of pure color—bright blues and reds and purples that register at a distance only as a just-perceptible vibrato—the air pumping into the vibraphone. (It is hard to avoid musical metaphors with Thiebaud and hard to avoid the musical metaphors of his period and locale: the airy, light, cool California jazz of Stan Getz and Zoot Sims and Al Cohn. It is not a bad analogy to say that Thiebaud is to de Kooning as Zoot Sims and Paul Desmond are to Lester Young.) These rings are Thiebaud's own invention, though influenced, he has said, by the Catalonian artist Joaquin Sorolla (trust Thiebaud, unpretentious autodidact, to find a forgotten name as a master [see Nash, fig. 7]). But they seem to have a beginning in empirical accident. In sketching an object, Thiebaud would begin "drawing in color" and then correct the drawing in darker color until the original outlines peeped out from beneath. The halo came, as halos will, unbidden but not unearned. Invisible at a distance, they give a lovely breathing radiance to his pictures. The cakes seem blessed. (St. Thomas Aquinas, in his treatise on halos, proposed that the angel's halos were not a something that made their subjects more perfect—after all, how could you be more perfect than an angel?—but were a kind of tribute to the already perfect, a Something Extra added by God. It seems unlikely that Thiebaud would have known this but it resonates with the right idea: it is their halos that lift them into angel food.)

"It's not so much fun to be known as the pieman," Thiebaud says ruefully, and one sometimes feels that he is reluctant to talk too much about the cake-and-pie pictures, partly because they are his hit, and after a time every artist comes to hate his hit, and partly because it is easy to make them back into the confections from which they've been lifted. They are a touch too easy to love. As a response, he has become over the years insistent on the "formal" or even "formalist" basis of his work, mostly as a way of warding off the dimmer kind of criticism. (Though he got it anyway; you can't ward off the dimmer kind of criticism with a power field of crosses and a plantation of garlic.)

But as time goes on, he seems more willing to surrender himself to the pull of his subject matter and has even defined with a typically "succinct reductiveness" what makes them moving, emotional, rather than merely formal. "Without that formalist manner and expertise I would go off in a headlong way," he says:

But of course I do think a lot about the subject matter, which exercises some sort of mysterious pull. It's just very, very familiar. *I spent time in food preparation, I sold papers on the streets, and I went into Kresses or Woolworths or Newberrys, to see the eccentric display of peppermint candy. They're mostly painted from memory — from memories of bakeries and restaurants — any kind of window display. It's the* exclusionary *aspect that gets me — there's a lot of yearning, there.*

It is this sense of the beautiful come-on and its inaccessibility, of the kid with his nose pressed against the window and nothing but Jell-O waiting at home, that gives the pictures their leap of the heart, even when seen from across an ocean. His cakes and pies still manage to suggest that "exclusionary aspect," a serene abundance that is always a windowpane away.

THIEBAUD'S CAKES APPEARED ON THE SCENE and were soon shown in New York, just around the time when the New York version of Pop Art appeared in galleries and museums, and it became easy—almost inevitable—to see Thiebaud as one more of the militants in that march.

This was a natural confusion. Alongside Rosenquist's canned corn, Warhol's soup cans and Brillo boxes, Dine's bathrobes and Wesselman's mouths and pink nudes, Thiebaud's cakes (and lipsticks and bow ties) were bound to be seen as a similar venture, with similar satiric (or, at least, sardonic) ends. For many people still see his work that way—as a slightly more painterly (and, by implication *retardataire*) variant of Pop. Thomas Hess, in a surprisingly uninsightful essay for that usually sharp-eyed writer, said of them in *ARTnews* that "Looking at these pounds of slabby New Taste Sensation, one hears the artist screaming at us from behind the paintings, urging us to become hermits: to leave the new Gomorrah where layer cakes troop down air-conditioned shelving like cholesterol angels, to flee to the desert and eat locusts and pray for faith. [He] preaches revulsion by isolating the American food habit."

In retrospect, it is easy to see and catalogue all the ways in which Thiebaud is not a Pop artist, or even nearly one. His art is not governed or even overseen

by a Duchampian magistrate. Although he draws affectionately on the "found" effects of anonymous window designers, his style is not an appropriated style. Though granted certain freedoms by commercial art, his art has none of the actual qualities of advertising imagery. His subjects are not taken over straight, in any sense, and every brush stroke refers to a world of painting and depiction that stretches right back to the beginning of art. The Pop artists were mostly kidding the grand manner of de Kooning and the Abstract Expressionists, where Thiebaud was reaching for the same effects in a more modest, comic mode.

Thiebaud has some things in common with the Pop artists, many of whom also loved the comic effects of repetition and reduction. But his pictures seek a final effect very different from that of Pop. Pop proper is fast; Thiebaud is slow. In a Lichtenstein comic book picture, for example, many things come at you: the graphic clarity, and the comic subject, and the Art Nouveau outlines. But they come at you fast and all together, in a single blinding strobe-lit moment. Thiebaud's art by comparison, in its Zenlike insistence that we empty out our minds and give a lemon or a bird or a cake its full inspection as a thing, is closer to a koan than a crack, and demands time. The Pop resonance of his subjects is apparent, but they come at us slowed down and chastened, with a host of ambivalent feelings—nostalgic, satiric, elegiac, longing, inquiring—attached, so that our experience ends calmed down and contemplative: *enlightened.*

Thiebaud himself has always been a bit reluctant to embrace Pop, which he recognized had some of the aspects of a "racket "—a regimented shakedown of the establishment by critics and artists. "I was never a card-carrying member," he says now jokingly. And yet, among the Pop artists, with his sturdy refusal to let any artist succumb to a label, Thiebaud did find many to admire, particularly and significantly Claes Oldenburg and Jasper Johns. "Oldenburg's spirit and interest in caricature and cartoon and his transformations of ordinary things appeal to me. Those two seemed to be looking into themselves without the emphasis on identical, conceptual notions and discourse."

If in one sense Thiebaud needs, after all these years, to be released from bondage to Pop, he also proposes another way of getting Pop—of "reading" it,

as the boys in the academy would say. There's a perfectly reasonable sense in which Thiebaud *is* an American Pop artist—in the same way that Peto or Harnett or Stuart Davis are, in the same way that Johns is. The comically heightened or engorged veneration for "real things, and real things only," in Walt Whitman's phrase, appears in Pop, but it hardly belongs to it. The essential Pop joke—that dumb ordinary life is a repository of meaning as potentially rich as anything imagined in an ideal realm of the aesthetic—is his joke, too, and he shares the Pop artist's love of the pomposity-puncturing plain object. But where they were satirists, he is a comedian. Though he longs for a homemade grand manner as sincerely as Clyfford Still, his pictures recognize that the small necessary realities of lived experience—the things of this world—always force their way into any dream of pure painting, as they will into any art of pure thought. Between de Kooning and Duchamp, he tells us, dessert intervenes.

ALTHOUGH THIEBAUD has gone on painting his found and vernacular objects in the almost forty years since he first came to them, one can also sense, beginning in the early seventies, a kind of tug within his work to get away from a subject and effect too easily, one might say, too sweetly, won. It was only in the 1970s, when Thiebaud moved to San Francisco, that he arrived at a genuinely new departure in his work with the cityscapes that remain the most surprising and in some ways the most "challenging" of all his paintings. The viewer was now thrown into an almost Piranesian world, where ordinary streets turned into vertical planes and skyscrapers nestled together like people hugging (happily) for dear life before the downslope on a roller-coaster. Where the previous window-world had been governed by a chaste and precise perspective, this new world exists only at perspective's extremes, where the visual field becomes so foreshortened that the distant and near collapse into a single wall of shapes, or else, as in the freeway pictures, the view becomes so hovering and omniscient that one thinks of the imagery shot from helicopters that begins so many action movies.

If the *Cakes* and the other ordinary objects are Thiebaud's equivalent to

Audubon's birds—inspired and easy to love—the San Francisco street scenes are his equivalent to Audubon's mammals: violent, monochromatic, and less concerned with the clear articulation of color than with space and movement. Many "Thiebaudisms" remain and are unmistakably his—the habit of building design out of simple-seeming repetition, the love of long shadow, and the juxtaposition of white ground and bright object with long shadows and halos. But their emotional effect is entirely different. The nostalgia that peeks around the edges of Thiebaud's earlier works, the implicit longing for the disappearing world of window display and five-and-dime luxury, the sense that this cake *might* have happened in a mid-American past, has entirely vanished. The cityscapes unmistakably belong to a car-bound, gas-driven, contemporary America. They show a city people have made and cars have conquered. The cakes, with their low point of view, still suggest a child's vision; the San Francisco street scenes suggest a commuter's view, another hill to climb that grows steeper every day.

Thiebaud modestly ascribes the transformation in the pictures of those years to his removal, in the seventies, to San Francisco. "I came to them slowly," he recalls:

I was playing around with abstract notions of the edge — I was fascinated, living in San Francisco, by the way that different streets came in and then just vanished. So I sat out on a street corner and began to paint them, but they didn't really work. No one view seemed to get this sense of edges appearing, things swooping around their own edges, that I loved. Then Brian O'Doherty pointed out something simple to me, and that was the way that Hopper made up his pictures — reoriented them, composed them indoors. So I began to do that. I went right back in the studio and began to play around with graphite and eraser. I thought it through and then went back to direct observation.

There's an element of oriental art in them, that kind of flattening out of planes — and a lot of playing around, maybe too much playing around. San Francisco is a fantasy city. It's easy to make it into a pretend city, a kind of fairy tale. There's an almost Australian sense of quick riches, of hills and precipitousness. In order to get it to work, you have to feel it in the pit of your stomach. Unless you

interrupt the process of convenience, the easy digestion of space, you can't get the feeling. You have to take some chances. I'm not always sure about them myself, and sometimes fear there's too much academic abstraction in them.

The most striking likeness in the cityscapes is to the seascapes (more than to the earlier cityscapes) that Thiebaud's friend and contemporary and fellow pillar of California painting, Richard Diebenkorn, was undertaking just around the same time: his *Ocean Park* series. At the simplest levels, both artists were taking partly horizontal scenes and making them into vertical pictures. Diebenkorn took the long expanses of Venice beaches and stood them upright like refrigerators; Thiebaud took the way San Francisco falls down and made it stand up. Thiebaud makes of San Francisco's gravity what Guardi made of Venice's water—an imagined substance that can extend even into the sky. Both painters' series are based on a simple criss-crossing grid with capped tops above, and both draw on the coloristic play between handsome khakis and ochers and sudden accents of sky blues and sea greens.

The ironies and parallels run deeper still; the two artists were in effect trading places. Thiebaud had gone up to Diebenkorn's Northern California, the almost too-pleased with itself, olives-and-red-wine civilization of Northern California, while Diebenkorn was thrust as an outsider into Thiebaud's special Southern California world of glaring, over-white light and appealing cheapness. Each painter—drawing, one feels, on the other's manner—turned the material right around. Diebenkorn made the honky-tonk of Venice Beach into the handsomest series of hedonistic abstractions we have; Thiebaud made a fairy-tale city into an emptied-out, freeway-heavy, slightly mysterious one.

Diebenkorn's *Ocean Park* paintings and Thiebaud's cityscapes together surely mark a moment in the transformation of American civilization—the moment when California became the primary place where people imagined grown-up pleasures and imagined them in a style marked above all by an easy and unimpeded movement between the natural and the cultural. Those two poles of nature and culture—things made by God and things made by Mammon—are usually supposed to be the two opposed sites of American art—with nature trumping culture until in the 1960s culture at last devours nature. In that

scheme California was the ultimate *made* place, the inferno of plastic signs and stolen waters, and if it offered pleasures they were the slightly guilty pleasures of shared infantilism or, at best, permanent adolescence: sno-cones and sports cars. But, in Thiebaud's and Diebenkorn's painting from the seventies, things made and things seen and things found all roll together easily. What registers in Thiebaud's cityscapes, after all, is not the disruption of the hills by the modern towers and streets, but the orchestration of streets and towers together into a single vertiginous, falling-all-over, E-ride city: "A fairy-tale city." Even the subjects that are, for most of us, most heavily weighted with aesthetic disdain—the cloverleaves of the expressways, the second-rate international-style skyscrapers—are treated with an amused fascination, and a kind of pleasure is taken in the baroque articulation of these utterly functional forms.

It is hard to imagine pictures like these—American surely in their subjects, but almost Mediterranean in their sense of ease—emerging in any other place in America before California in the seventies. Abundance had always been one of Thiebaud's subjects, but it had before been the touching, stuccoed, mock-epic abundance of windows and diners. Now one has a sense in the cityscapes, just as one does in the *Ocean Park* series, of an abundance that does not look outward for approval, of an entire civilization in the sun that just exists. The censorious, lingering puritan moralizing that attaches to even some of the best American city scenes before—to Hopper's lonely New York mornings, say—has vanished here. If nothing survived of Northern California but the cityscapes, we would say, surely, as we do when we look at eighteenth-century views of Venice, "What an odd and pleasure-seeking city that must have been, and what fun they must have had there!"

———

IF, IN ONE WAY, THIEBAUD BENEFITED unintentionally from the emergence of Pop, in another way just as strangely he benefited from the confident explosion of the San Francisco and Northern California good life in the past twenty years. The olive-oil and Merlot and goat-cheese and dried-tomato culture that began in Northern California and changed the country's cooking—

and cooking is always the root note of every hedonistic chord a civilization strikes—took Thiebaud on as its own Chardin. More Americans probably know Thiebaud from his illustrations for the *Chez Panisse Desserts* cookbook than from any other single source, and later he would do a beautiful and almost equally popular illustrated version of M.F.K. Fisher's translation of Brillat-Savarin's *Physiology of Taste.*

This has its ironies, of course, since even the cake-and-pie pictures were rooted in Depression-era experiences—and Depression-era pastry—which were the direct opposite of what came later. The kinds of cake he had become famous for painting were exactly the kind of pre-portioned commercial stuff that the sons and daughters of Alice Waters most despised. But the essential note of respectful delight for "minor" sensual experience that rings throughout his work rang true for that generation—as a description not of what they wanted to cook but of the spirit in which they wanted to cook it. That the sensual life if ordered densely enough and treated intelligently enough could be art, that dessert was a large enough subject for an artist if the artist were willing to give it the same intensity of purpose that had once been reserved for religion, that the things of this world were enough if you *cared* about them enough—all of these lessons could be learned from Wayne Thiebaud's pictures, and were. (To this day, Alice Waters's stationery bears a quote from Cézanne: "The day is coming when a single carrot, passionately observed, will start a revolution.") The resemblance *here* lies exactly with M.F.K. Fisher, whose sublime prose shares with Thiebaud's painting a combination of extremely simplified and austere language—no great food writer has ever written about food with a less "sumptuous" vocabulary—and shares an extremely unpuritanical and world-affirming vision: *The world is what it is, and you make of it what you can.*

Had Thiebaud's career and work ended there—the lovable cakes, the demanding cityscapes—it would have seemed complete. Yet remarkably the "research" that filled the cityscapes has just in the last few years brought forth a late flowering that not even the artist's keenest admirers could

have anticipated, a new chapter when one expected a postscript. In November 1997 Thiebaud showed forty landscapes at a San Francisco gallery, all but seven completed in the previous two years—an enormous new body of work. They take as their subject a landscape unknown, it seems, even to most Californians: not hilly San Francisco or oceanic Los Angeles, but the delta of the Sacramento River. It is a landscape almost Tuscan in its human articulation of terraces and farmed fields—but it is wet rather than sunny, with rivers and irrigation ditches snaking through, and all seen from high above. Where the point of view in the cityscapes was at one interval that of an ant trudging up the hills, the next of a God looking sympathetically down, in these new landscapes the view is entirely and unmistakably that of an eye in the sky—the view not so much of a satellite as of a small crop-dusting plane. The world it sees is fantastically rich, almost psychedelically colored. In place of the essentially rectilinear form of the cityscapes he builds a kaleidoscopic variety of shapes: striped furrows and striated fans, hot pink parallelograms and S-curves, magenta trapezoids locked into high violet-green cypresses. The horizon is nearly always pushed right up out of the top of the pictures, while the river itself usually becomes a big muddy white or paste-colored snake slithering its way through the landscape, surrounded on all sides by fantastic tributary flourishes that depend on it.

A new tininess, a miniaturization, emerges: thousands of flat geometric shapes seem packed into a single foot of the pictures, while the linear pattern of furrows and crop striations and ditches adds an incised, wild, nearly Op-art element to what had been before, essentially, a classical language. At times the landscapes seem so intricately wired and brightly colored that it is like looking down into the innards of a computer chip. The pictures' colors are hallucinatory, as though Ruisdael had painted them on acid. They are the sublime of Orange Crate art.

The analogies of the "natural" to the man-made, the love of geometry in natural form, fill the pictures. What had been a playful and joking back and forth between natural and man-made in the cityscapes, a play between the hill and asphalt on it, here becomes an unresolvable unity. What's man-made, what's nature-made and who cares? This is the world made by the California farmer, as much as the beautiful terraced background of the Bellini's *St. Francis in*

Ecstasy was made by the Tuscan peasant, and the old, powerful sense of nature graced rather than despoiled by artificial order is given a new life here, and at an improbable time. Just as the anonymous woman who made up Kresge's window every morning is the unspoken but admired collaborator in the cake pictures, the nameless determined farmers of the Sacramento delta (who make the fruit that goes on the cakes . . .) are Thiebaud's fellow-artists here.

Wollheim, once again Thiebaud's most articulate and committed admirer, writes of these last landscapes that "certain characteristics of these paintings—the independence of color from the strict requirements of depiction . . . have led critics to postulate a late age style." If we look for an analogy in another late style in American art, we find it—with the odd poetic irony that the lives of painters constantly supply. It is in another late style, in the last "conscious" paintings made by the declining de Kooning. For there, too, we see in a purely abstract form a language of hooks, scrawls, half circles, and hot color seeming to depict a watery surface that never quite dissolves or drips, but always remains puddled in odd after-the-shower-in-the-garden shapes. By a beautiful overlap, the all-me painter and the all-the-world painter ended up in the same Paradise—not the clean well-lighted cafe of the European imagination, but someplace more like Wallace Stevens's Key West of the mind, a place with bright wet colors in the sun, the Big Rock Candy Valley.

———

THE CRITIC—that *other* critic, the one who usually does the pronouncing on these occasions—fusses in the seat we have asked him, so unfairly, to abdicate. "Okay, I see that he's an accomplished painter, and he played an important role in the rise of California art, and he's admirably restless and he has a lovely temperament and the relationship to de Kooning is surprising, and who can deny that, yes, the cake pictures are charming and the landscapes seductive—but really, who are we comparing him to? Pollock? *Really* to Chardin? *Really* to de Kooning? Is he really, well . . . *major*?" This question confronted head on is, in a way, the most demanding—if you insist, the most radical—that Thiebaud's painting poses.

Let's try to confront it and say that Wayne Thiebaud is a modest but not a minor artist, that his majority depends in many ways on his modesty. His work is major in a couple of ways—one local or at least national, the other rooted in some permanent truths about painting.

First, Thiebaud's painting, like most good painting, lightly proposes its own supporting traditions, retrospectively creates its own apostolic succession. Thiebaud's painting implies—in its evident sources, in its immanent effects—that a crucial American tradition in art is the eccentric empirical tradition, a tradition that begins at the beginning of American art with Audubon and weaves in and out of the conventional boundaries of illustration and commerce and high art and low, taking in at once "naive" artists like the simple fruit painters of the nineteenth century, illustrators such as N. C. Wyeth, forgotten painters like Selden Gile, and more acknowledged (if hard to place) masters like Stettheimer and Cornell and Oldenburg and Steinberg. (Thiebaud himself might throw de Kooning and Johns in there, too, as more eccentric than we allow.) The elements of this eccentric empirical tradition, which prefers the Weird Fact to the Big Romance, are complicated, but its shared traits are evident. There is, first, a love of craft, though this need not be craft in the obvious sense, of skill at depicting the way things look. (Though for Thiebaud himself, of course, this is of great consequence.) It may involve craft in the other sense; the belief that artists should be quietly crafty—*shrewd,* able to calculate their effects, and create something that may seem naive and merely assembled, but that is in fact composed and knowing. This craftiness, whether that of Cornell making his boxes or of Ryder among his potions and lacquers painting his nocturnes, is a bedrock principle of the eccentric empirical.

Next, the subject of and materials of the American eccentric empirical must usually be ordinary experience, just what there is and recorded for its own sake—not, as Audubon puts it, at the service of a sublime system, but at liberty, dispersed. It involves a readiness to, in Johns's famous words, take something and do something to it (and then do something else to it, the part that gets forgotten), which in turn involves a pragmatic willingness to see that the world *is* just things, and more things, and still more things, and that's enough. You love the things for their thingness, not in spite of it. And this acceptance of the

world-as-things is tied to an urge to find some style so conventionally inexpressive that you can make it completely yours. Art can shade over, in the eccentric empirical tradition, into scientific description or ornithological illustration or found objects or commercial art or technical drawing or even into the forms of window display, and benefit from the shading over. There is, within this tradition and evident in Thiebaud, a belief that real feeling will come from its suppression within a system of design. It is not sublimation or understatement, but a soulfulness that comes from having a lot invested in the "wrong," or at least the unconventional, object. It is a tradition whose sign is the dumb thing transformed through the loving acceptance of its dumbness. This acceptance is rooted, in turn, in the belief that, as Bud Abbott puts it somewhere about his partner, nothing and nobody's *that* dumb. That the eccentric empirical is hardly the whole or even the very best of our tradition—it excludes the self-made Grand Mannerists, from Sargent through Serra—is obvious. But, like the equivalent tradition in our literature that gave us A. J. Liebling and Fisher, it is a sideshow often better than the big top, and Thiebaud is one of its most wonderful performers.

And then, in a larger sense, Thiebaud is not minor because a readiness to be "minor" in a good cause is one of the ways that painting distinguishes itself most clearly from all the other arts. Bad ideas can sometimes last a thousand years, and none worse than the famous formula "ut pictura poesis"—as the picture, so the poem. Pictures are major in a different way than books are. Pictures don't inform and they lessen themselves by illustrating. What they do best, to use a favorite Thiebaudian word, is *inquire.* Inquiry for its own sake is what we value in paintings—the renewed sense they give us that looking, and by a natural emotional extension experience itself, can be taken apart, dissected, caressed, burnished, improved, considered, deepened, even provisonally placed. And inquiry in any form, if it is to be valuable, asks pointed questions, draws small circles, even cake-shaped ones. It is not merely that it can be so, but defiantly that it must be so—that a picture, like an experiment, is only as good as the narrowing of its question. The four greatest pure painters (Giovanni Bellini, Vermeer, Velásquez, and Manet) after all are never minor, but often small, and usually still. Even the analogy to scientific experiment is only half right, for with

painting we accept that the inquiry alone is enough and we do not demand conclusions or conclusiveness. We are content with inquiry itself; and if the painter's love of limited elements is at times like the scientist's love of small questions, it is also at times like the stage magician's, who also uses a restricted range of props—cards, balls, cups, hats—for his effects, and gets his glory through the ordinariness of his illusions.

To have your goods out in the shop window on the corner between inquiry and enchantment is a fine thing for a painter to do, and Wayne Thiebaud does. Thiebaud is an artist of charm, comedy, precise observation, and a pensive sense of longing. He is as major as those things are. He takes as his subject, and expresses as his preoccupations, light, longing, dessert, our strange cities, the California landscape, the nature of American manufacture and the manufacture of American nature, abundance and exclusion and the pleasures and risks of window shopping, and his art is exactly as large or small as those things seem to you.

In a curious way, and more than any other single thing, Thiebaud challenges us to be true to the real sources of our happiness, to the way that in a haphazard commercial culture, small areas of order appear—a San Francisco hill caught in a corridor of skyscrapers that look as inevitable as Monument Valley, a shop window seemingly laid out by the hand of God—and become in our memories as sacred as stained glass and at times as sad. What sustains his art is not so much how shadowed or complex his view of that happiness is, but how confidently he knows that getting the happiness down right will convey the sadness, too. He proposes that the American subject is the self-evidence of happiness, and . . .

. . . "The self-evidence of happiness!" (the little cakes seem to cry out at last, even as the pronouncer takes a breath for his last bite of the rhetorical apple). The self-evidence of happiness! Three bites and it's gone.

Note

Quotations from the artist derive from conversations with him, most particularly a long one in December 1999. The information about his past comes from the artist, from Bill Berkson, "Wayne's World," in *Modern Painters* 11, no. 2 (Summer 1998): 18–19; and from Steven Nash's essay in this book. Richard Wollheim's writings on, and interviews with, Thiebaud have been a provocation and an inspiration throughout. The quotations here are from "A Painter's Alchemy," *Modern Painters* 11, no. 2 (Summer 1998): 20–24. The quotation from John Updike appears in his collection *More Matter: Essays and Criticism* (New York: Knopf, 1999), 794. The one from Bruce McCall is in his memoir *Thin Ice* (New York: Random House, 1997), 64. I learned about Selden Gile and the Oakland Six from Nancy Boas's fine *The Society of Six: California Colorists* (Berkeley: University of California Press, 1997).

I devoted a short essay in the 29 April 1991 *New Yorker,* 78–80, to the study of a single Thiebaud painting, *Cakes,* when it had just entered the collection of the National Gallery of Art. Having struggled hard to get the sentences right then, I have used a few again here.

WAYNE THIEBAUD

A Paintings Retrospective

1
Cigar Counter 1955
Oil on panel, 25 ¼ × 42 ⅞ in. (63.8 × 108.9 cm)
Signed and dated upper right: *Thiebaud 1955*
Thiebaud Family Collection

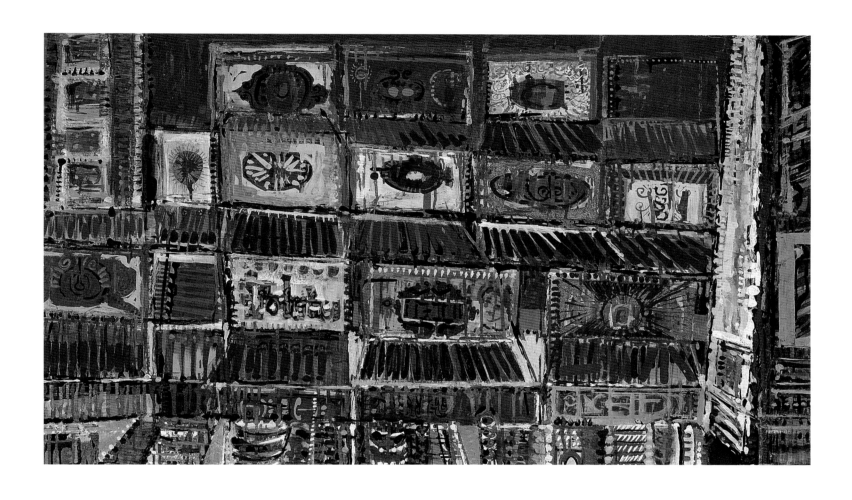

2

Pinball Machine 1956
Mixed media on masonite, 36 × 48 in. (91.4 × 121.9 cm)
Signed and dated upper right: *Thiebaud '56*
Thiebaud Family Collection

3

Ribbon Store 1957
Oil on canvas, 28 × 34 in. (71.1 × 86.4 cm)
Signed and dated lower right: *Thiebaud '57*
Thiebaud Family Collection

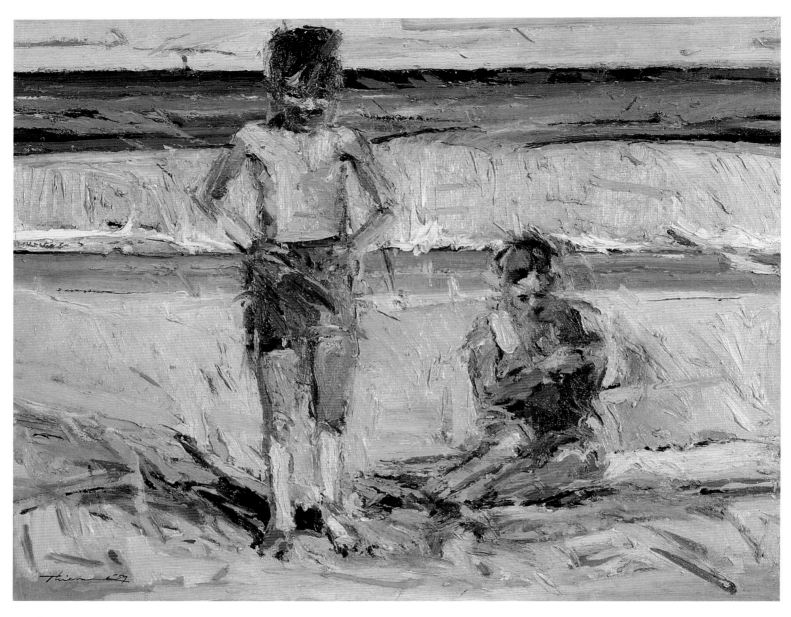

4

Beach Boys 1959
Oil on canvas, 23 ⅞ × 30 in. (60.6 × 76.2 cm)
Signed and dated lower left: *Thiebaud '59*
Matthew L. Bult

5

Sleeping Figure 1959
Oil on canvas, 24 × 20 ¼ in. (61 × 51.4 cm)
Signed lower right: *Thiebaud*; signed on
 right edge: *Thiebaud*; inscribed on
 reverse: *Sleeping Figure*
Thiebaud Family Collection

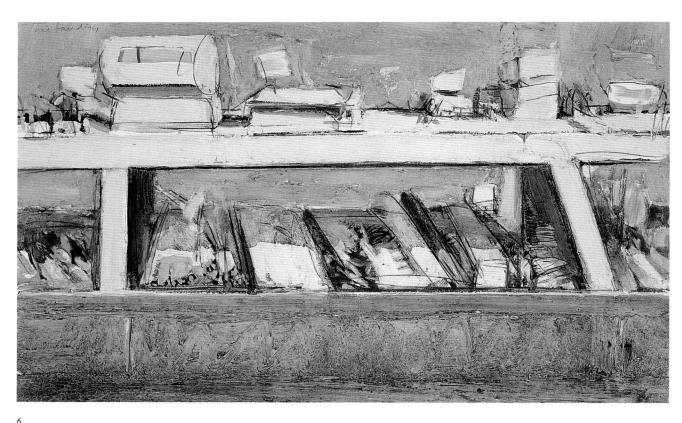

6
Delicatessen Counter 1961
Ink, oil, and watercolor on paper, 16 × 26 ¼ in. (40.6 × 66.7 cm)
Signed and dated upper left: *Thiebaud 1961*
Private collection
Courtesy of Allan Stone Gallery, New York

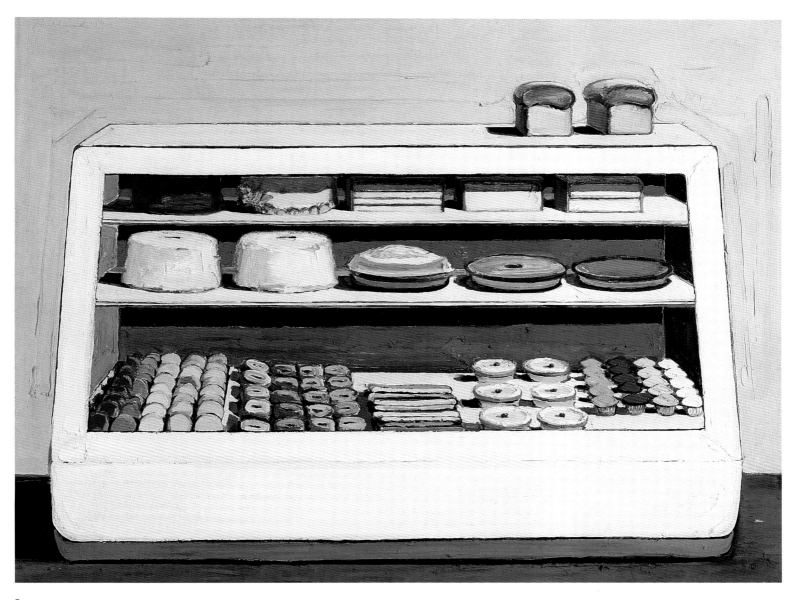

7

Bakery Counter 1962
Oil on canvas, 54 ⅞ × 71 ⅞ in. (139.4 × 182.6 cm)
Signed and dated upper left: *Thiebaud 1962*
Collection of Mr. and Mrs. Barney A. Ebsworth

New York only

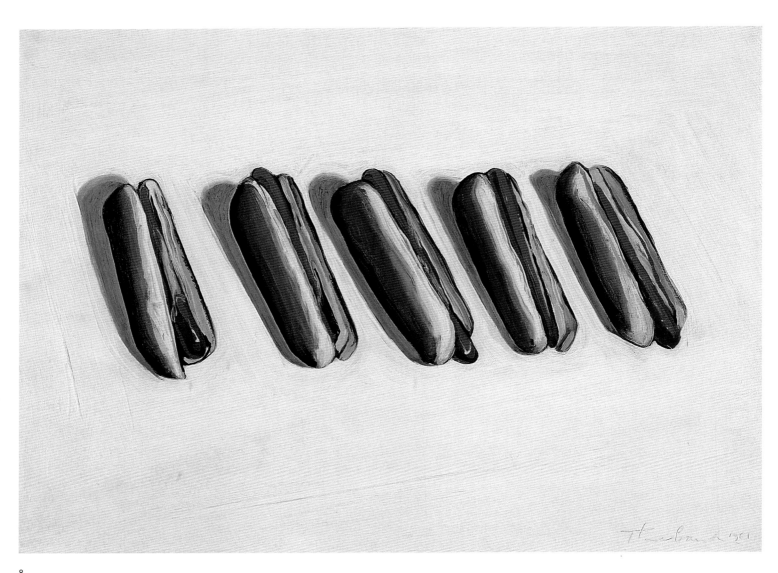

8
Five Hot Dogs 1961
Oil on canvas, 18 × 24 in. (45.7 × 61 cm)
Signed and dated lower right: *Thiebaud 1961*;
 signed on stretcher: *Thiebaud*
Private collection

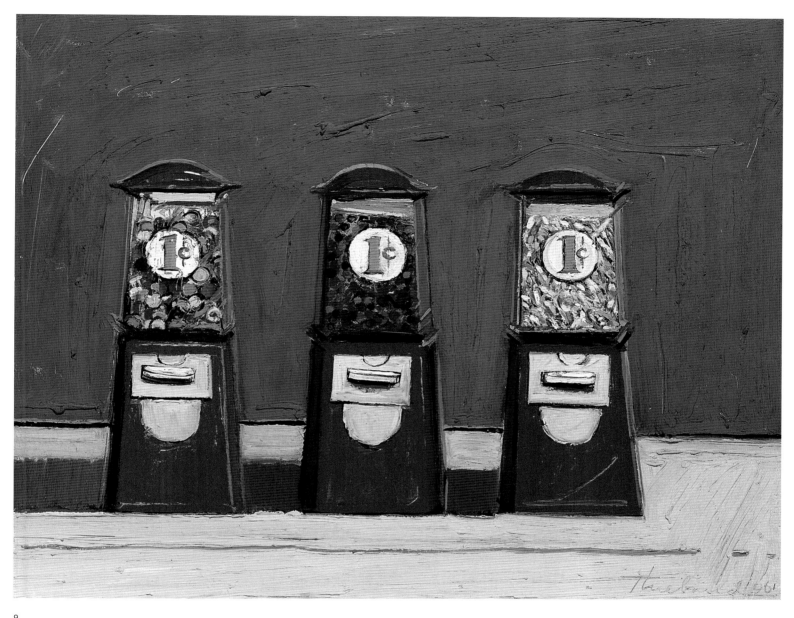

9
Penny Machines 1961
Oil on canvas, 23 ¼ × 29 ¾ in. (60.3 × 75.6 cm)
Signed and dated lower right: *Thiebaud 1961*
Gretchen and John Berggruen, San Francisco

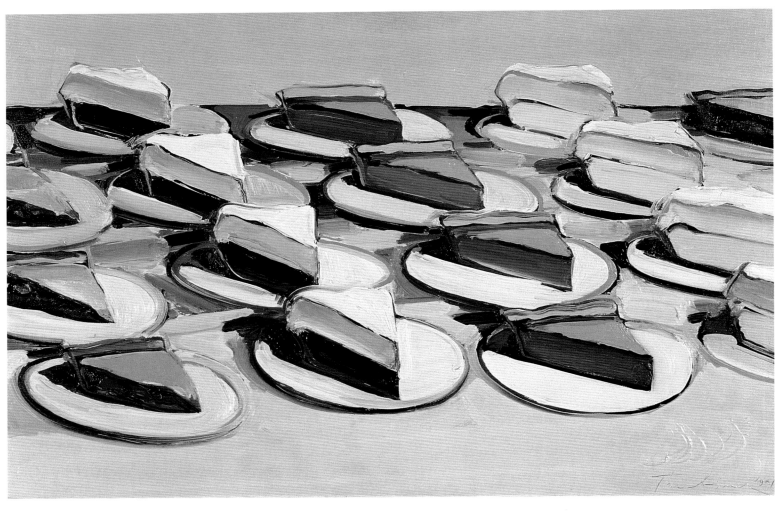

10
Pies, Pies, Pies 1961
Oil on canvas, 20 × 30 in. (50.8 × 76.2 cm)
Signed and dated lower right: *Thiebaud 1961*
Crocker Art Museum, Sacramento
Gift of Philip L. Ehlert in memory of Dorothy Evelyn Ehlert

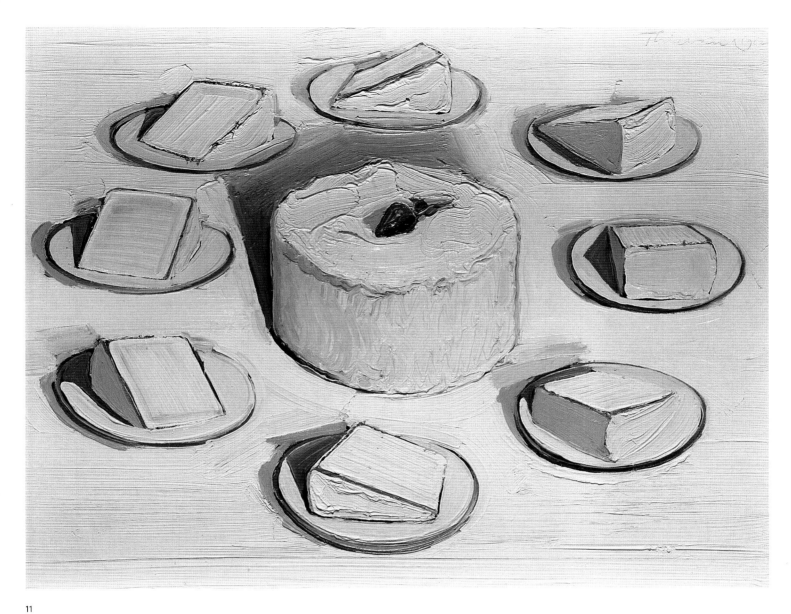

11

Around the Cake 1962

Oil on canvas, 22 ⅛ × 28 ⅛ in. (56.2 × 71.2 cm)

Signed and dated upper right: *Thiebaud 1962*

Spencer Museum of Art, The University of Kansas, Lawrence

Gift of Ralph T. Coe in memory of Helen Foresman Spencer

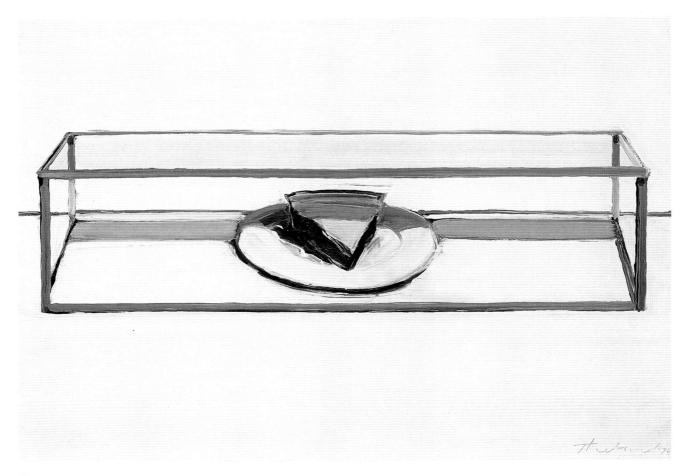

12
Caged Pie 1962
Oil on canvas, 20 ⅛ × 28 ⅛ in. (51.1 × 71.4 cm)
Signed and dated lower right: *Thiebaud 1962*
San Diego Museum of Art
Museum purchase with the Earle W. Grant
 Endowment Funds

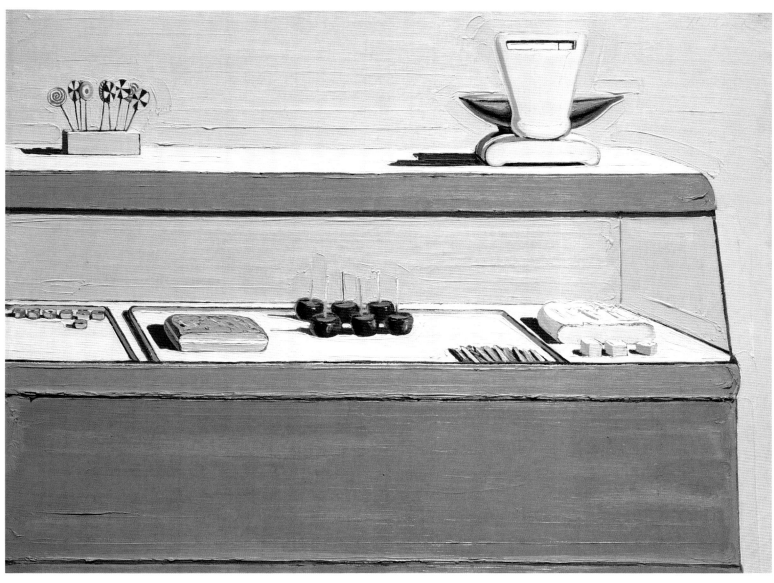

13
Candy Counter 1962
Oil on canvas, 55 ½ × 72 in. (141 × 182.9 cm)
Signed and dated upper right: *Thiebaud 1962*
Collection of Harry W. and Mary Margaret Anderson

San Francisco only

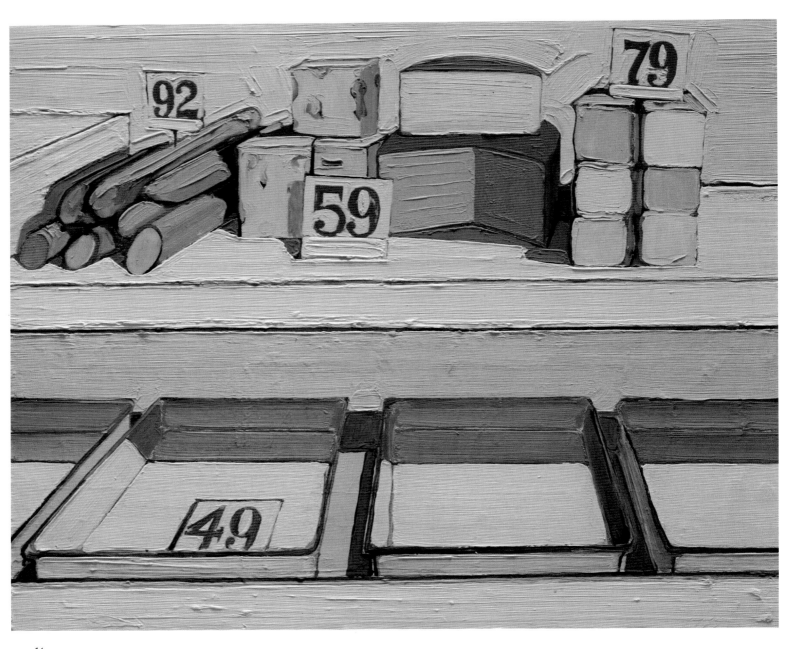

14

Delicatessen Counter 1962
Oil on canvas, 30 ¼ × 36 ¼ in. (76.8 × 92.1 cm)
Signed and dated right side: *Thiebaud 62*
The Menil Collection, Houston

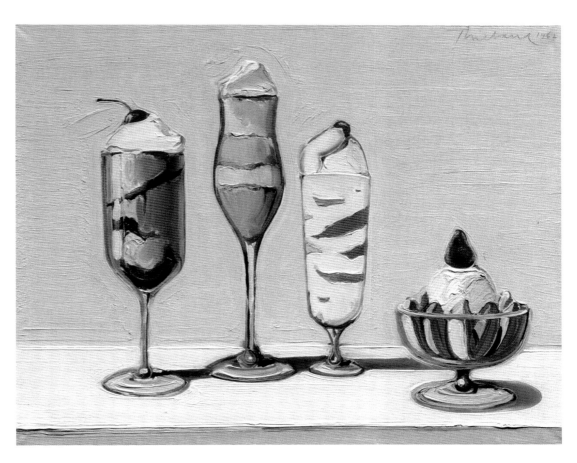

15
Confections 1962
Oil on linen, 16 × 20 in. (40.6 × 50.8 cm)
Signed and dated upper right: *Thiebaud 1962*
Byron Meyer, San Francisco

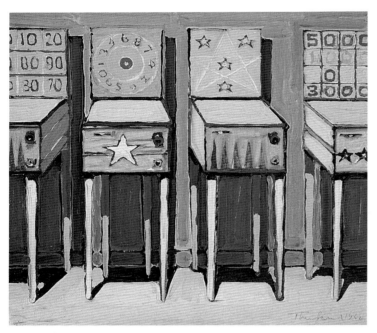

16
Four Pinball Machines (Study) 1962
Oil on canvas, 11 ⅛ × 12 in. (28.3 × 30.5 cm)
Signed and dated lower right: *Thiebaud 1962*;
 signed and dated on stretcher: *Thiebaud 1962*
Private collection
Courtesy of Allan Stone Gallery, New York

17 [FACING PAGE]
Four Pinball Machines 1962
Oil on canvas, 67 ½ × 72 in. (171.5 × 182.9 cm)
Signed and dated lower right: *Thiebaud 1962*
Mr. and Mrs. Ken Siebel

San Francisco and New York only

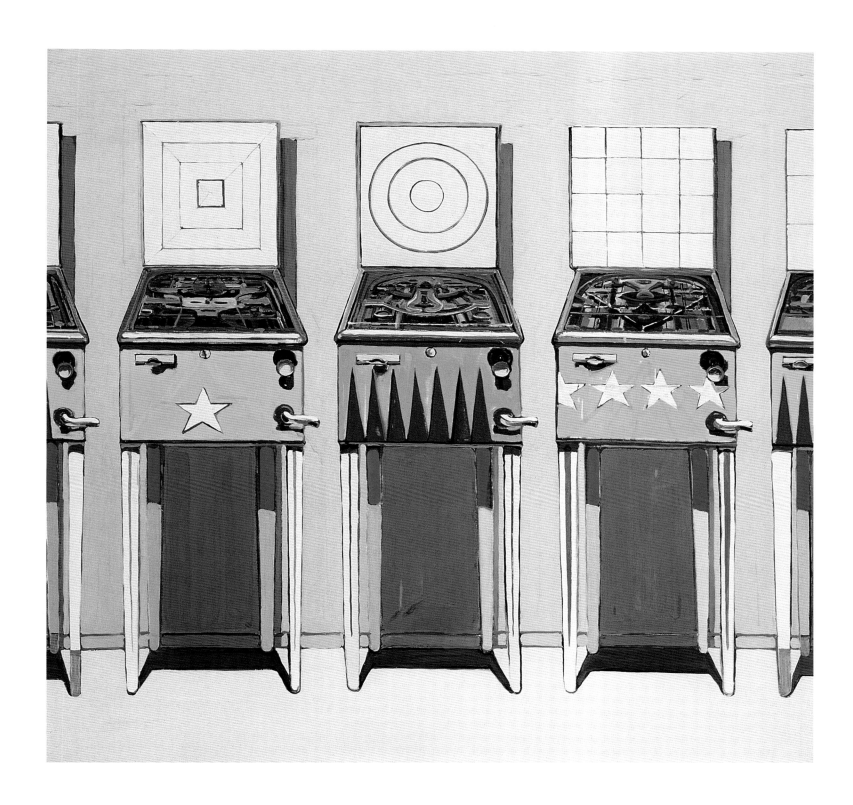

18
Salad, Sandwiches and Dessert 1962
Oil on canvas, 55 × 72 in. (139.7 × 182.9 cm)
Signed and dated upper right: *Thiebaud 1962*
Sheldon Memorial Art Gallery and Sculpture Garden, Lincoln
Nebraska Art Association, Thomas C. Woods Memorial

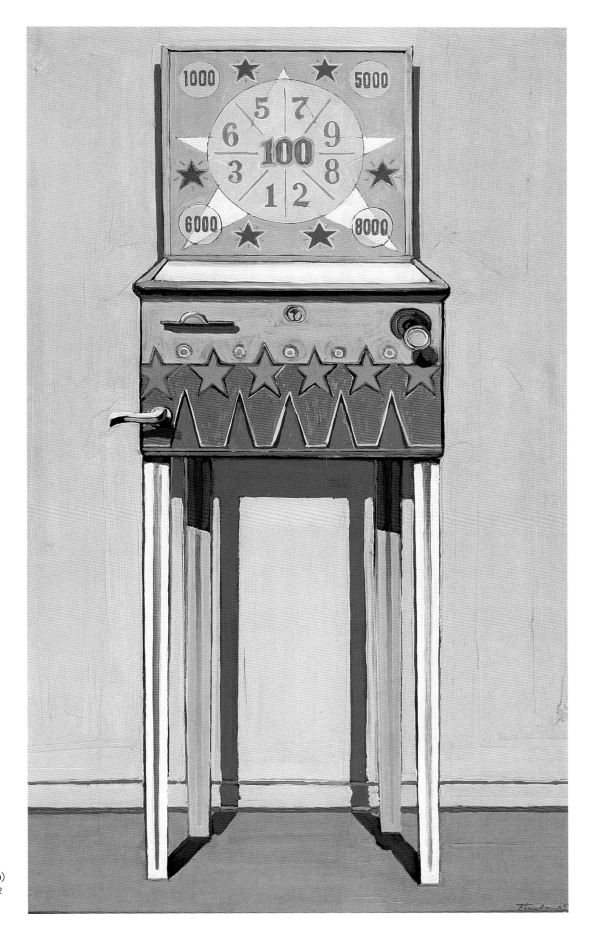

19
Star Pinball 1962
Oil on canvas, 60 × 36 in. (152.4 × 91.4 cm)
Signed and dated ower right: *Thiebaud '62*
Georgene and John Tozzi

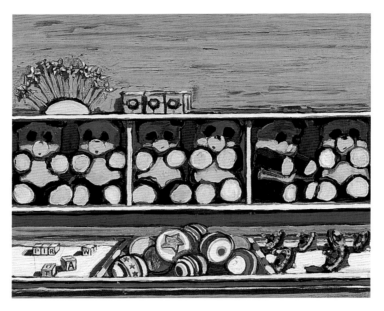

20
Toy Counter Study 1962
Oil on canvas, 10 ⅛ × 12 ¼ in. (25.7 × 31.1 cm)
Signed and dated lower right: *Thiebaud 1962*
Thomas W. Weisel

21 [FACING PAGE]
Toy Counter 1962
Oil on canvas, 59 ¼ × 71 ¼ in. (151.8 × 182.3 cm)
Signed and dated upper left: *Thiebaud 1962*
Thomas W. Weisel

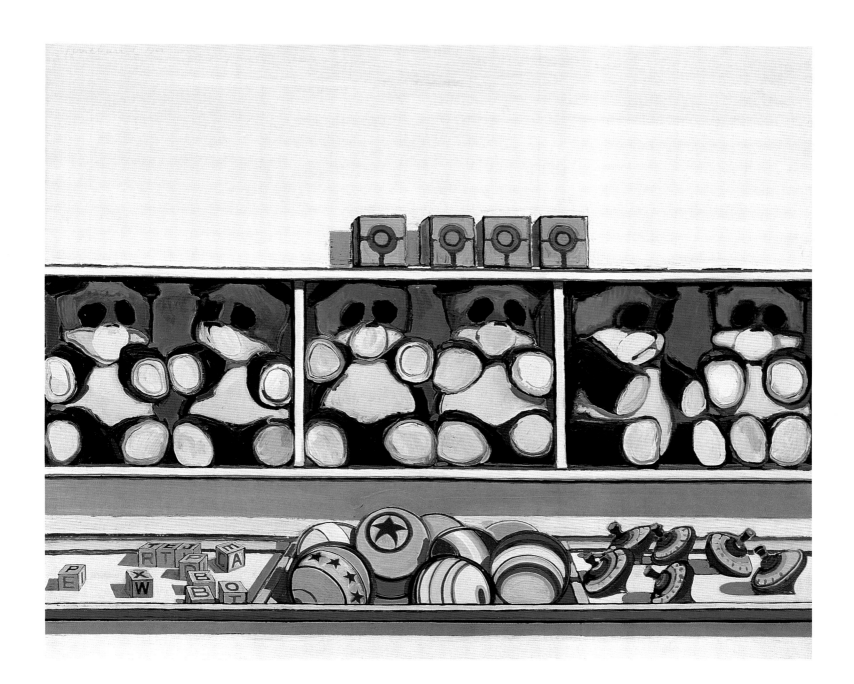

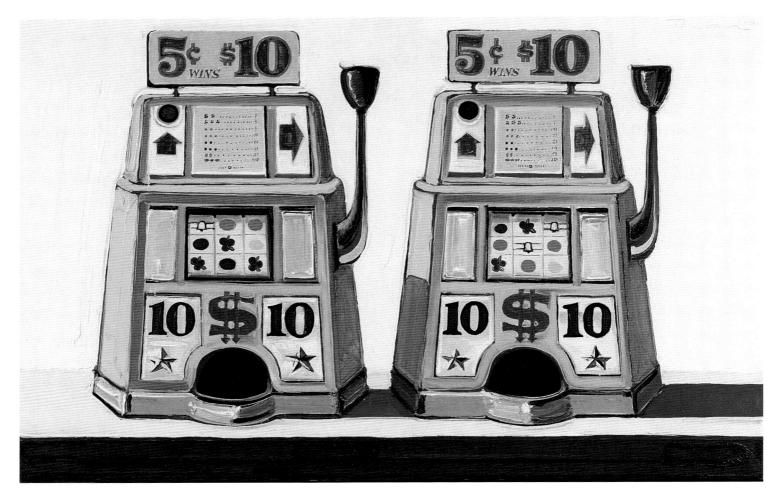

22
Twin Jackpots 1962
Oil on canvas, 30 × 46 in. (76.2 × 116.8 cm)
Signed and dated upper right: *Thiebaud 1962*
Darwin and Geri Reedy

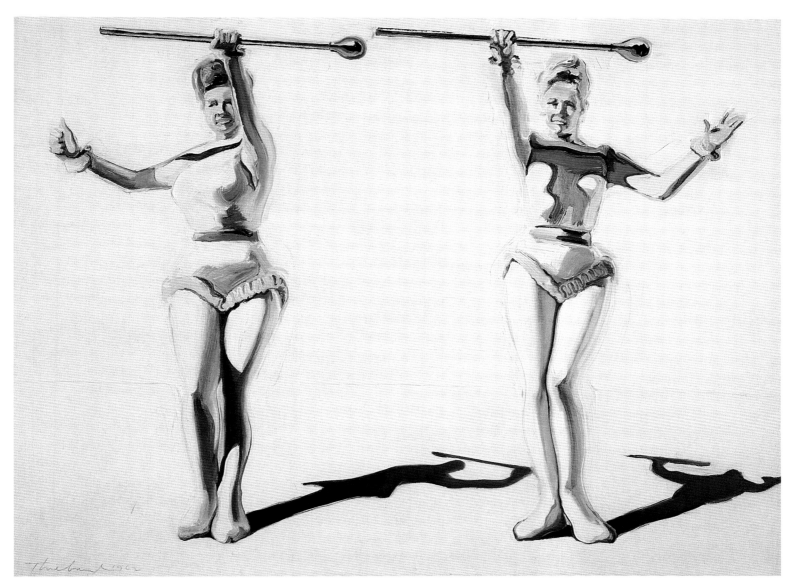

23

Two Majorettes 1962
Oil on canvas, 36 × 48 in. (91.4 × 121.9 cm)
Signed and dated lower left: *Thiebaud 1962*
Paul LeBaron Thiebaud

24
Black Shoes 1963
Oil on canvas, 20 × 28 in. (50.8 × 71.1 cm)
Signed and dated upper right: *Thiebaud 1963*
Private collection

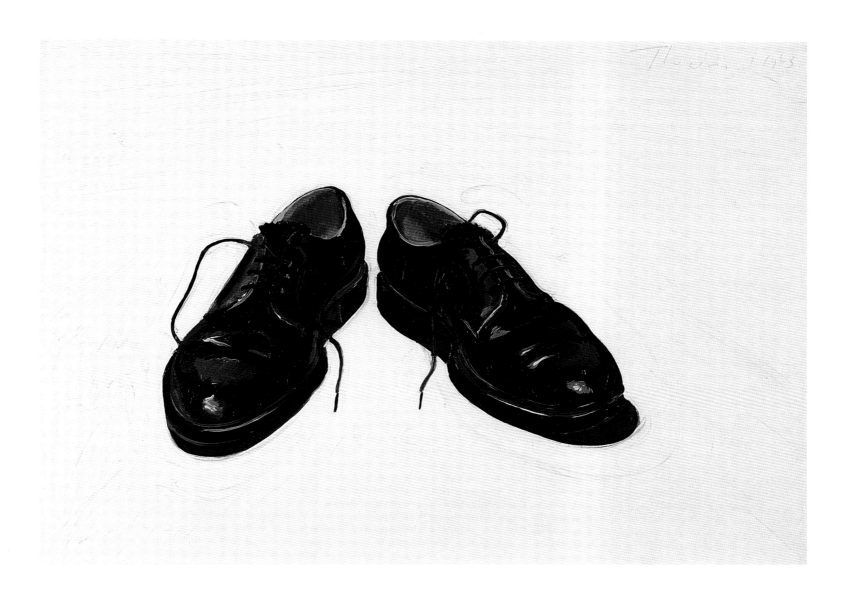

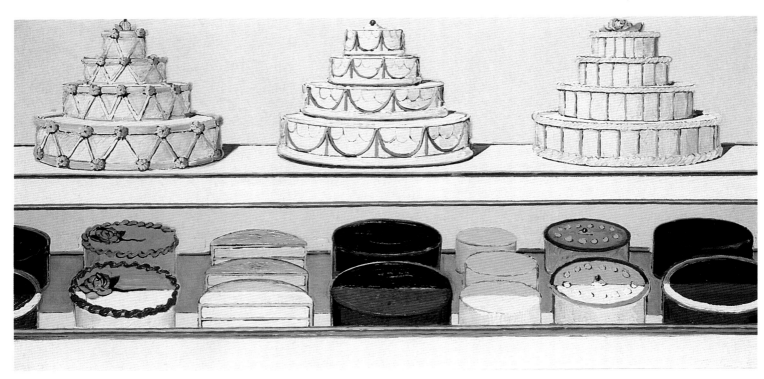

25
Cake Counter 1963
Oil on canvas, 36 ⅝ × 72 in. (93 × 183 cm)
Signed and dated lower right: *Thiebaud 1963*
Museum Ludwig, Ludwig Donation, Cologne

San Francsico and Fort Worth only

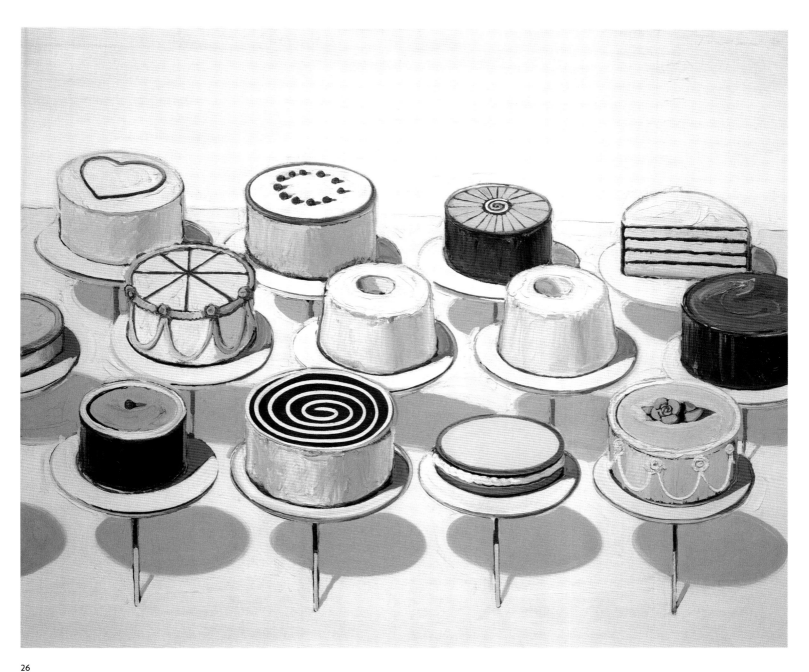

26
Cakes 1963
Oil on canvas, 60 × 72 in. (152.4 × 182.9 cm)
Signed and dated upper right: *Thiebaud 1963*
National Gallery of Art, Washington, D.C.
Gift in Honor of the 50th Anniversary of the National Gallery
 of Art from the Collectors Committee, the 50th Anniversary
 Gift Committee, and The Circle, with Additional Support
 from the Abrams Family in Memory of Harry N. Abrams

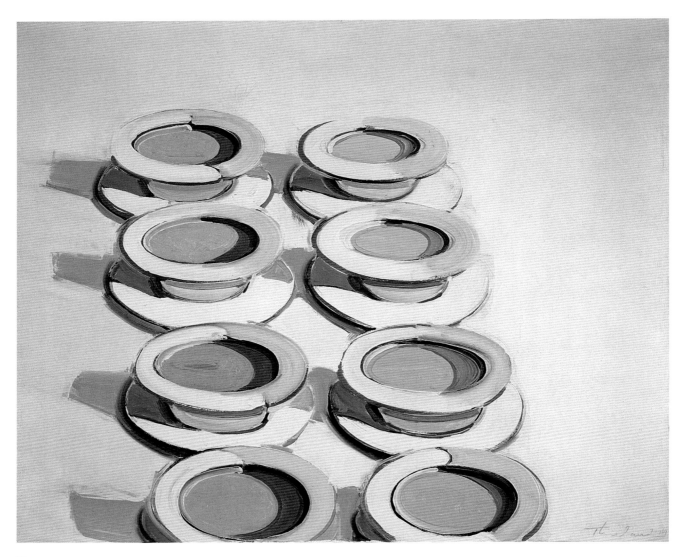

27

Cream Soups 1963
Oil on canvas, 29 ¼ × 36 in. (75.6 × 91.4 cm)
Signed and dated lower right: *Thiebaud 1963*
Private collection
Courtesy of Allan Stone Gallery, New York

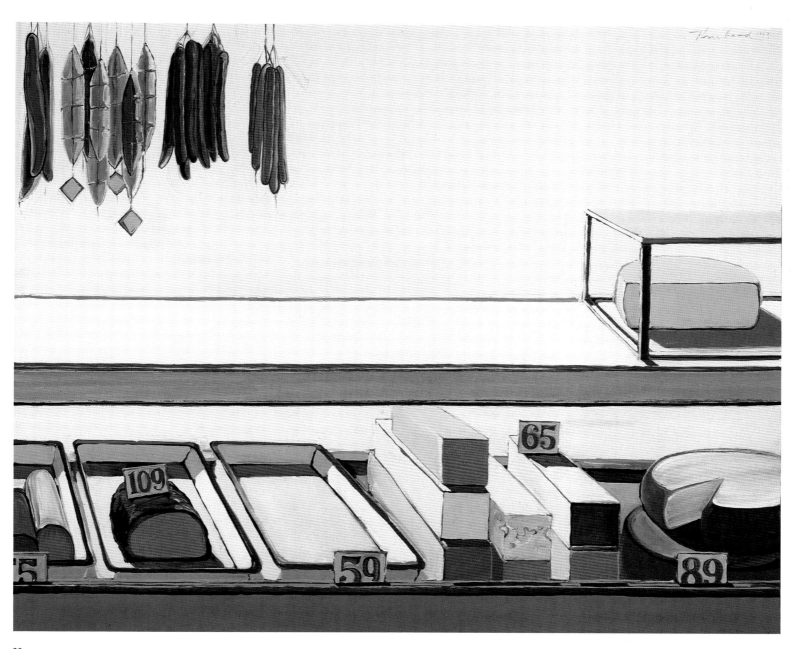

28

Delicatessen Counter 1963
Oil on canvas, 60 ½ × 73 in. (153.7 × 185.4 cm)
Signed and dated upper right: *Thiebaud 1963*;
 signed and dated ower right: *Thiebaud 1963*
Private collection

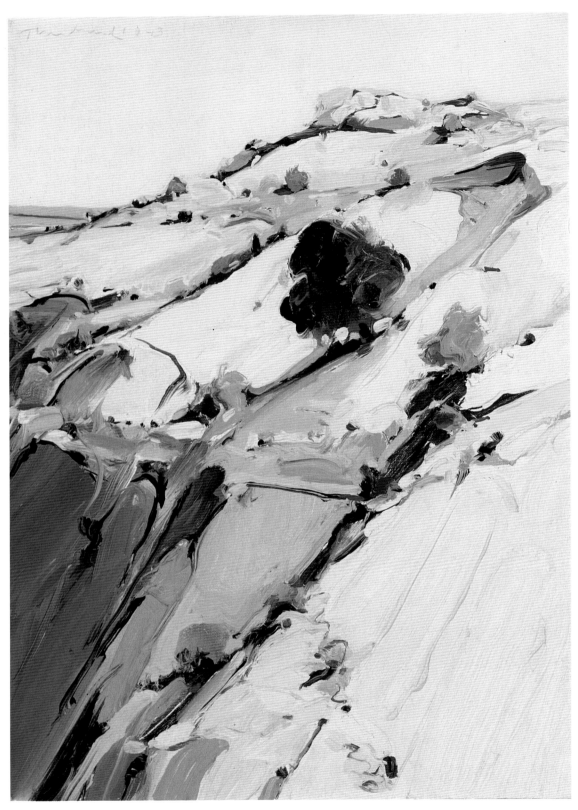

29

Hillside 1963
Oil on canvas, 16 × 11 in. (40.6 × 27.9 cm)
Signed and dated upper left: *Thiebaud 1963*;
 signed and dated on reverse: *Thiebaud 1963*
Matthew L. Bult

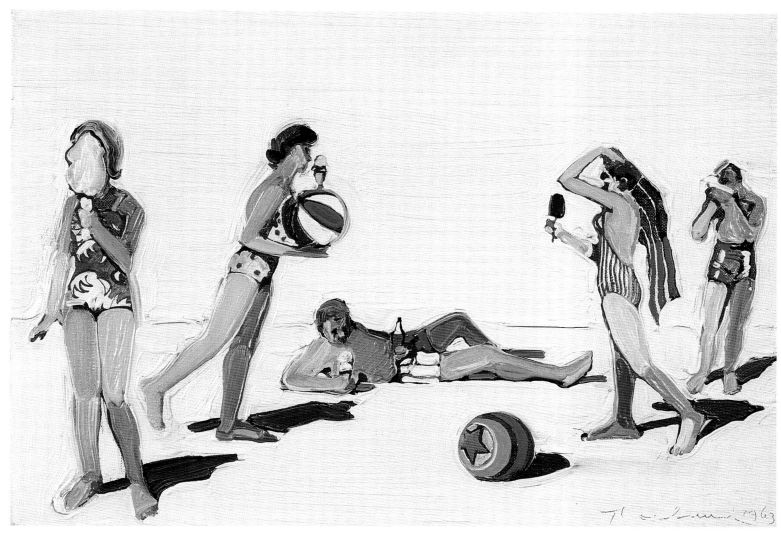

30
Five Eating Figures 1963
Oil on canvas, 10 × 14 in. (25.4 × 35.6 cm)
Signed and dated lower right: *Thiebaud 1963*;
 signed on stretcher: *Thiebaud*
Charles and Glenna Campbell

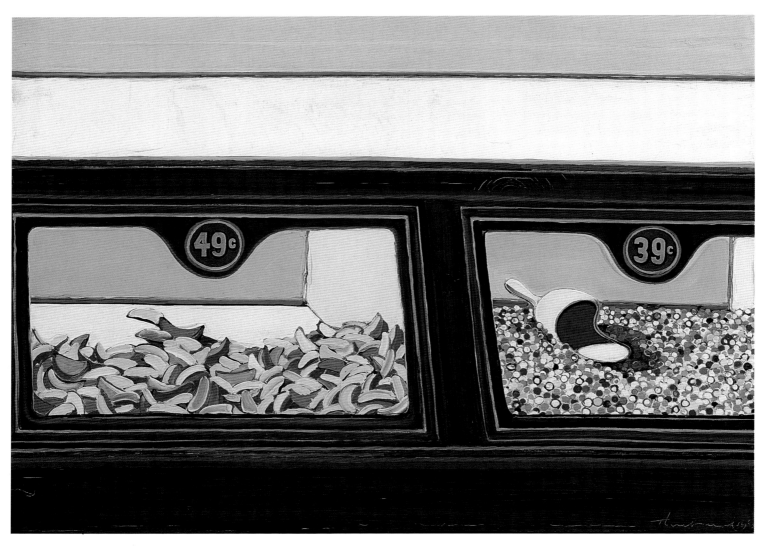

31
Candy Counter 1963
Oil on canvas mounted on panel, 28 × 38 in. (71.1 × 96.5 cm)
Signed and dated lower right: *Thiebaud 1963*
Mr. and Mrs. Ken Siebel

San Francisco and New York only

32 [FACING PAGE]
Girl with Ice Cream Cone 1963
Oil on canvas, 48 ⅛ × 36 ¼ in. (122.2 × 92.1 cm)
Signed and dated upper right: *Thiebaud 1963*
Hirshhorn Museum and Sculpture Garden,
 Smithsonian Institution
The Joseph H. Hirshhorn Bequest Fund,
 Smithsonian Collections Acquisition Program,
 and Museum Purchase, 1996

Washington only

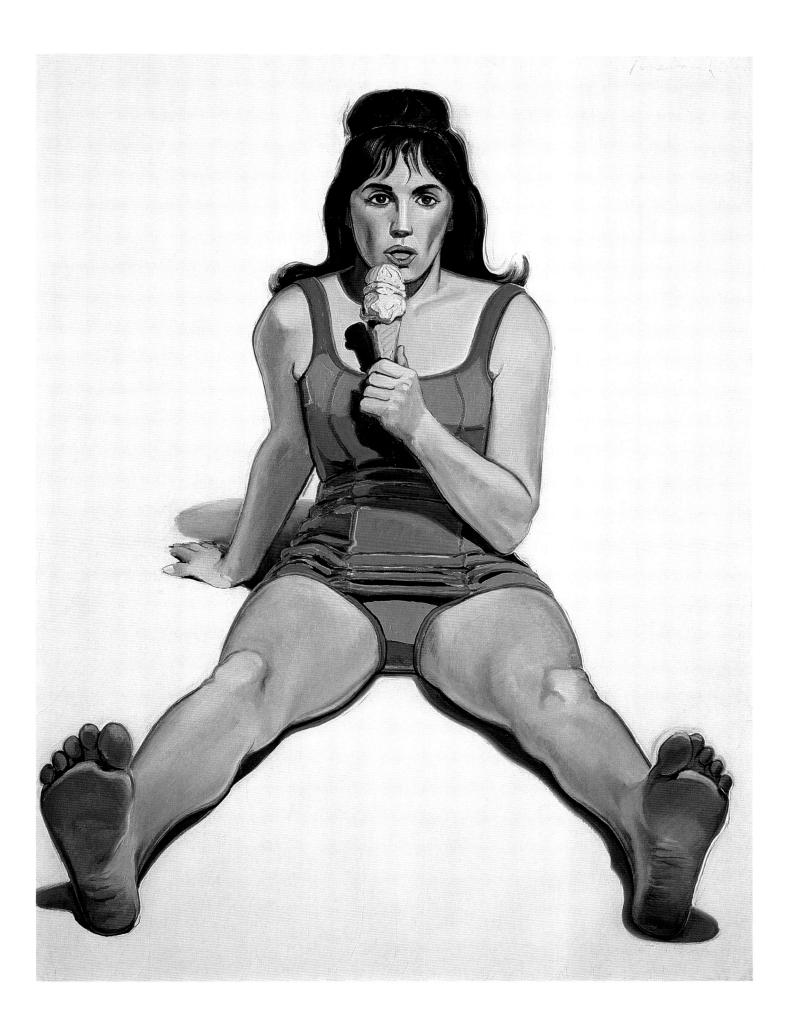

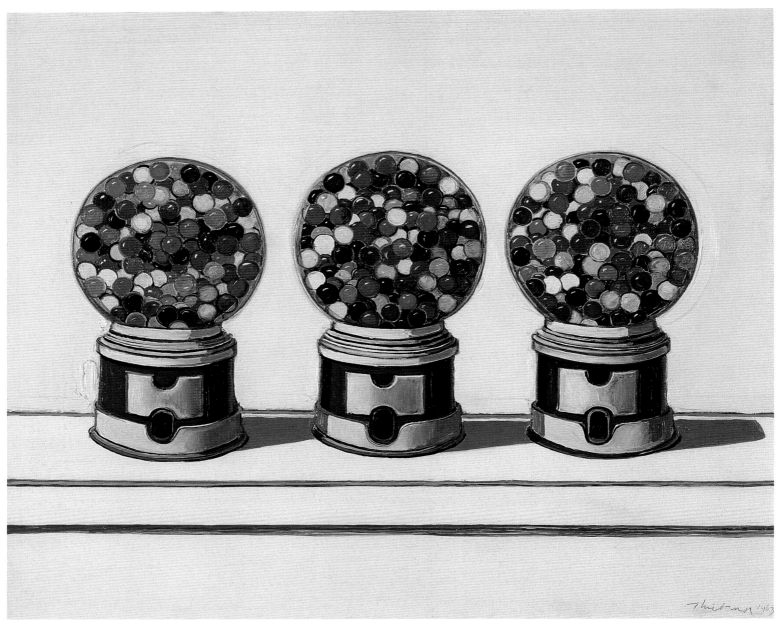

33

Three Machines 1963

Oil on canvas, 30 × 36 ½ in. (76.2 × 92.7 cm)

Signed and dated lower right: *Thiebaud 1963*;
 inscribed on stretcher: *3 Machines Thiebaud 1963*

Fine Arts Museums of San Francisco

Museum purchase, Walter H. and Phyllis J. Shorenstein Foundation
 Fund and the Roscoe and Margaret Oakes Income Fund with
 additional gifts from Claire E. Flagg; The Museum Society
 Auxiliary; Mr. and Mrs. George R. Roberts; Mr. and Mrs. John N.
 Rosekrans, Jr.; Mrs. and Mrs. Robert Bransten; Mrs. and Mrs.
 Steven MacGregor Read; and Bobbie and Mike Wilsey. Formerly
 Morgan Flagg Collection

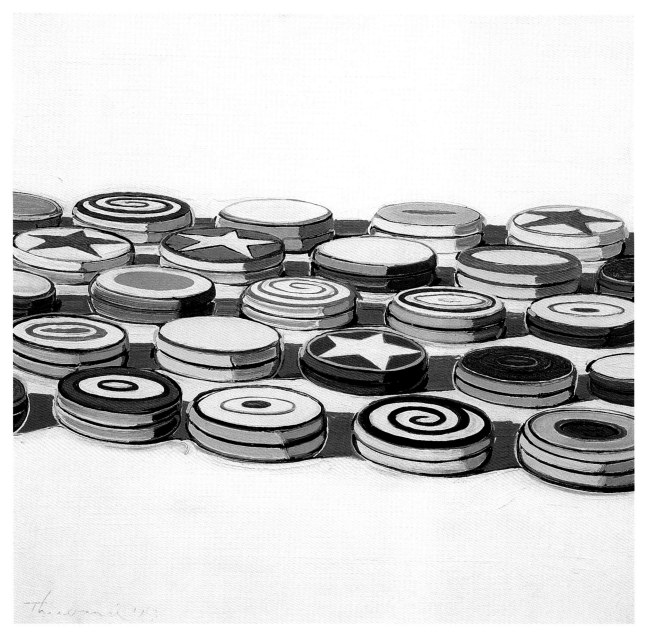

34
Yo-Yos 1963
Oil on canvas, 24 × 24 in. (61 × 61 cm)
Signed and dated lower left: *Thiebaud 1963*
Albright-Knox Art Gallery, Buffalo, New York
Gift of Seymour H. Knox, 1963

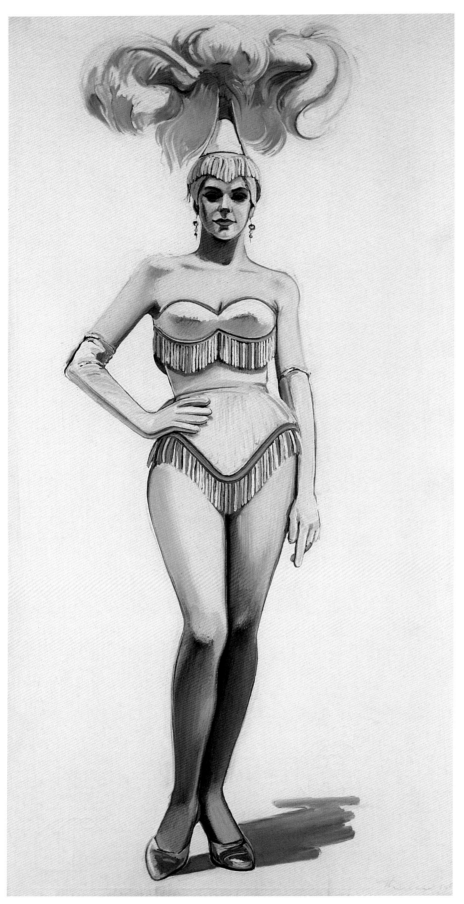

35
Revue Girl 1963
Oil on canvas, 72 × 36 in. (182.9 × 91.4 cm)
Signed and dated lower right: *Thiebaud 1963*;
 inscribed on stretcher: *"Revue Girl"Thiebaud 1963*
Robert S. Colman

San Francisco only

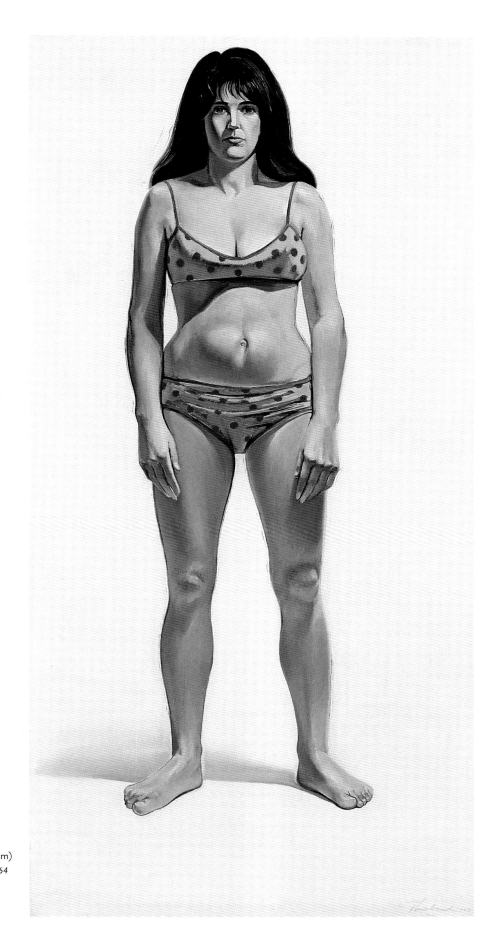

36
Bikini 1964
Oil on canvas, 72 × 35 ⅞ in. (182.9 × 91.1 cm)
Signed and dated lower right: *Thiebaud 1964*
The Nelson-Atkins Museum of Art,
 Kansas City, Missouri
Gift of Mr. and Mrs. Louis Sosland

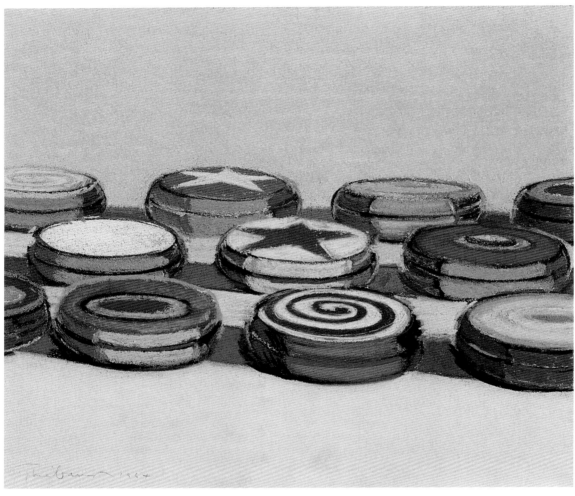

37
Yo-Yos 1964
Pastel on cardboard, 8 ½ × 10 in. (21.6 × 25.4 cm)
Signed and dated lower left: *Thiebaud 1964*
Gretchen and John Berggruen, San Francisco

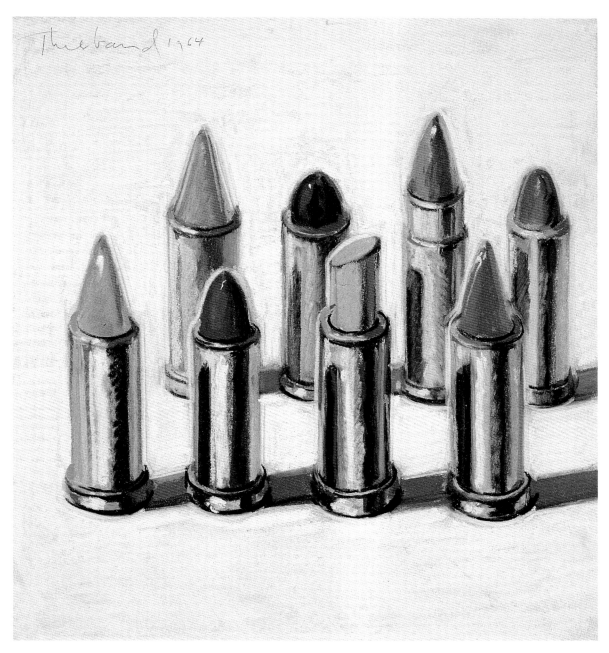

38
Eight Lipsticks 1964
Pastel on paper, 10 × 9 in. (25.4 × 22.9 cm)
Signed and dated upper left: *Thiebaud 1964*
Private collection
Courtesy of Allan Stone Gallery, New York

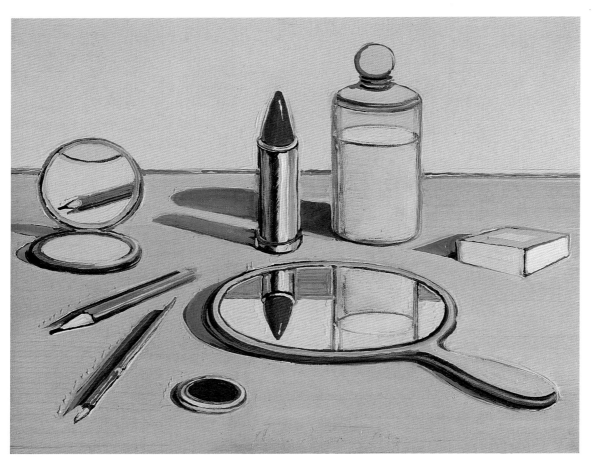

39
Cosmetics 1964
Oil on canvas, 12 × 14 ⅞ in. (30.5 × 37.8 cm)
Signed and dated bottom middle: *Thiebaud 1964*
Private collection

40 [FACING PAGE]
Man Sitting—Back View 1964
Oil on canvas, 36 × 29 ½ in. (91.4 × 74.9 cm)
Signed and dated lower right: *Thiebaud 1964*
Collection of the Albrecht-Kemper Museum of Art, St. Joseph, Missouri
Purchased with funds from the William Toben Memorial Fund and
 donations from museum friends

42
Two Seated Figures 1965
Oil on canvas, 60 × 72 in. (152.4 × 182.9 cm)
Private collection

41 [FACING PAGE]
Girl in White Boots 1965
Oil on canvas, 72 × 60 in. (182.9 × 152.4 cm)
Signed and dated bottom center: *Thiebaud 1965*
Collection of Blair Sabol
Courtesy of Lawrence Markey Gallery, New York

43
Woman in Tub 1965
Oil on canvas, 36 × 60 in. (91.4 × 152.4 cm)
Signed on reverse: *Thiebaud*
Private collection, St. Louis, Missouri

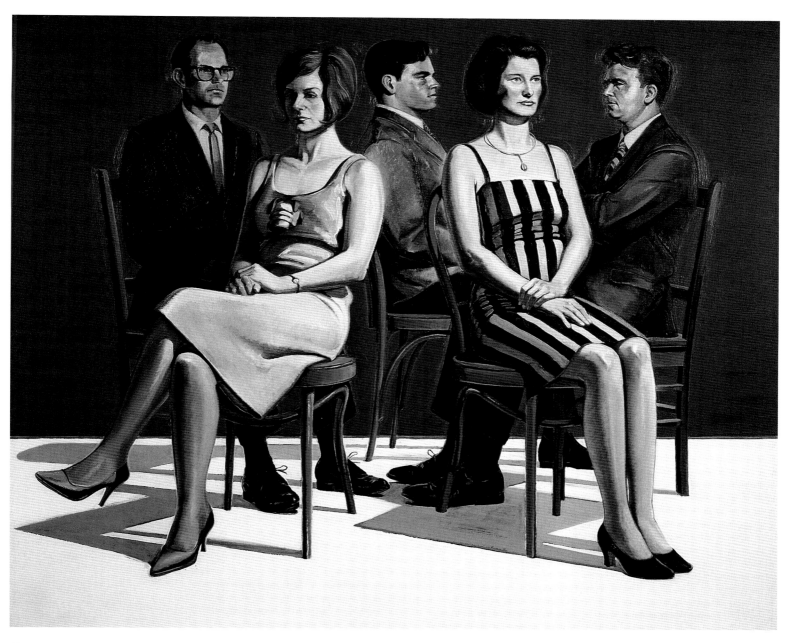

44

Five Seated Figures 1965
Oil on canvas, 60 × 72 in. (152.4 × 182.9 cm)
Private collection

45
Portrait of Sterling Holloway 1965
Oil on canvas, 17 × 22 in. (43.2 × 55.9 cm)
Signed and dated upper left: *Thiebaud 1965*
John Modell, San Francisco

46

Orange Grove 1966
Oil on canvas, 24 × 30 in. (61 × 76.2 cm)
Signed and dated lower left: *Thiebaud 1966*;
 signed and dated on reverse: *Thiebaud / 1966*
Paul LeBaron Thiebaud

47
Black Ice Cream 1967 (?)
Oil on canvas on panel, 12¼ × 15½ in. (31.1 × 39.4 cm)
Signed lower right: *Thiebaud*
Collection of Mr. and Mrs. W. A. Moncrief, Jr.

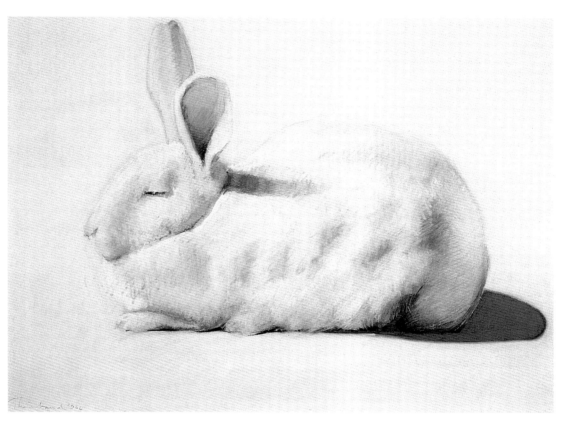

48

Rabbit 1966
Pastel on paper, 15 × 20 in. (38.1 × 50.8 cm) (sight)
Signed and dated lower left: *Thiebaud 1966*
Lindy Bergman

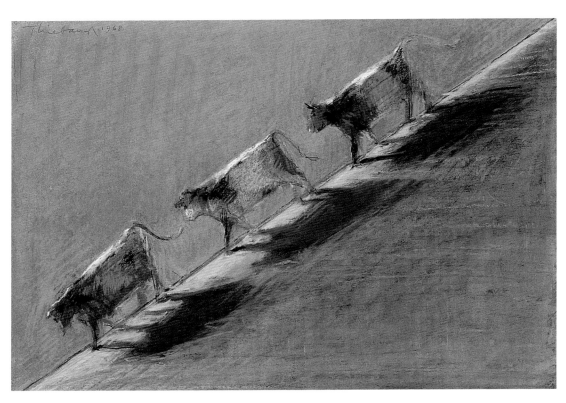

49
Cow Ridge 1968
Pastel on illustration board, 8 × 11 in. (20.3 × 27.9 cm)
Signed and dated upper left: *Thiebaud 1968*
Nan Tucker McEvoy

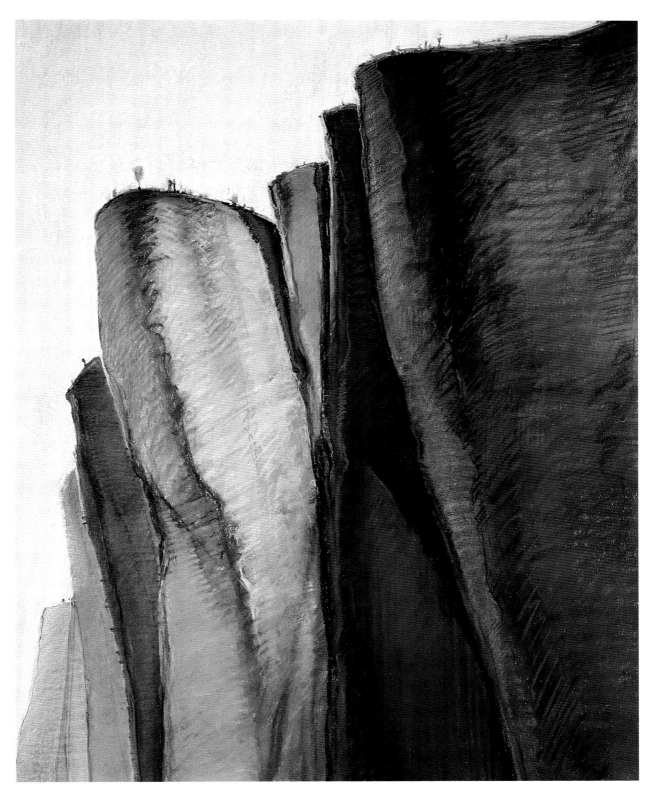

50
Study for Bluffs 1967
Pastel on paper, 29 × 23 in. (73.7 × 58.4 cm)
Private collection
Courtesy of Allan Stone Gallery, New York

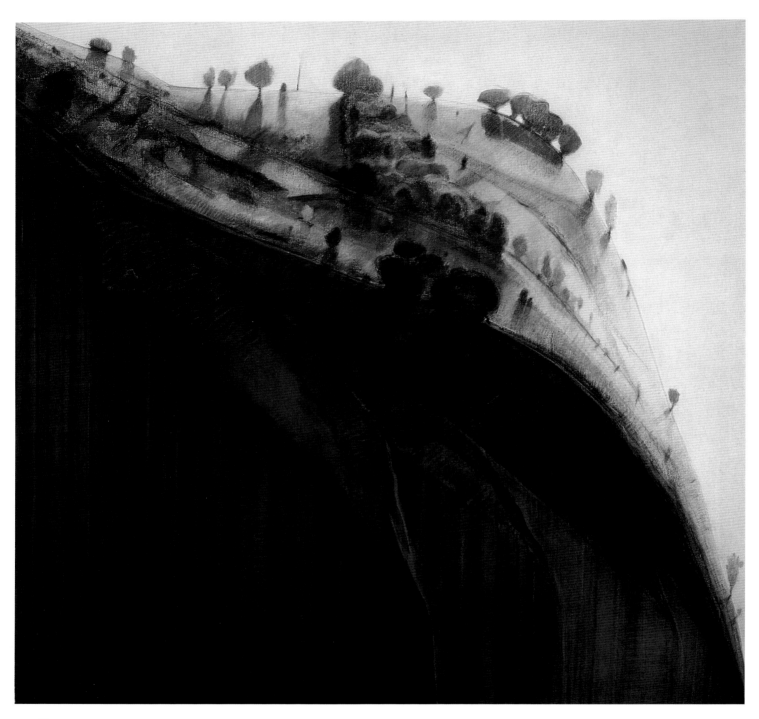

51
Coloma Ridge 1967-68
Acrylic and pastel on canvas, 74 × 75 ¼ in. (188 × 192.4 cm)
Signed and dated lower left: *Thiebaud 1967–68*
Paul LeBaron Thiebaud

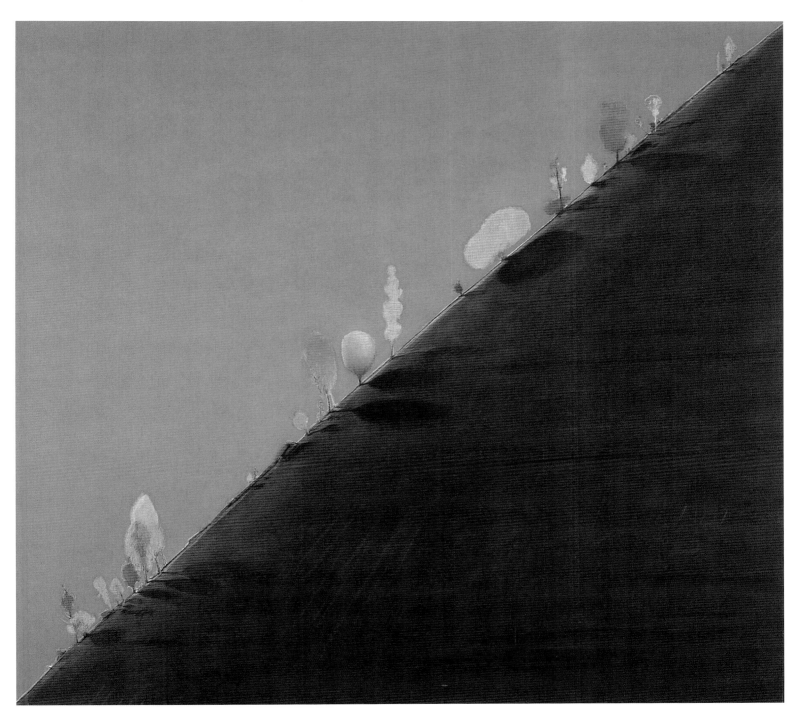

52
Diagonal Ridge 1968
Acrylic on canvas, 77 ¾ × 84 in. (197.5 × 213.4 cm)
Signed and dated lower right: *Thiebaud 1968*
Private collection
Courtesy of Allan Stone Gallery, New York

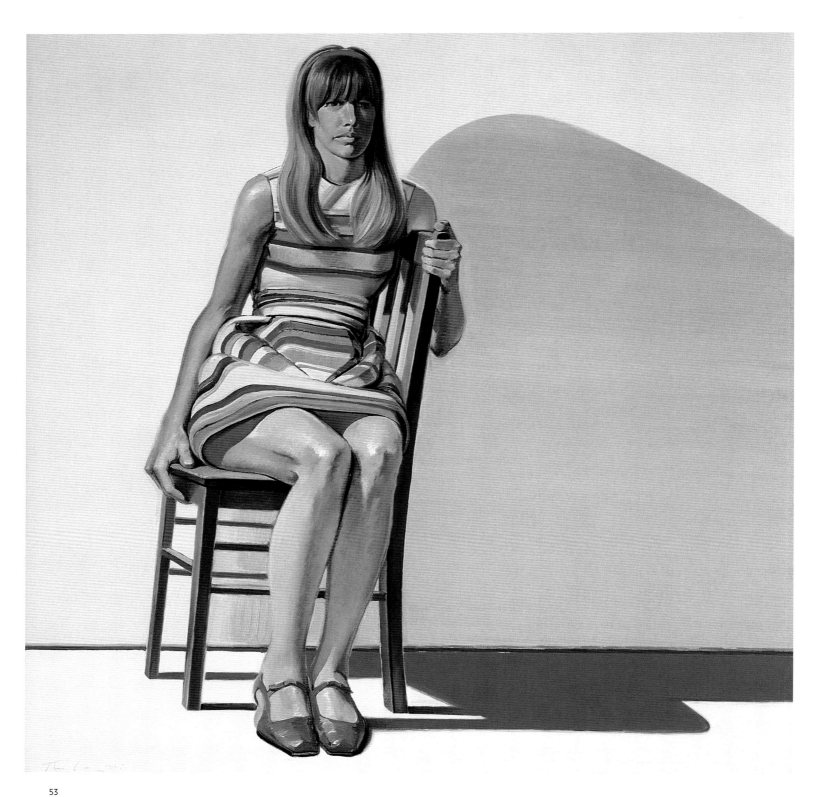

53
Girl in Blue Shoes 1968
Oil on canvas, 48 × 48 in. (121.9 × 121.9 cm)
Signed and dated lower left: *Thiebaud 1968*
Private collection
Courtesy of Allan Stone Gallery, New York

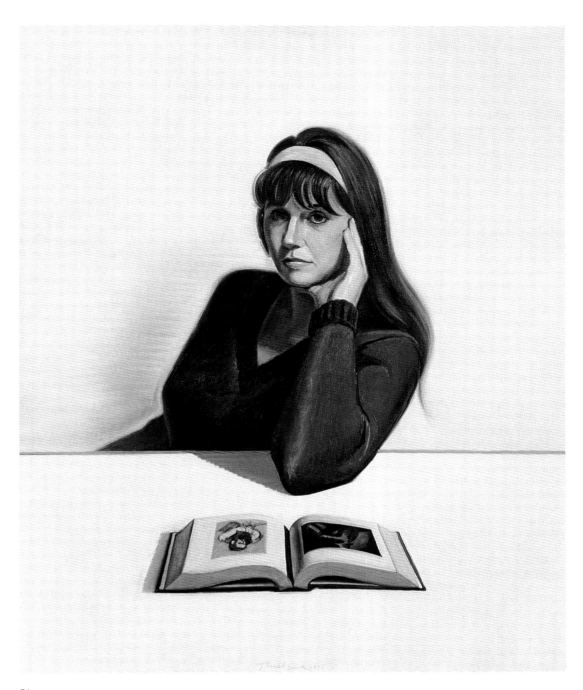

54
Betty Jean Thiebaud and Book 1965–69
Oil on canvas, 36 × 30 in. (91.4 × 76.2 cm)
Signed and dated bottom middle: *Thiebaud 1965–69*
Crocker Art Museum, Sacramento
Gift of Mr. and Mrs. Wayne Thiebaud

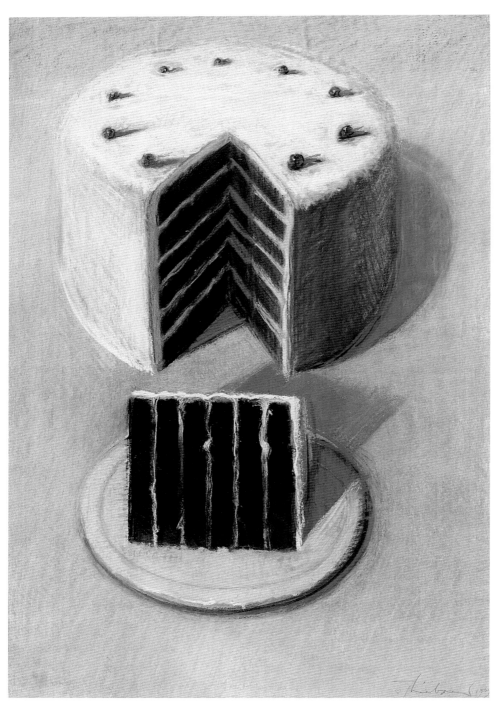

55
Chocolate Cake and Slice 1969
Pastel on paper, 27 × 18 ½ in. (68.6 × 47 cm) (sight)
Signed and dated lower right: *Thiebaud 1969*
Phyllis and Stuart G. Moldaw

56 [FACING PAGE]
Candy Counter 1969
Oil on canvas, 47 ½ × 36 ⅛ in. (120.7 × 91.8 cm)
Signed and dated top center: *Thiebaud 1969*
Paul LeBaron Thiebaud

Fort Worth, Washington, New York only

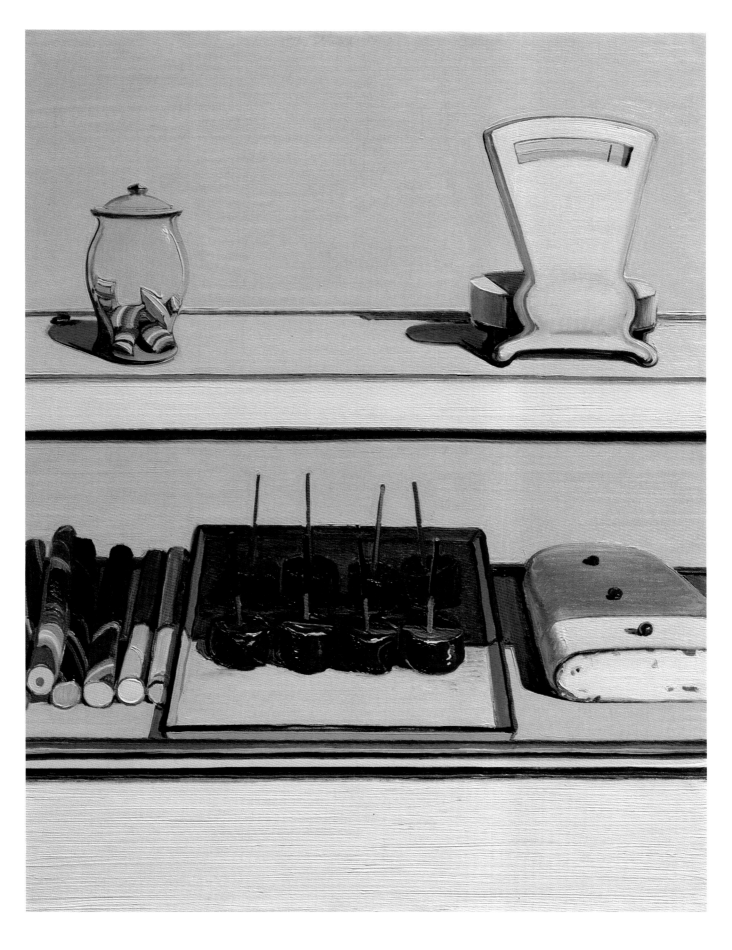

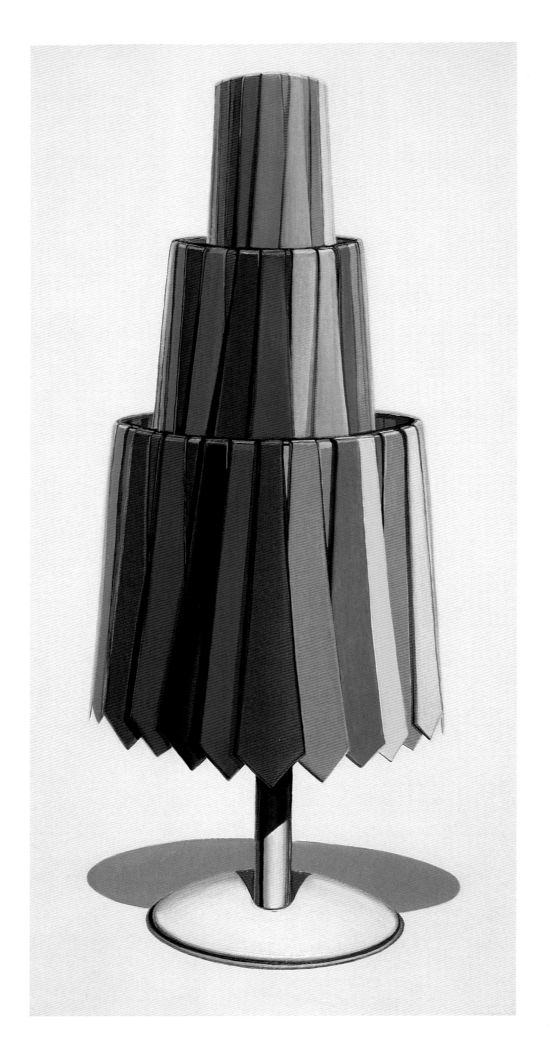

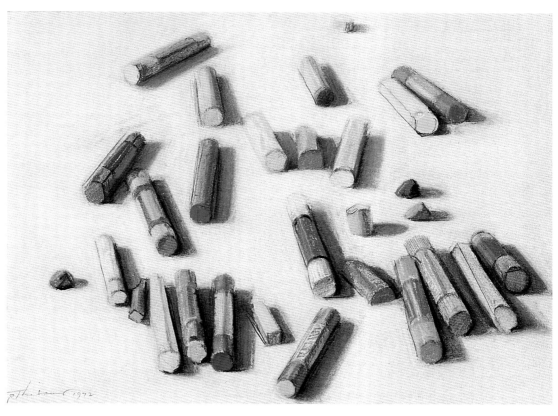

58
Various Pastels 1972
Pastel on paper, 10 ½ × 14 in. (26.7 × 35.6 cm)
Signed and dated lower left: ♥ *Thiebaud 1972*
Morgan Flagg Collection

57 [FACING PAGE]
Tie Rack 1969
Oil on canvas, 72 × 36 in. (182.9 × 91.4 cm)
Signed and dated lower right: *Thiebaud 1969*
Private collection
Courtesy of Allan Stone Gallery, New York

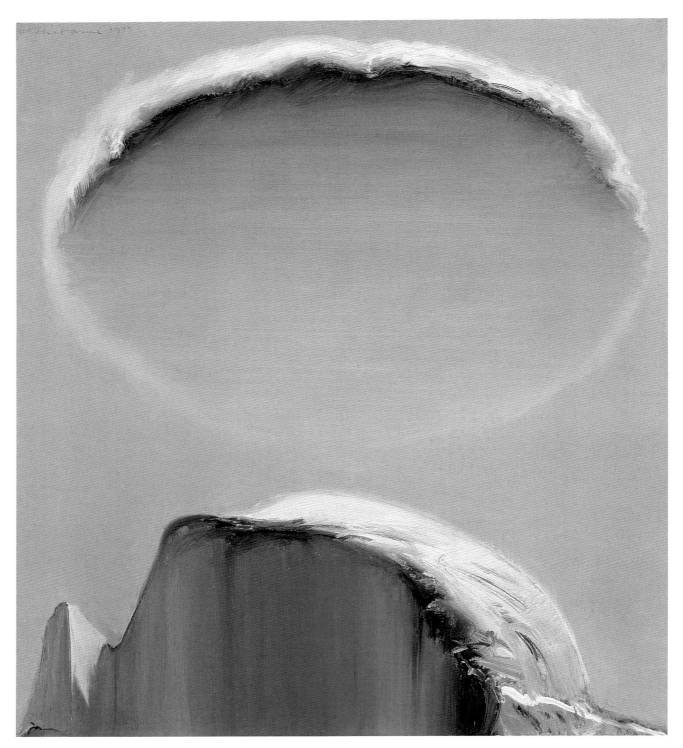

59
Half Dome and Cloud 1975
Oil on canvas, 25 ⅞ × 23 in. (65.7 × 58.4 cm)
Signed and dated upper left: ♥ *Thiebaud 1975;*
 signed on back: ♥ *Thiebaud 1975;*
 signed and dated on stretcher: ♥ *Thiebaud 1975;*
 inscribed on stretcher: *Half Dome and Cloud*
Georgene and John Tozzi

60 [FACING PAGE]
Yellow Dress 1974
Oil and charcoal on paper mounted on
 rag board, 30 × 22 ⅜ in. (76.2 × 56.8 cm)
Signed and dated lower right: *Thiebaud 1974*
Charles and Glenna Campbell

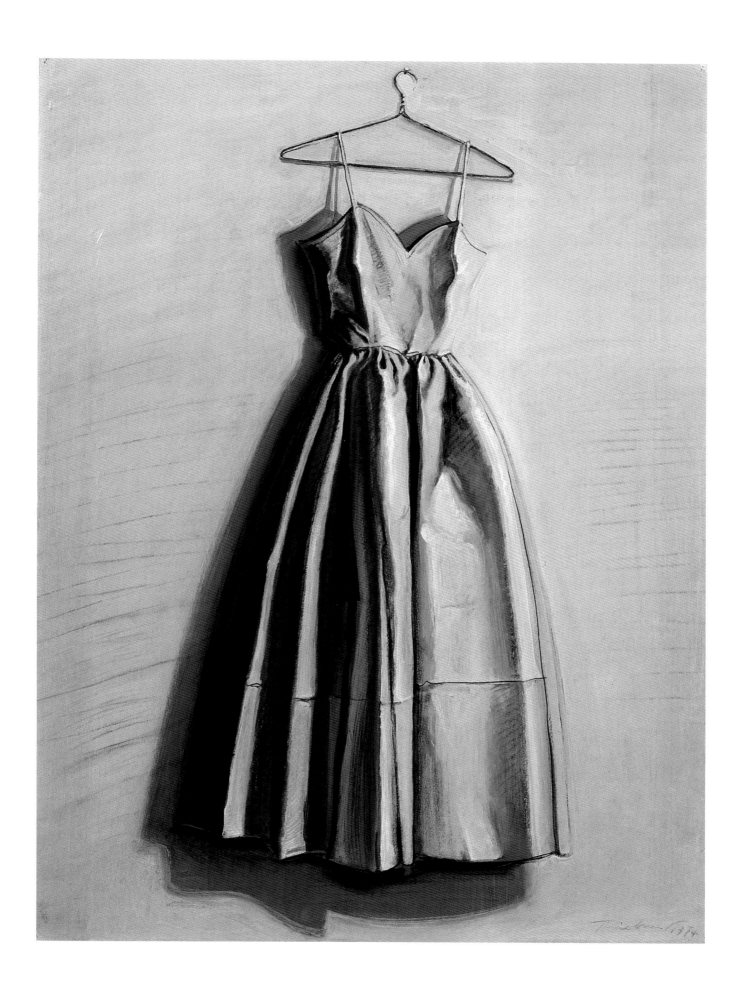

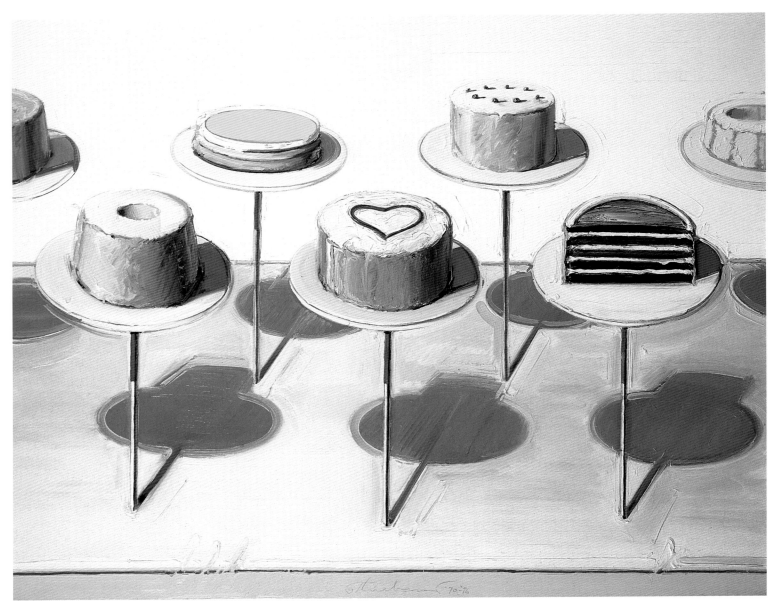

61
Cake Window (Seven Cakes) 1970–76
Oil on canvas, 48 × 59 ⅜ in. (121.9 × 150.8 cm)
Signed and dated bottom center: ♥ *Thiebaud '70–'76*
Private collection, New York

New York only

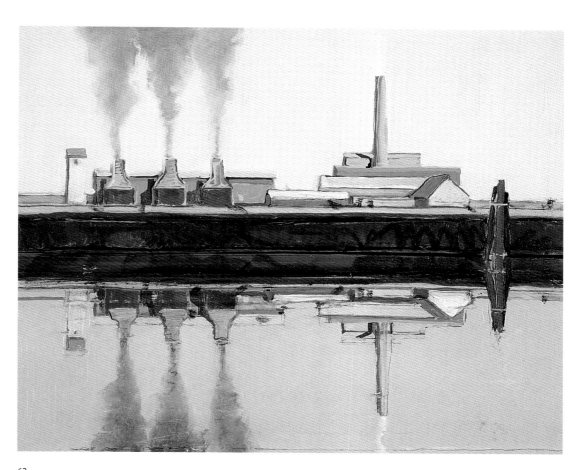

62

River Factory 1966–76

Oil on paper mounted on board,

 10 ¼ × 12 ½ in. (26 × 31.8 cm)

Signed and dated on reverse:

 Thiebaud 1966, 1976

Private collection

Courtesy of Allan Stone Gallery, New York

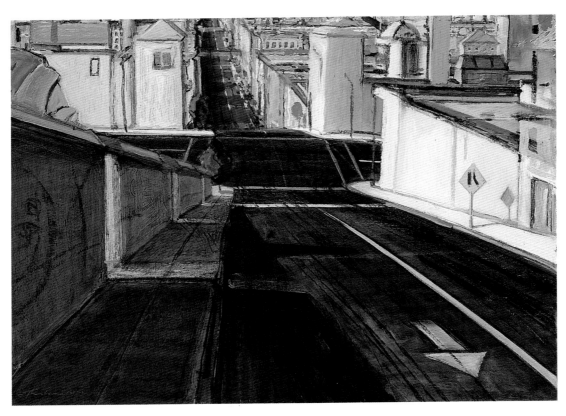

63
Street Arrow 1975–76
Oil on canvas, 18 ⅛ × 24 ½ in. (46 × 62.2 cm)
Signed and dated lower left: ♥ *Thiebaud 1975–6*:
 signed and dated on reverse: ♥ *Thiebaud 1974–76*
Matthew L. Bult

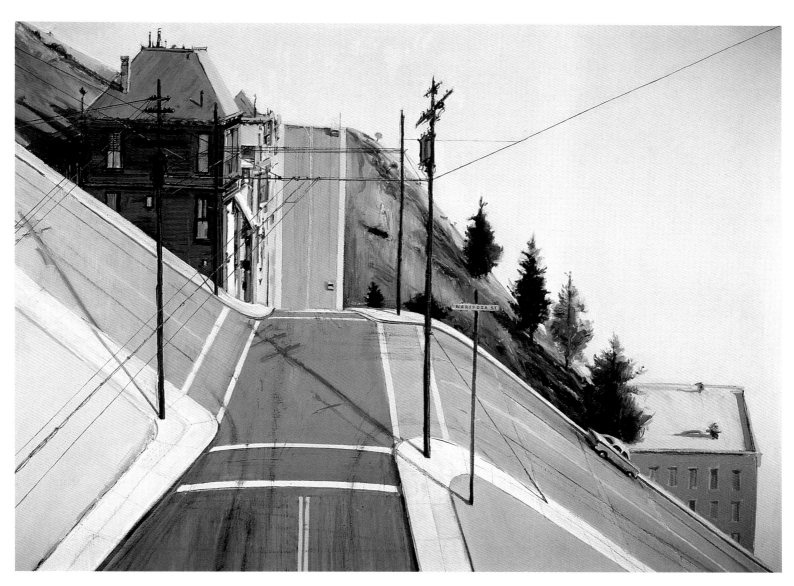

64

24th Street Intersection 1977

Oil on canvas, 35 ⅝ × 48 in. (90.5 × 121.9 cm)

Private collection

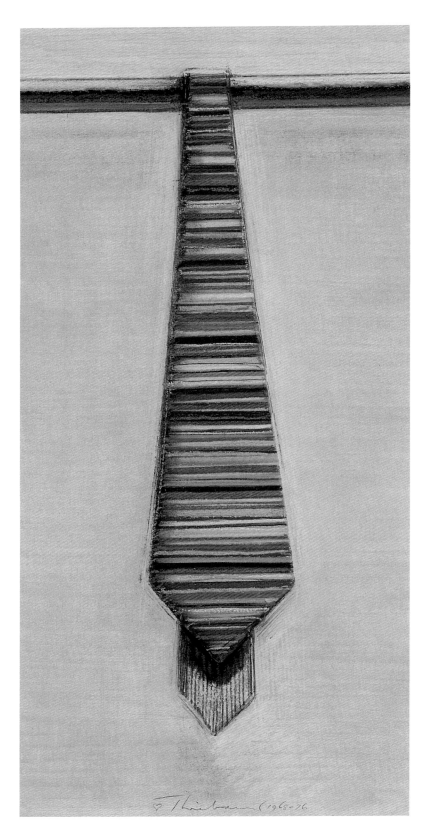

65
Striped Necktie 1968–76
Pastel on paper, 20 ½ × 10 in. (52.1 × 25.4 cm)
Signed and dated bottom middle: ♥ *Thiebaud 1968–76*
Gretchen and John Berggruen, San Francisco

66 [FACING PAGE]
Candy Ball Machine 1977
Gouache and pastel on paper, 23 ¾ × 17 ¾ in.
 (60.3 × 45.1 cm) (sight)
Signed and dated lower right: ♥ *Thiebaud 1977*
Gretchen and John Berggruen, San Francisco

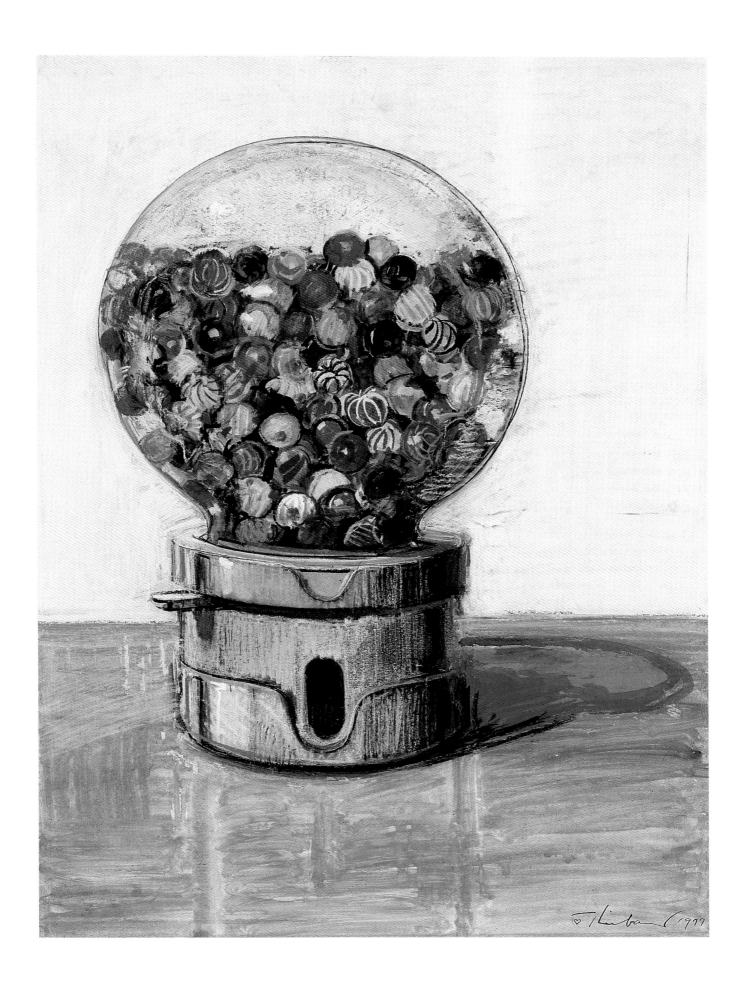

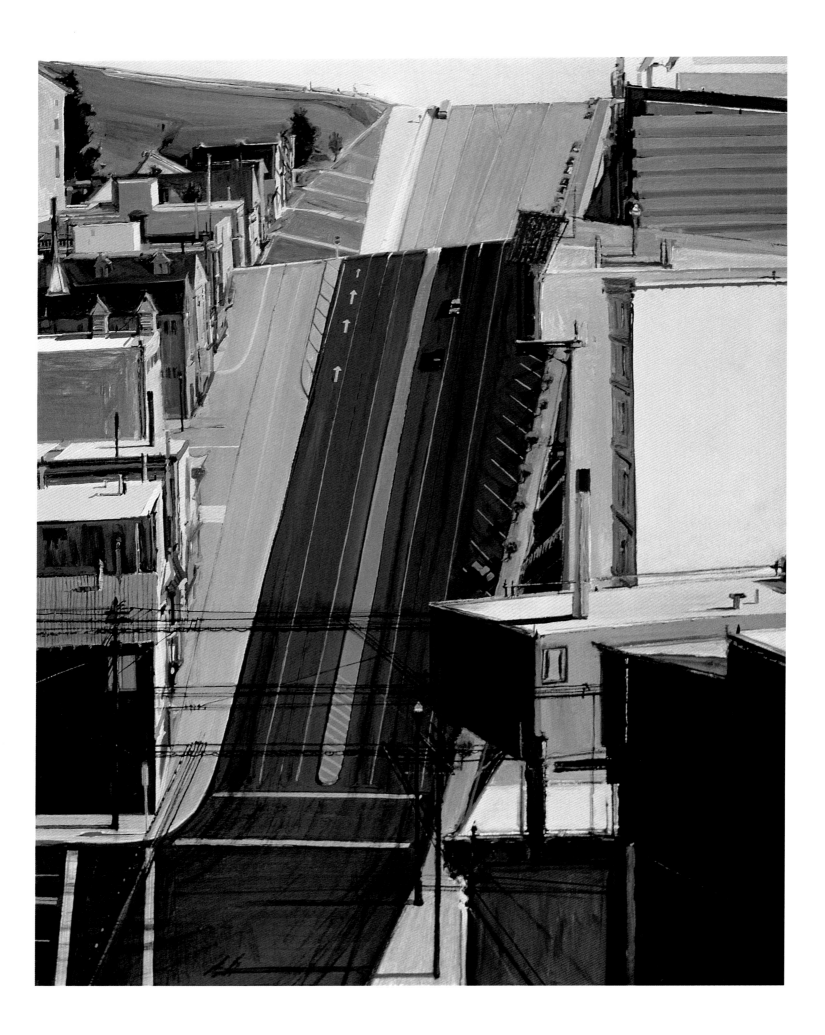

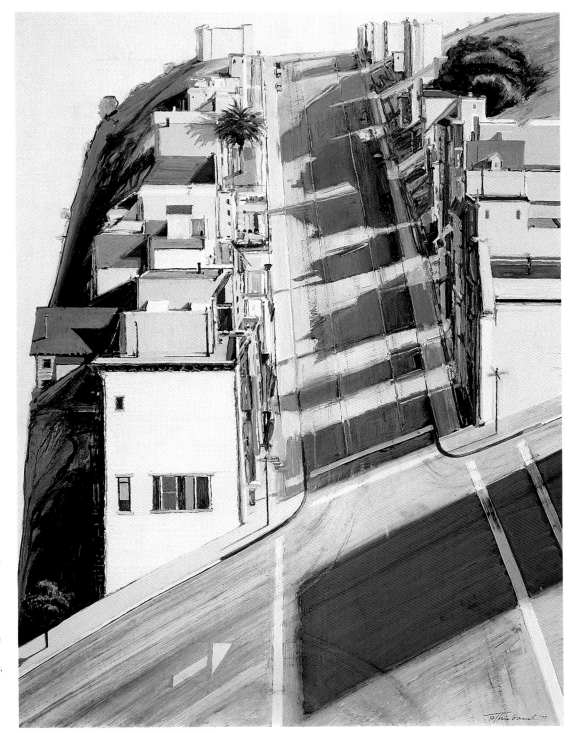

68
Ripley Ridge 1977
Oil on canvas, 48 × 36 in. (121.9 × 91.4 cm)
Signed and dated lower right: ♥ *Thiebaud '77*
Paul LeBaron Thiebaud

67 [FACING PAGE]
18th Street Downgrade 1978
Oil on canvas, 60 × 48 in. (152.4 × 121.9 cm)
Signed lower left: ♥ *Thiebaud*
Collection City and County of San Francisco,
 San Francisco International Airport
Purchased through the Joint Committee of
 the San Francisco Art Commission and
 the San Francisco Airport Commission

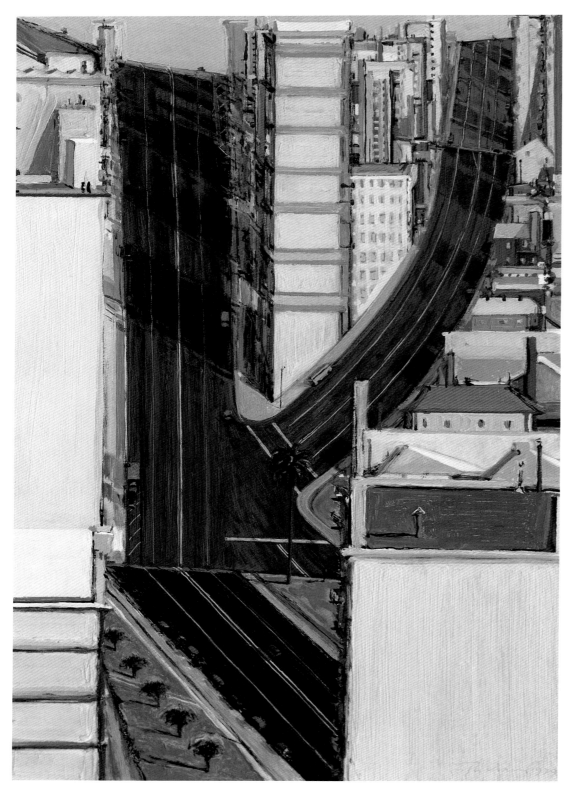

69
Curved Intersection 1979
Oil on linen, 23 × 16 in. (58.4 × 40.6 cm)
Signed and dated lower right: ♥ *Thiebaud 1979*
Ruth and Alan Stein

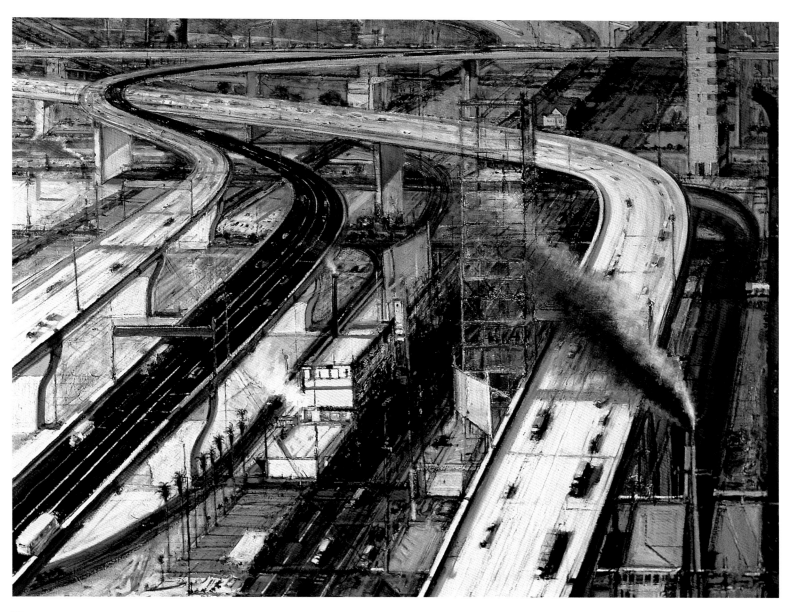

70

Freeways 1975–79

Oil on canvas, 48 × 60 in. (121.9 × 152.4 cm)

Signed lower left: ♥ *Thiebaud*; signed and
 dated on reverse: ♥ *Thiebaud 1975–9*

Thomas W. Weisel

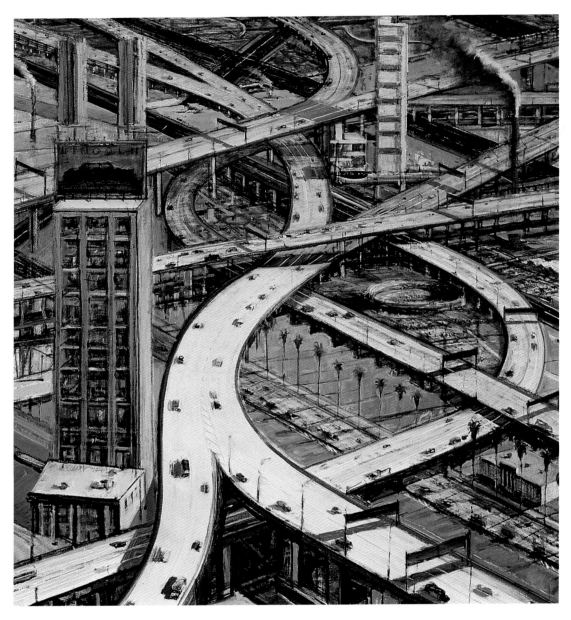

71
Urban Freeways 1979
Oil on canvas, 44 ⅜ × 36 ⅛ in. (112.7 × 91.8 cm)
Signed and dated bottom center: ♥ *Thiebaud 1979*;
 signed and dated on reverse: ♥ *Thiebaud 1979*
Private collection

72 [FACING PAGE]
Apartment Hill 1980
Oil on linen, 65 × 48 in. (165.1 × 121.9 cm)
Signed and dated on reverse: *Thiebaud 1980*
The Nelson-Atkins Museum of Art, Kansas City, Missouri
Purchase: acquired with the assistance of the Friends of Art

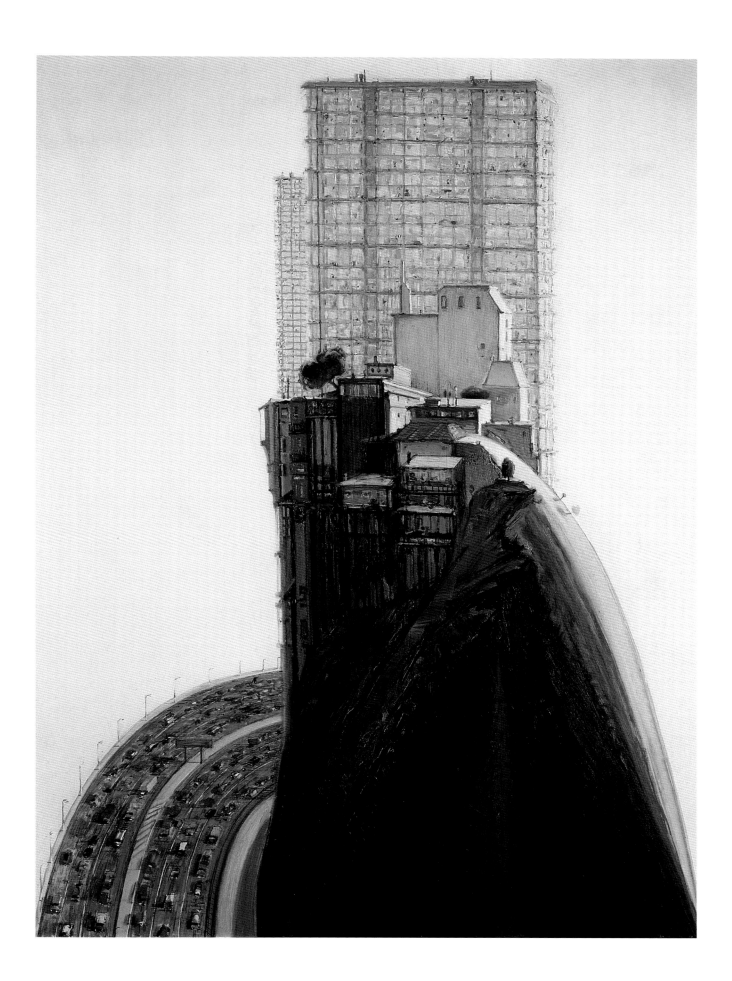

73
Hill Street (Day City) 1981
Oil on canvas, 48 × 36 ⅛ in. (121.9 × 91.8 cm)
Signed and dated upper right: *Thiebaud 1981*
Collection of Robert Lehrman, Washington, D.C.

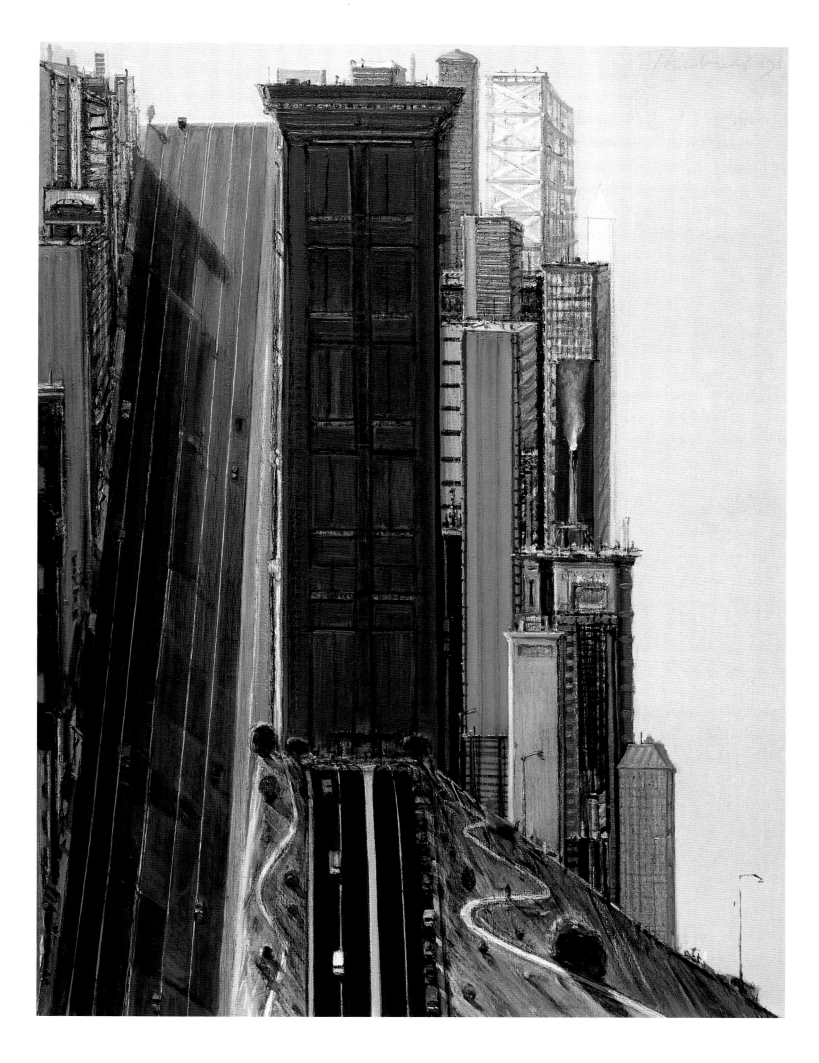

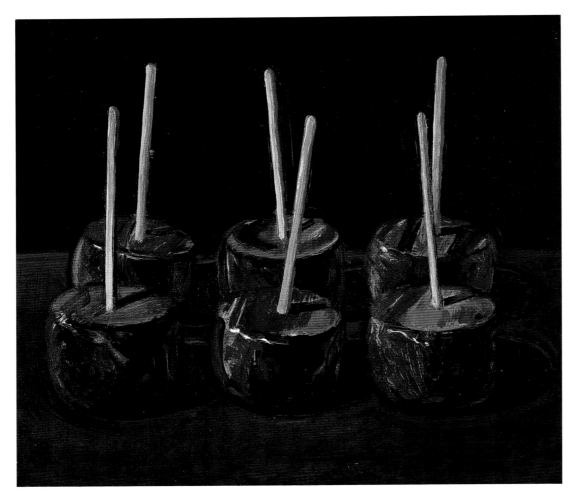

74
Dark Candy Apples 1983
Oil on wood, 11 ⅝ × 13 in. (29.5 × 33 cm) (sight)
Signed and dated top center: *Thiebaud 1983*
Private collection

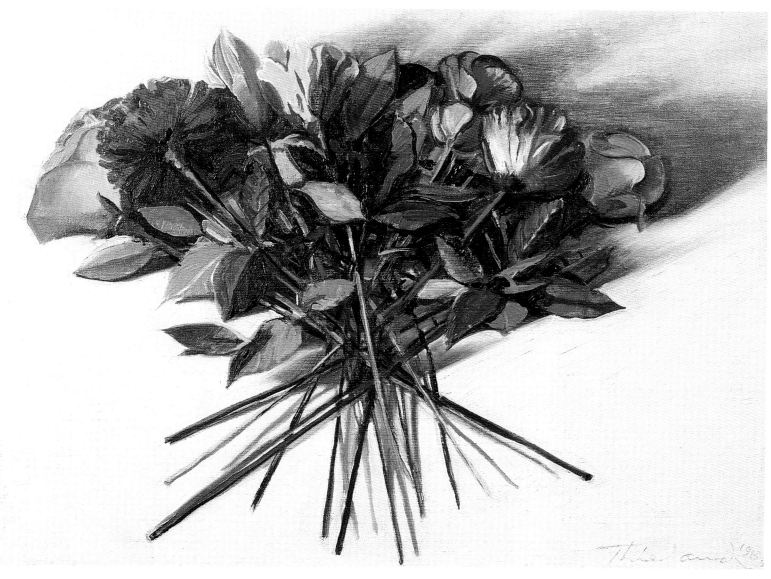

75
Flower Fan 1983
Oil on canvas, 18 × 24 ⅛ in. (45.7 × 61.2 cm)
Signed and dated lower right: *Thiebaud 1983*
Collection of Mr. and Mrs. W. A. Moncrief, Jr.

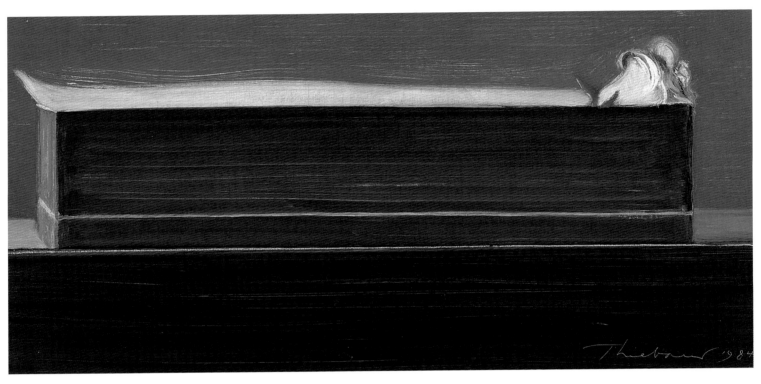

76
Boxed Rose 1984
Oil on wood, 8 ⅛ × 16 in. (20.6 × 40.6 cm)
Signed and dated lower right: *Thiebaud 1984*;
 signed and dated on reverse: *Thiebaud 1984*
Thiebaud Family Collection

77
Dark Desk Still Life 1986
Watercolor and gouache on paper, 18 ⅝ × 24 in. (47.3 × 61 cm)
Signed and dated lower right: *Thiebaud 1986*
Private collection

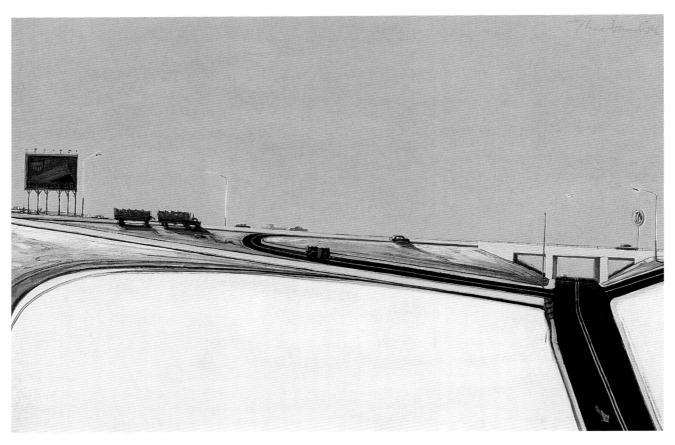

78
Freeway Exit 1986
Oil on canvas, 24 × 36 in. (61 × 91.4 cm)
Signed and dated upper right: *Thiebaud 1986*;
 signed and dated on reverse: *Thiebaud 1986*
Georgene and John Tozzi

79 [FACING PAGE]
California Valley Farm 1987
Oil on canvas, 50 × 36 in. (127 × 91.4 cm)
Signed and dated on reverse: *Thiebaud 1987*
Private collection

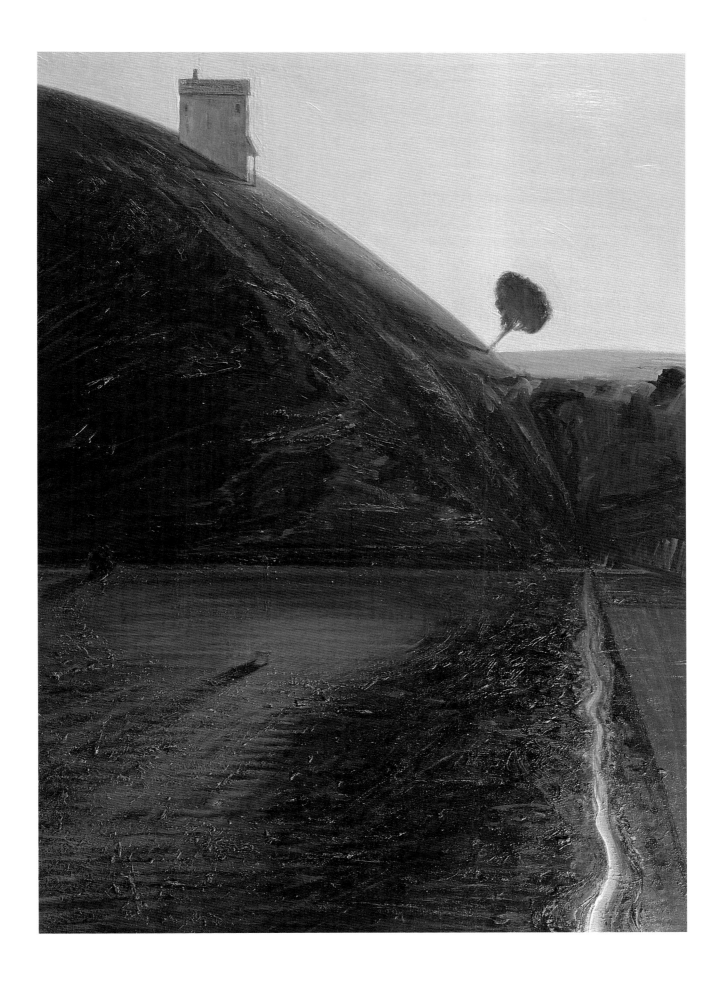

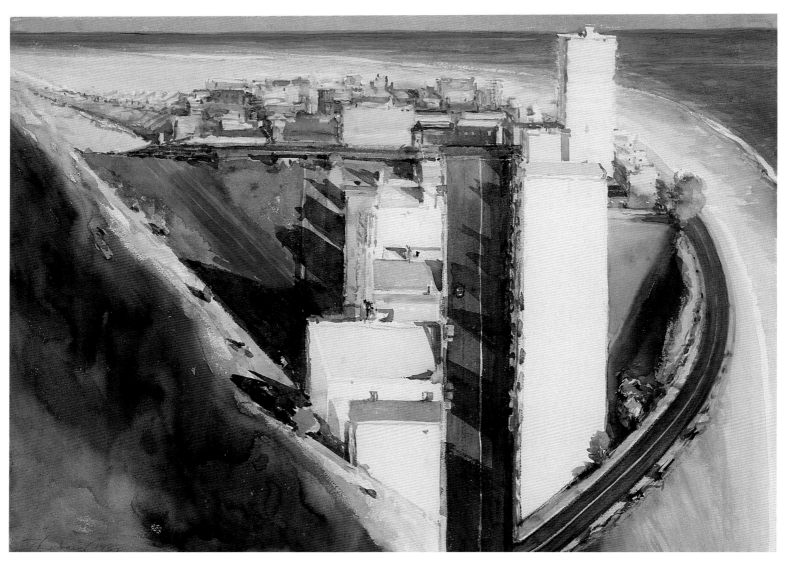

80

Ocean City 1987

Watercolor and charcoal on paper, 22 ½ × 30 ¼ in. (57.2 × 78.1 cm)

Signed and dated lower left: *Thiebaud 1987*

Paul LeBaron Thiebaud

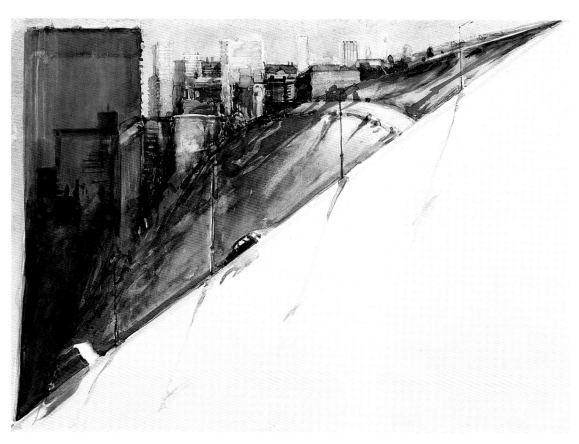

81
Diagonal Ridge 1987
Watercolor on paper, 11¼ × 14⅞ in. (28.6 × 37.8 cm)
Signed and dated lower right: *Thiebaud 1987*
Private collection

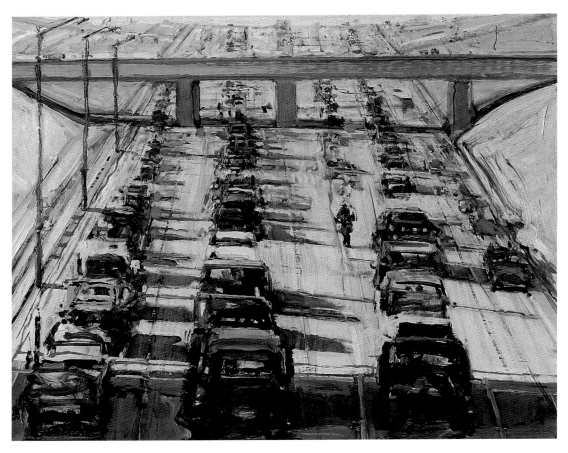

82
Heavy Traffic 1988
Oil on paper mounted on board,
14 × 17 in. (35.6 × 43.2 cm)
Private collection

83 [FACING PAGE]
Lighted City 1987–88
Gouache and charcoal on paper,
29 × 20 in. (73.7 × 50.8 cm)
Signed and dated lower right:
Thiebaud 88 and *Thiebaud 1987*
Private collection
Courtesy of Allan Stone Gallery, New York

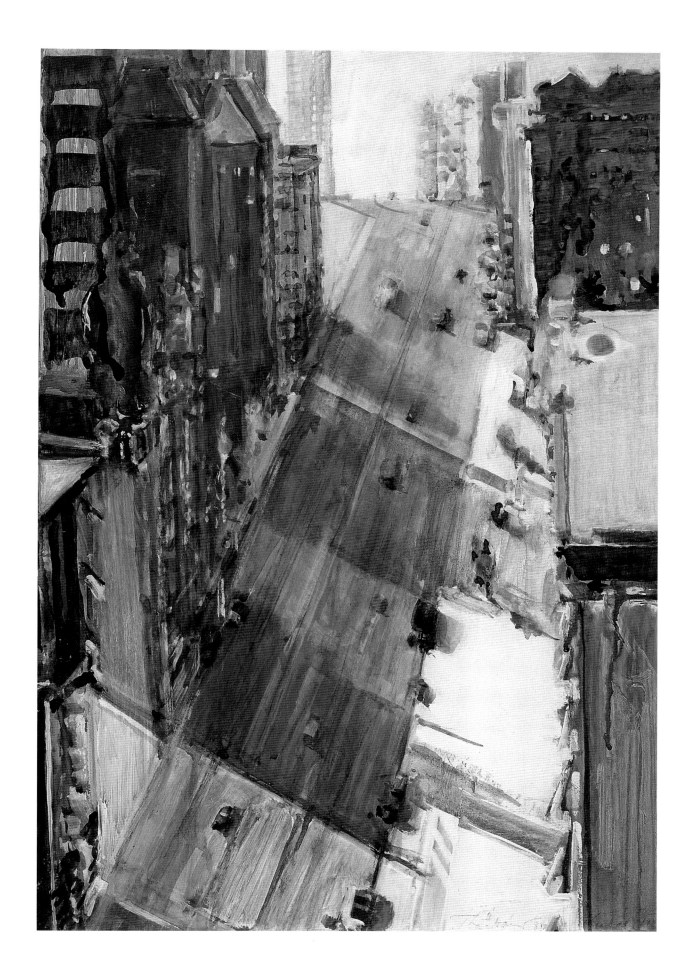

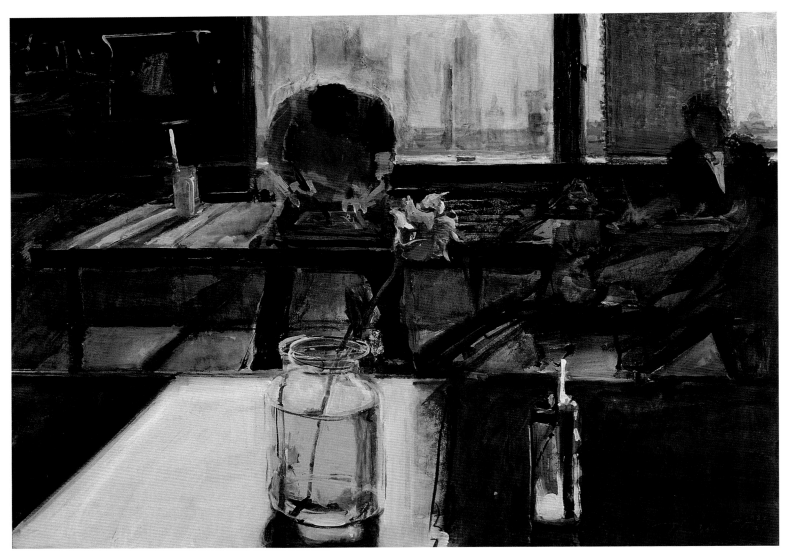

84
Art Studio 1982–91
Gouache and charcoal on paper,
 20 × 27½ in. (50.8 × 69.9 cm)
Signed and dated lower right:
 Thiebaud 1982/1991
Private collection

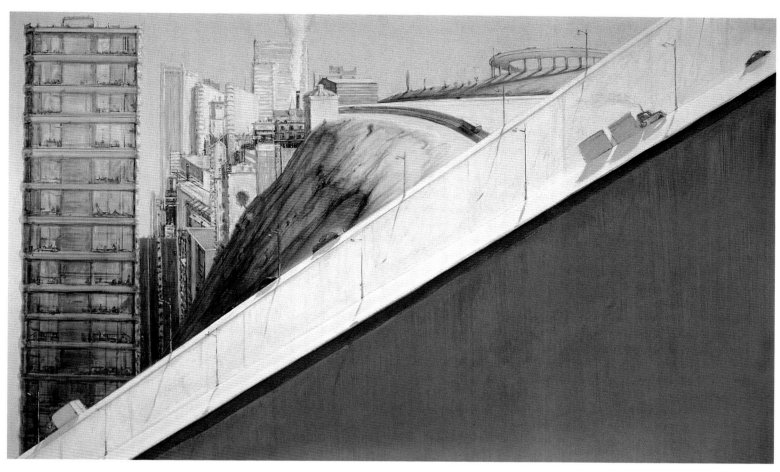

89
Diagonal Freeways 1993
Acrylic on canvas, 36 × 60 in. (91.4 × 152.4 cm)
Morgan Flagg Collection and Fine Arts Museums of San Francisco
Partial gift of Morgan Flagg

88 [FACING PAGE]
Park Place 1993
Oil on canvas, 60 ¼ × 54 ¼ in. (153 × 137.8 cm)
Signed and dated upper left: *Thiebaud 1993*
Collection of Steven and Mary Read

90
Window Views 1993
Oil on canvas, 72 × 64 in. (182.9 × 162.6 cm)
Signed and dated lower left: *Thiebaud 1993*
Private collection, San Francisco

San Francisco, Washington, and New York only

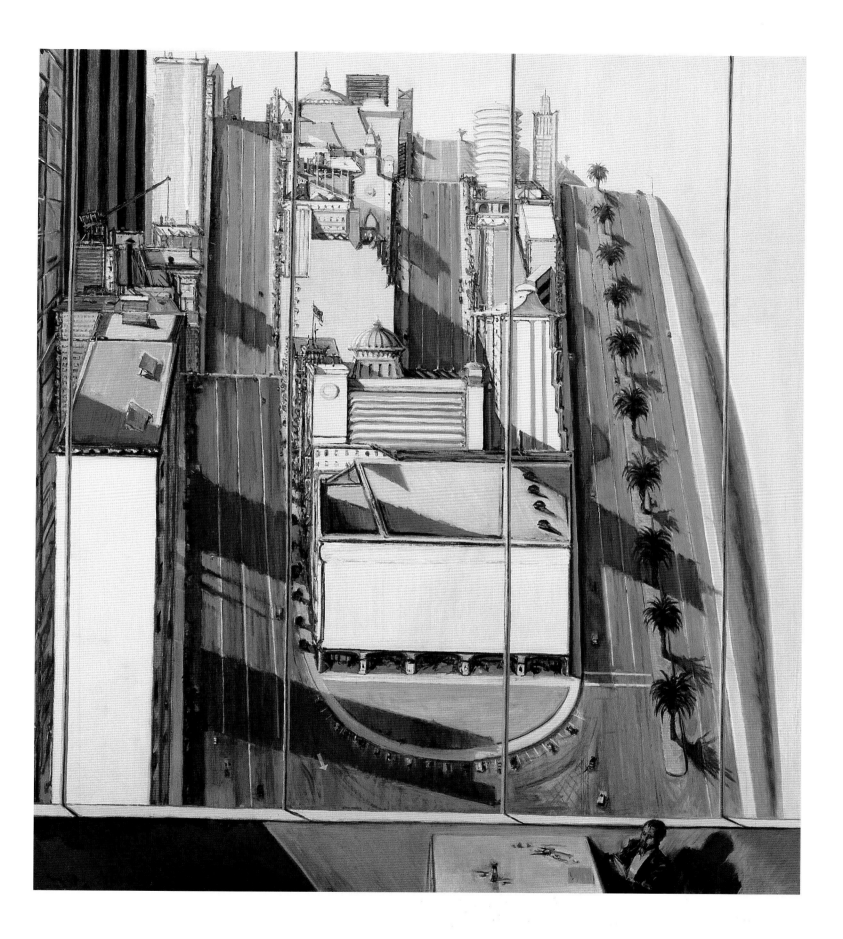

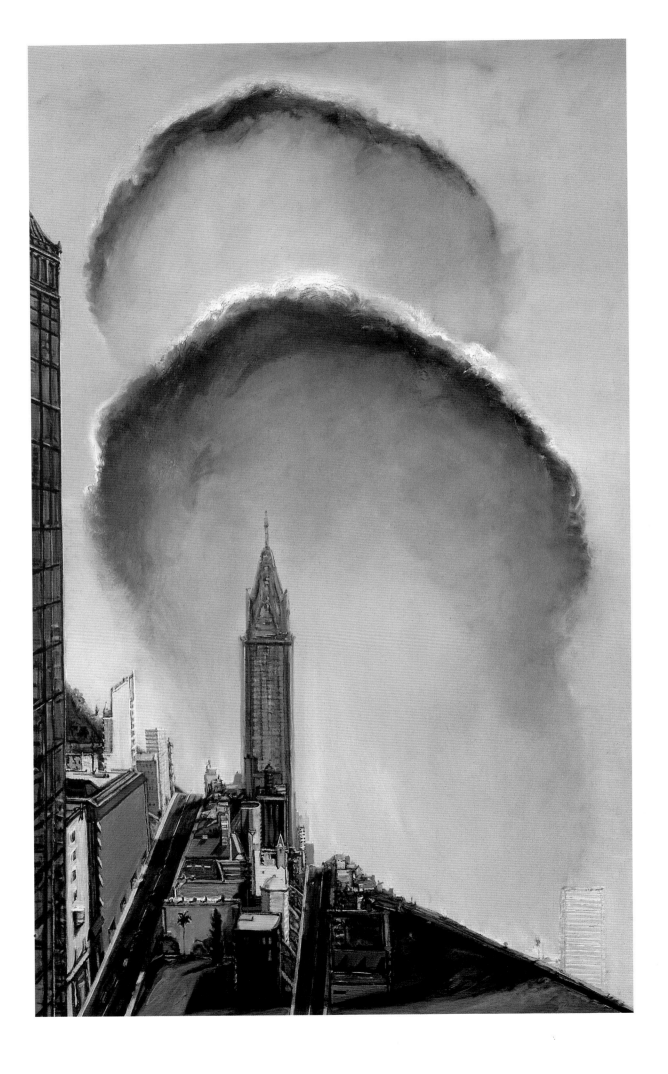

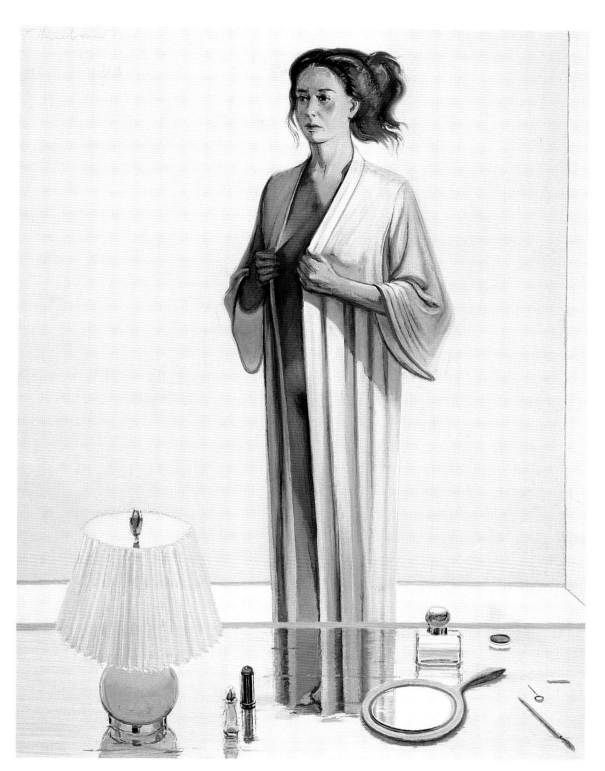

92
Dressing Figure 1994
Oil on paper mounted on panel, 41¼ × 31¼ in. (106.1 × 80.7 cm)
Signed and dated upper left: *Thiebaud 1994*
Private collection

91 [FACING PAGE]
Cloud City 1993–94
Oil on canvas, 60 × 36 in. (152.4 × 91.4 cm)
Signed and dated lower right: *Thiebaud '94*;
 signed and dated on reverse: *Thiebaud 1993–94*
Estate of William C. Janss

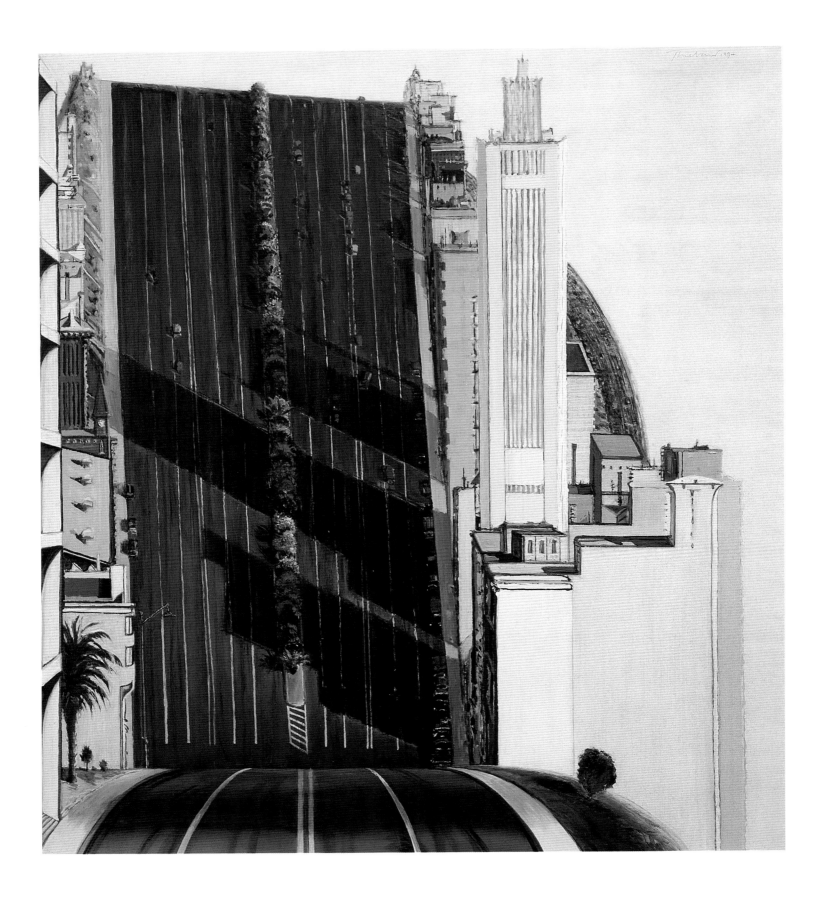

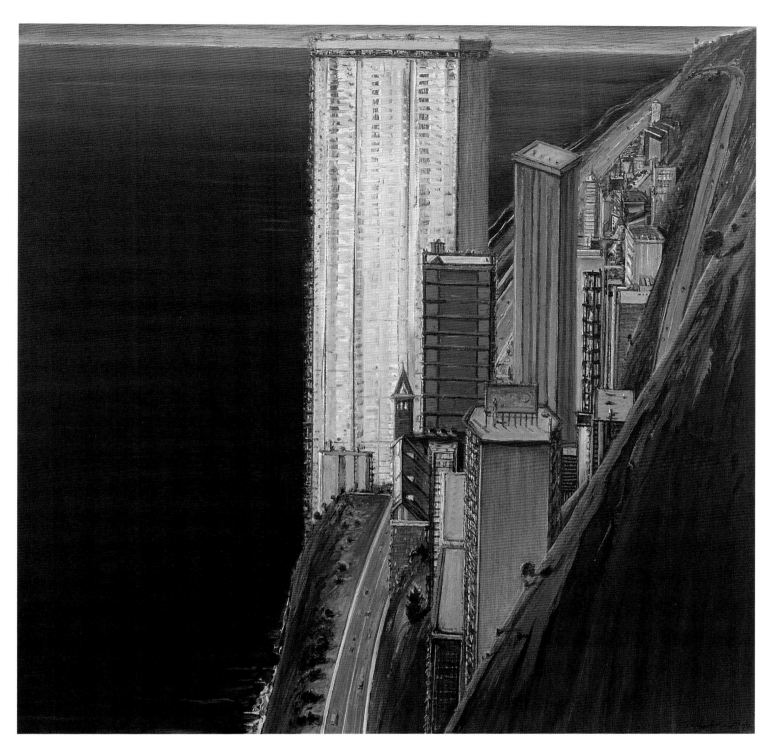

94
Resort Town 1995
Oil on linen, 47 ¾ × 47 ¾ in. (121.3 × 121.3 cm)
Signed and dated lower right: *Thiebaud '94;*
 signed and dated on reverse: *Thiebaud 1994*
Collection of Mr. and Mrs. S. N. Herman, Chicago

93 [FACING PAGE]
Wide Downstreet 1994
Oil on canvas, 54 × 48 in. (137.2 × 121.9 cm)
Signed and dated upper right: *Thiebaud 1994;*
 signed and dated on reverse: *Thiebaud 1994*
Betty Jean Thiebaud

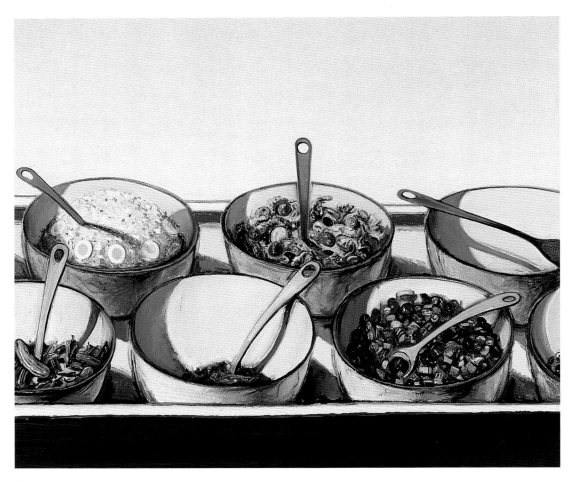

95
Deli Bowls 1995
Oil on linen, 37 ¼ × 43 ⅜ in. (94.6 × 110.2 cm)
Signed upper left: *Thiebaud*; signed on reverse: *Thiebaud*
Courtesy Campbell-Thiebaud Gallery

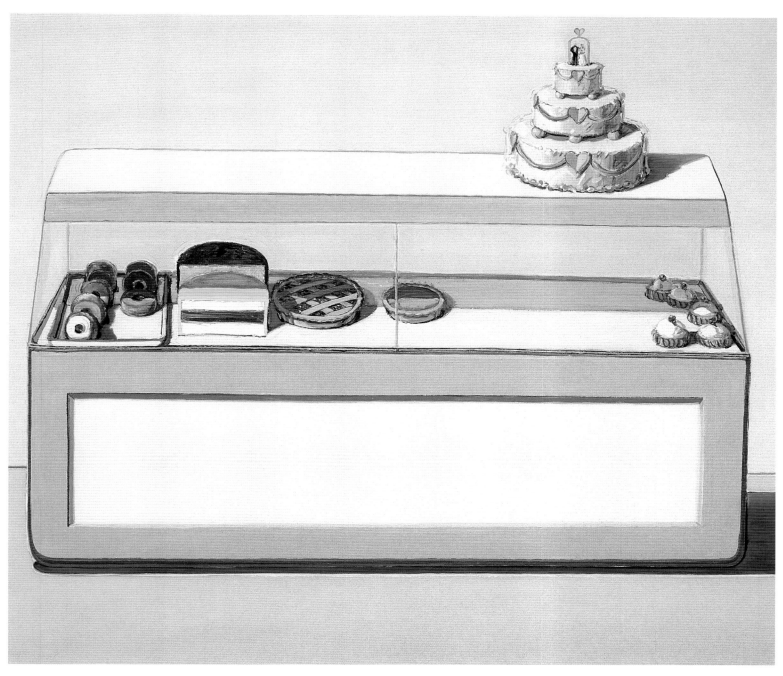

96
Bakery Case 1996
Oil on canvas, 60 × 72 in. (152.4 × 182.9 cm)
Signed lower left: ♥ *Thiebaud*
Private collection

Fort Worth and Washington only

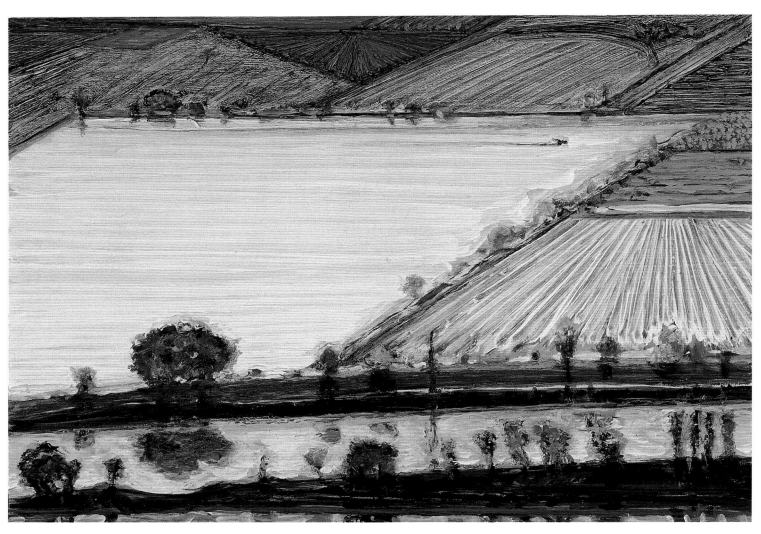

97
Channel Farms 1996
Oil on wood, 10 × 14 in. (25.4 × 35.6 cm)
Signed and dated on reverse: *Thiebaud 1996*
Linda and Jon Gruber

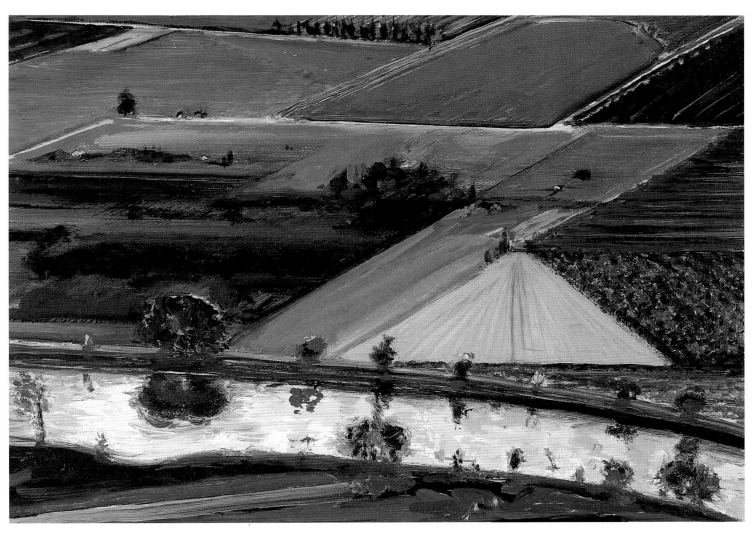

98
Farm Channel 1996
Oil on wood, 10 × 14 in. (25.4 × 35.6 cm)
Signed and dated on reverse: *Thiebaud 1996*
Private collection

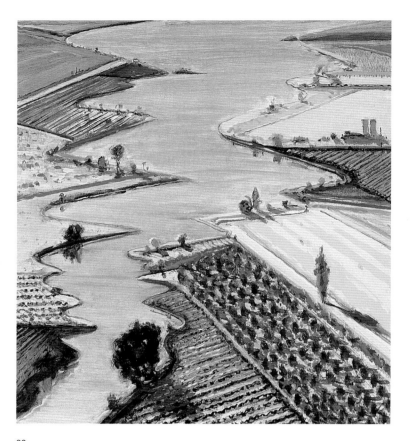

99
River and Farms Study 1995
Oil on wood, 13 ¼ × 12 in. (33.7 × 30.5 cm)
Inscribed on reverse: *River and Farms Study / 1995 / Thiebaud 1995*
Thomas W. Weisel

100 [FACING PAGE]
River and Farms 1996
Oil on canvas, 60 × 48 in. (152.4 × 121.9 cm)
Signed and dated lower left: *Thiebaud 1996*
Nan Tucker McEvoy

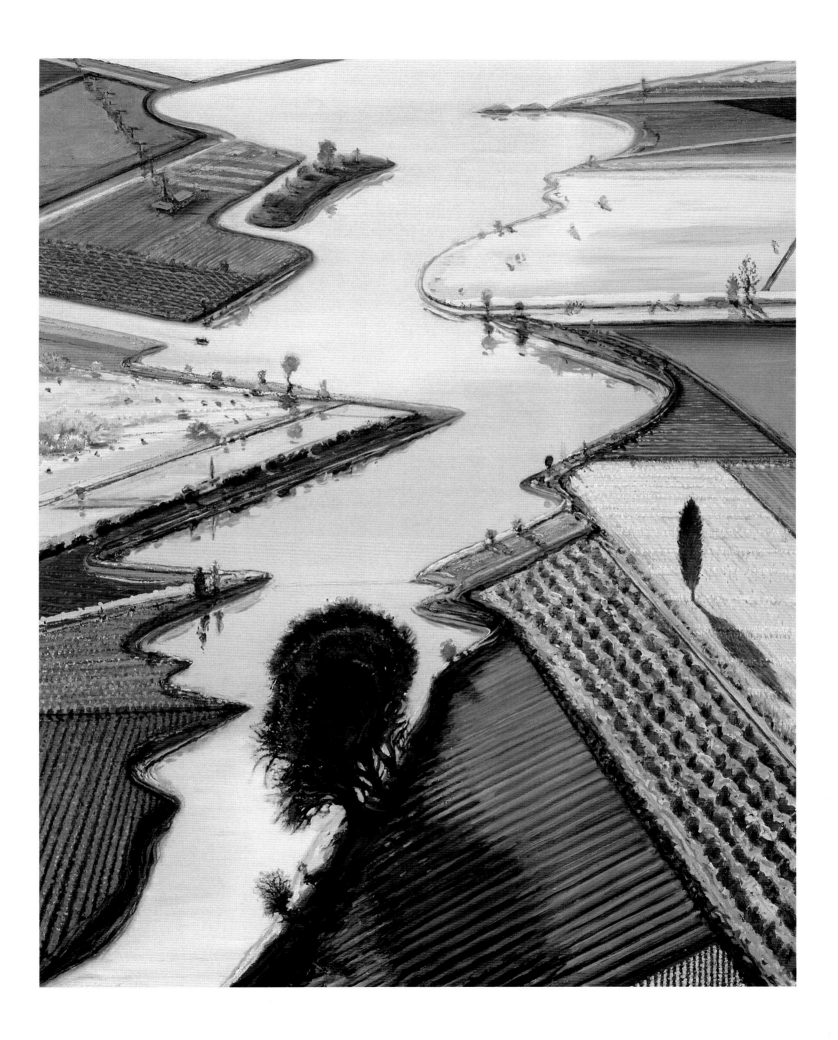

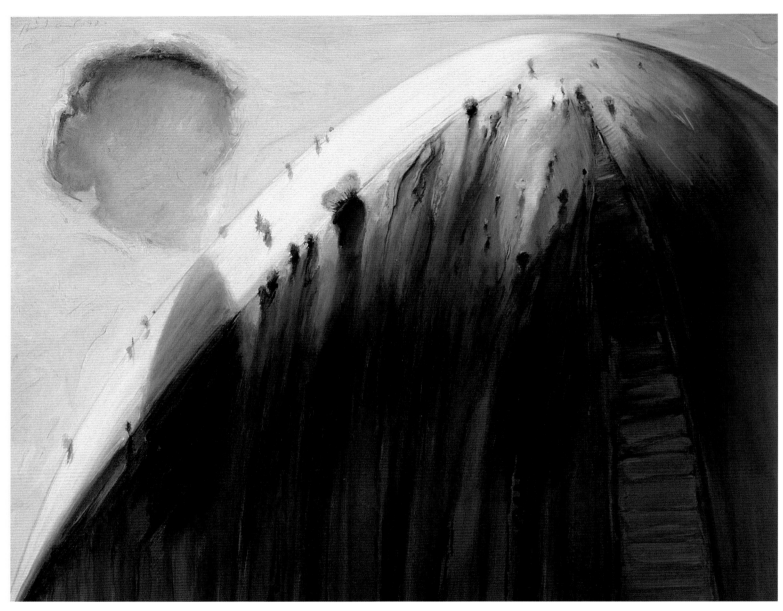

101
White Mountain 1995
Oil on canvas, 48 × 60 in. (121.8 × 152.3 cm)
Signed and dated upper left: *Thiebaud 1995*
Private collection

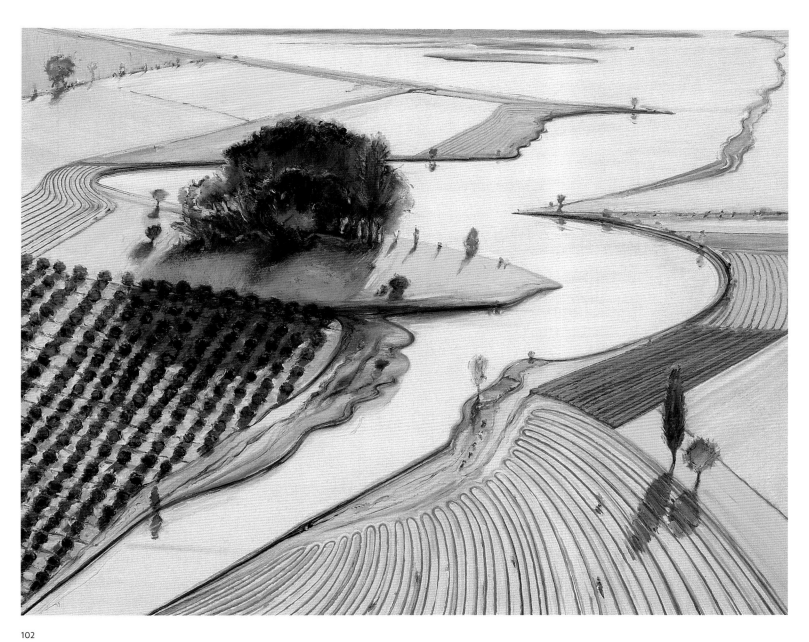

102
Waterland 1996
Oil on canvas, 48 × 60 in. (121.9 × 152.4 cm)
Signed and dated on reverse and on stretcher: *Thiebaud 1996*
Betty Jean Thiebaud

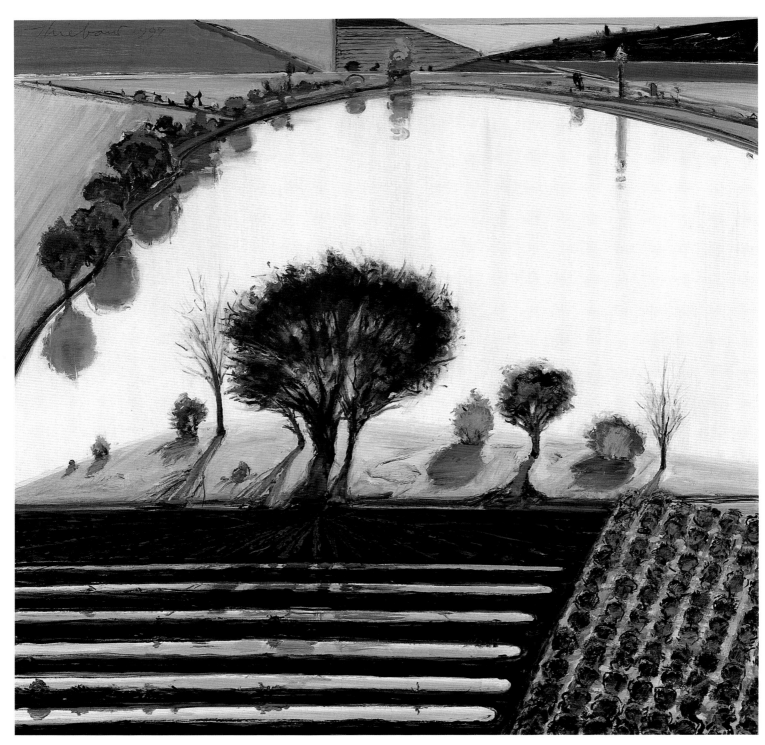

103
River Pool 1997
Oil on canvas, 36 × 35 ¾ in. (91.4 × 90.8 cm)
Signed and dated upper left: *Thiebaud 1997*
Paul LeBaron Thiebaud

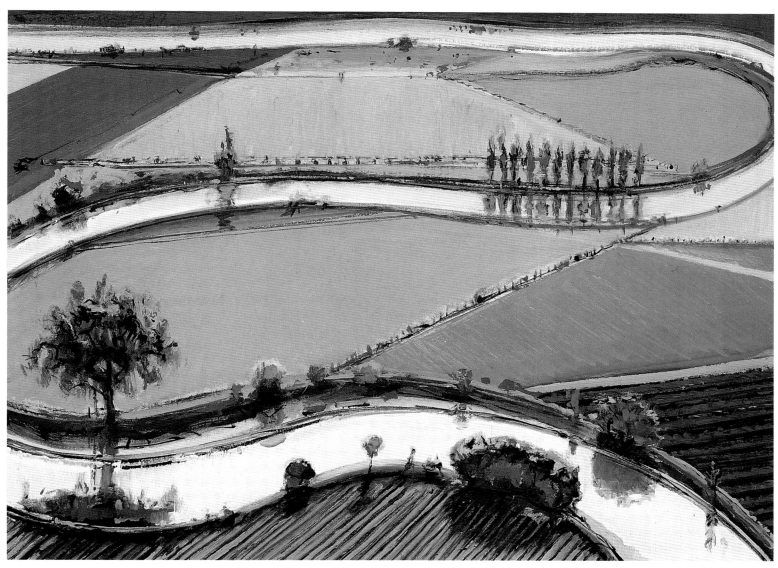

104
River Turns 1997
Oil on canvas, 30 × 40 in. (76.2 × 101.6 cm)
Signed and dated upper left: *Thiebaud 1997*
Mrs. Stephen Koshland

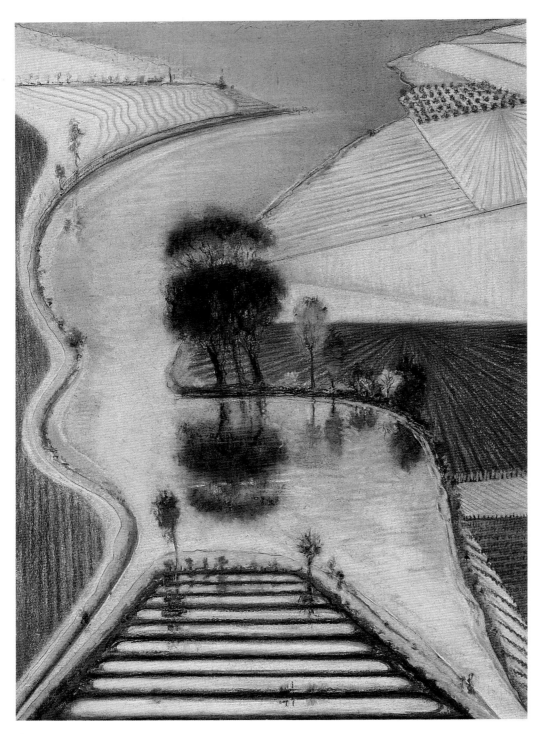

105
Delta 1998
Pastel on paper, 31 ¼ × 22 ⅝ in. (79.4 × 57.5 cm)
Private collection

106 [FACING PAGE]
Green River Lands 1998
Oil on canvas, 72 × 48 in. (182.9 × 121.9 cm)
Signed and dated upper right: *Thiebaud '98*;
 signed and dated on reverse: *Thiebaud '98*
Private collection

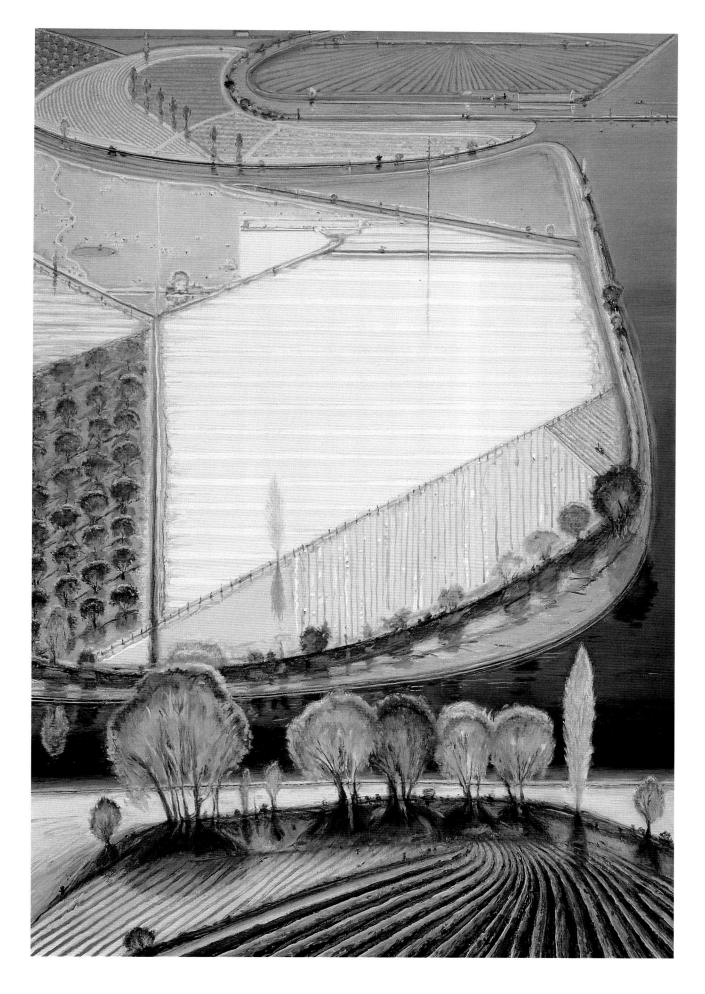

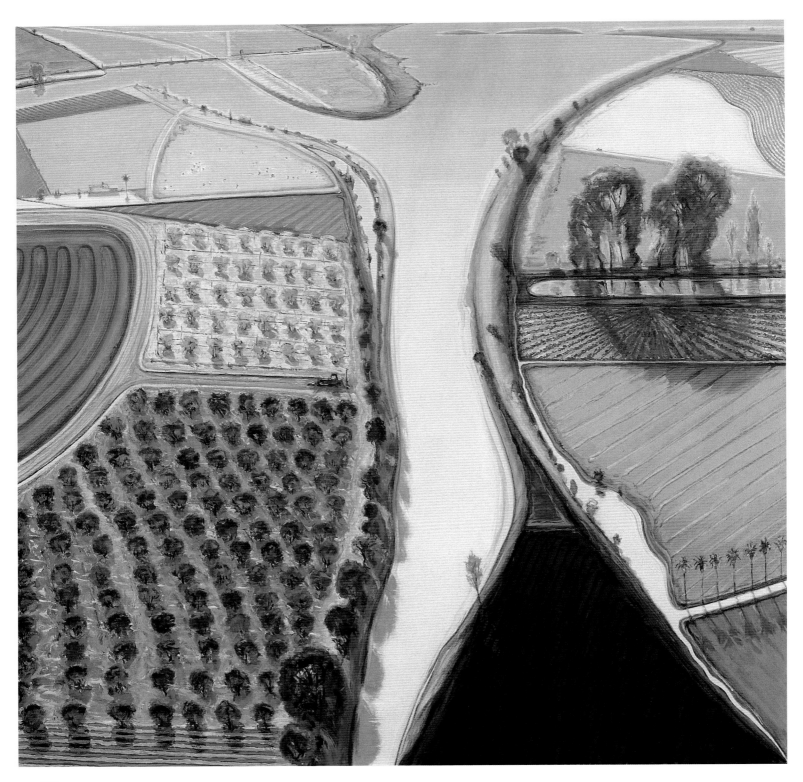

107
Y River 1998
Oil on canvas, 72 × 72 in. (182.9 × 182.9 cm)
Inscribed on reverse: ♥ *Thiebaud 1998 / Y River*
Courtesy Campbell-Thiebaud Gallery

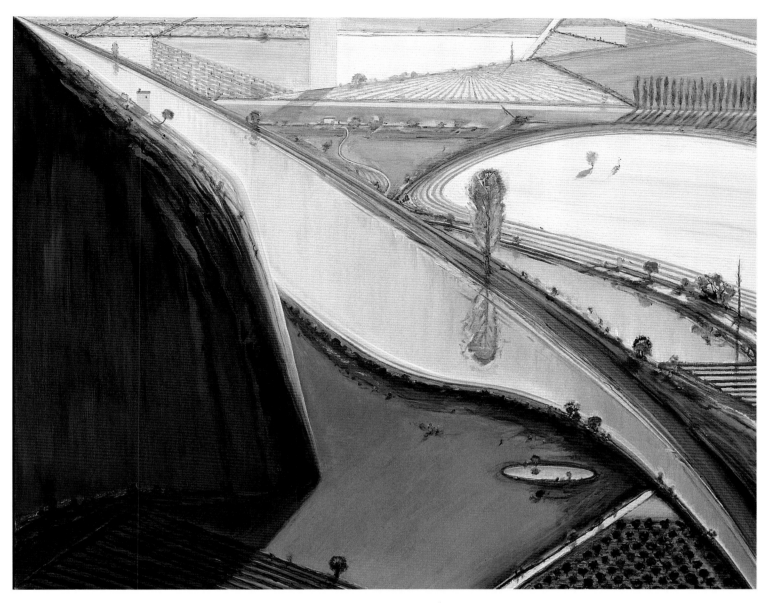

108

Ridge Valley Farm 1998

Oil on canvas, 48 × 60 in. (121.9 × 152.4 cm)

Signed upper right: *Thiebaud*; signed and
 dated on reverse: *Thiebaud '98*

Elle and Paul Stephens

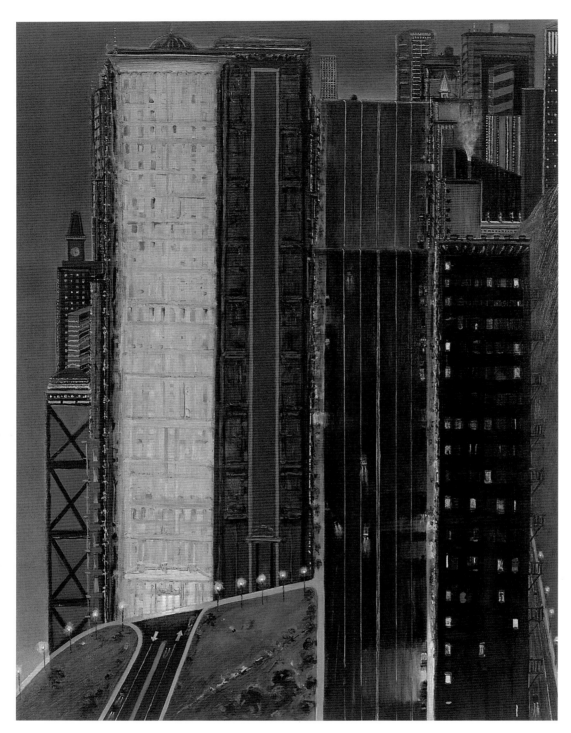

109
Dark City 1999
Oil on canvas, 72 × 55 in. (182.9 × 139.7 cm)
Signed lower left: ♥ *Thiebaud*; signed and
 dated on reverse: *Thiebaud 1999*
Courtesy LeBaron's Fine Art

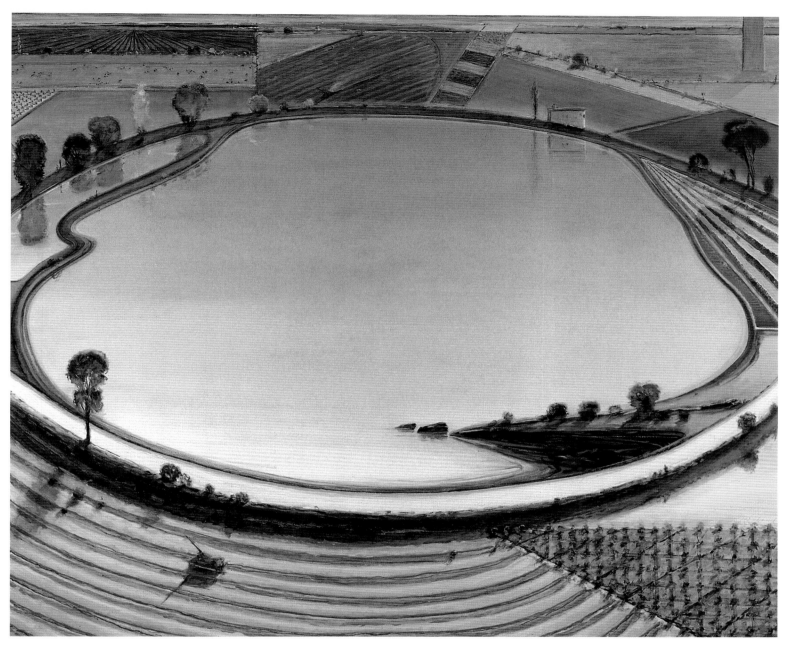

110
Reservoir 1999
Oil on canvas, 60 × 72 in. (152.4 × 182.9 cm)
Signed and dated lower right: *Thiebaud 99*
Mr. and Mrs. Gary M. Sumers, New York

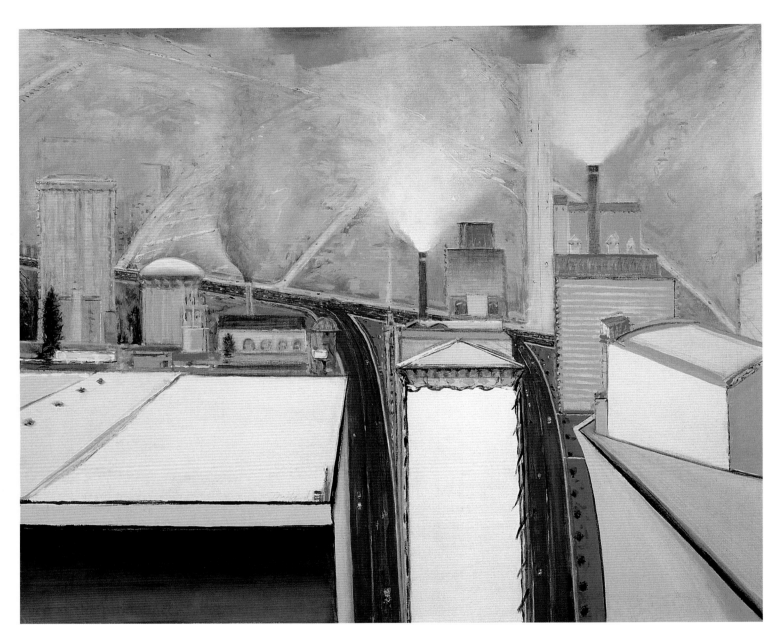

111
Grey City 2000
Oil on canvas, 40 ⅛ × 48 ⅛ in. (101.9 × 122.2 cm)
Inscribed on reverse: ♥ *Thiebaud* / *2000* / *"Grey City"*
Courtesy of LeBaron's Fine Art

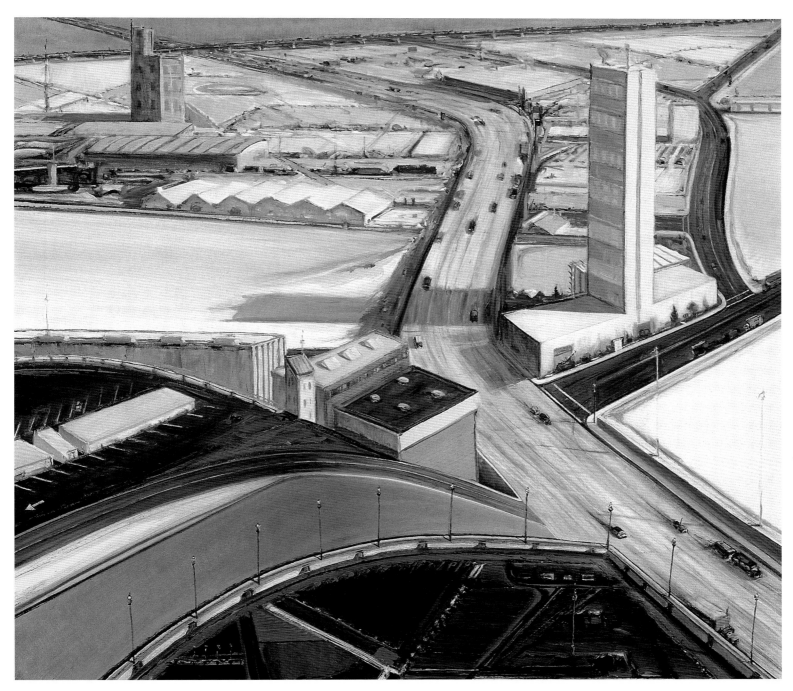

112
Towards 280 1999–2000
Acrylic and oil on canvas, 54 × 60 in. (137.2 × 152.4 cm)
Signed upper right: ♥ *Thiebaud*; signed and
 dated on reverse: *Thiebaud 2000*
Courtesy of LeBaron's Fine Art

113
Ice Cream Cone 1966
Painted box, oil on wood,
5⅜ × 2¾ × 2½ in.
(13.7 × 7 × 6.4 cm)
Betty Jean Thiebaud

114
Tennis Player 1990
Painted box, oil on canvas
mounted on wood,
3¼ × 5⁹⁄₁₆ × 2¾ in.
(8.3 × 14.1 × 7 cm)
Paul LeBaron Thiebaud

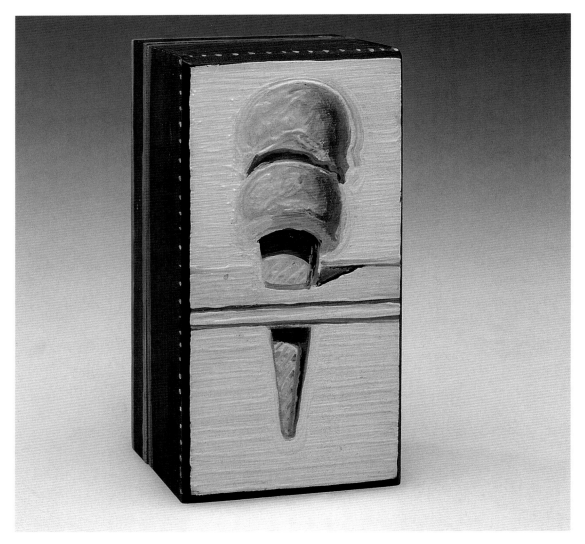

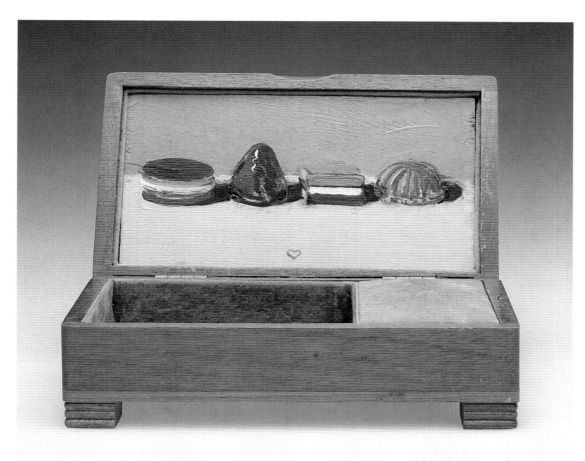

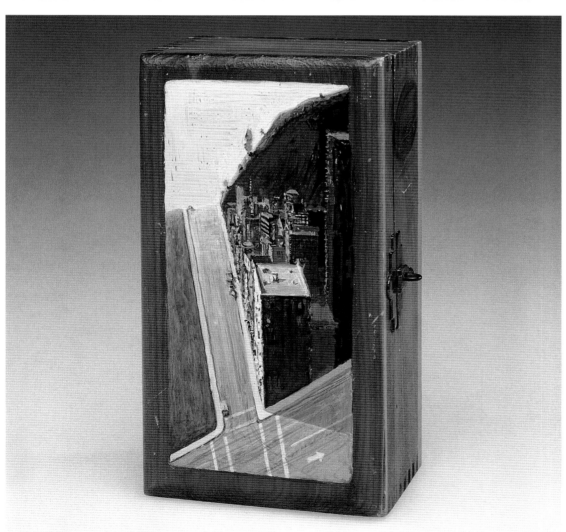

115
Candies 1993
Painted box, oil on wood,
4 ⅜ × 7 ¾ × 2 ¾ in.
(11.1 × 19.7 × 7 cm)
Inscribed bottom center: ♥
Paul LeBaron Thiebaud

116
Cityscape 1993
Painted box, oil on wood,
7 ⅝ × 4 × 3 in.
(19.4 × 10.2 × 7.6 cm)
Paul LeBaron Thiebaud

117
Flower in Glass 1995
Painted box, oil on paper
 mounted on wood,
 5 ⅝ × 6 × 3 ⅜ in.
 (14.3 × 15.2 × 8.6 cm)
Inscribed at bottom: *Happy*
 Birthday Betty Jean 1995 ♥
Betty Jean Thiebaud

118
Riverscape 1996
Painted box, oil on paper
 mounted on wood,
 6 × 7 ¹¹⁄₁₆ × 3 ⅝ in.
 (15.2 × 19.5 × 8.4 cm)
Inscribed lower left: ♥
Betty Jean Thiebaud

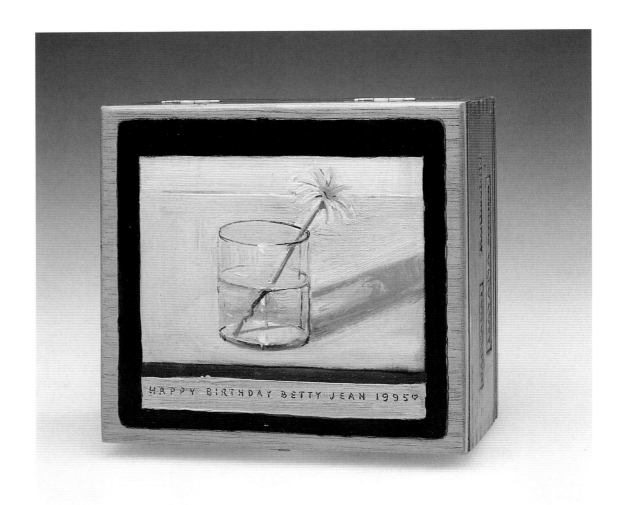

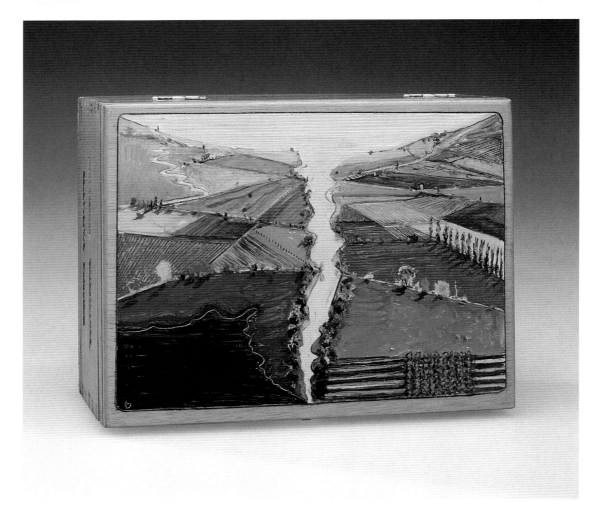

119
Bluff 1998
Painted box, oil on wood,
4 ¼ × 5 ¼ × 1 ¼ in.
(10.8 × 14.6 × 3.2 cm)
Paul LeBaron Thiebaud

120
Gooffy Doll 1999
Painted box, oil on wood,
4 ¹⁄₁₆ × 5 ⅞ × 4 ⅞ in.
(10.3 × 14.9 × 12.4 cm)
Inscribed upper left:
Gooffy Doll;
signed upper right: *Pop* ♥
Paul LeBaron Thiebaud

Wayne Thiebaud, ca. 1985–86.

Chronology

STEVEN A. NASH

Special thanks are due to Wayne Thiebaud for his help in compiling this chronology.

1920

Born Morton Wayne Thiebaud on 15 November in Mesa, Arizona, to Alice Eugenia LeBaron and Morton J. Thiebaud. Younger sister, Marjory Jean, born in 1924. Paternal grandfather was born in Switzerland and emigrated to Indiana where WT's father was born. Maternal grandmother was one of the original Mormon pioneers who settled in Utah in the mid-nineteenth century. Having converted from the Baptist to the Mormon church, the father involves his family very closely in church activities and eventually, around 1936–37, is ordained a bishop of the ward.

1921

Family moves to Long Beach, California. Father is an inventor and engineer who supports his family as a mechanic at the Ford Motor Agency in Long Beach, where he assembles Model T's, and then as a foreman in the motor pool of the Gold Medal Creamery. He patents an electric milk truck with doors that open on both sides and that steers from the center. He also designs the largest electric truck in the world, which runs between Los Angeles and San Francisco. When Gold Medal Creamery is acquired by Golden State Creamery, the family moves to Los Angeles where the father continues to work for the new company. WT spends a lot of time as a child on the Southern California farm in Wintersburg, Orange County, of his grandfather Rudolph, who came west after retiring from his post as a district superintendent of schools in Indiana. He had moved first to Mesa, Arizona, where he homesteaded a property, and later to California. WT's earliest memories of art activities are the projects his mother set up as diversions for the children on rainy days, and visits with his uncle Jess, an amateur cartoonist, who amused the children with his drawing skills.

1931–33

With the onset of the Great Depression, the father resigns his job at the creamery and moves the family to Southern Utah to take up farming. WT attends school for one semester in Hurricane, Utah, and the family acquires by lease with an option to buy a 5,000-acre ranch in 1931 between St. George and Cedar City, which they plant with a variety of crops. Between ages 11 and 13, WT helps with farm work. When their farm finally fails in 1933, the family moves back to Long Beach, where the father becomes a traffic safety supervisor for the city and, from 1943, sells real estate in the San Fernando Valley. From the age of about 13, WT is deeply involved in church activities, developing an interest in public speaking that would carry over into his college days. He also takes part in the church's Boy Scout troop and in church programs that celebrate momentous events in Mormon history.

Thiebaud family, ca. 1927–28, Long Beach. Standing, from the left: WT's grandmother, father, mother, aunt, and grandfather. In front: Wayne and his sister.

1935–38

Attends Long Beach Polytechnic High School. Participates in city-league basketball and the school's stage crew for theatrical productions, a musical trio, and a couple of school art classes. First takes up drawing while convalescing after breaking his back in sports. Especially interested in cartooning. Among his musical interests are the guitar, harmonica, singing, and yodeling; his trio, formed with friends from church, plays for church socials and appears on a local radio station. Early theatrical experience leaves a lasting impression, perhaps even influencing the strong lighting effects and compositional staging of paintings much later. Through an inspiring teacher named H. A. Foster, he is introduced to production work and leading design theories and is taken with other students to see plays at the Pasadena Playhouse. After school and during vacations he is employed by the Rivoli movie theater in Long Beach, sometimes making posters for lobby displays. Holds a variety of other part-time jobs, including sign painting, ice delivery, and dish washing.

1936

Works six or seven weeks during the summer in an apprentice program in the animation department of Walt Disney studios, as an "in-betweener," drawing the frames that run between the main frames produced by principal animators. Among the cartoon characters he works on briefly are Goofy, Pinocchio, and Jiminy Cricket. He is fired for pro-union agitation and going on strike, demonstrating at an early age an interest in liberal political causes.

1937

While still in high school, in summer attends the Frank Wiggins Trade School in Los Angeles to study commercial art. Takes a course taught by a fashion designer and a graphic designer.

1939–40

Works at odd jobs and as a sign painter, freelance cartoonist, and illustrator of movie posters in Long Beach.

1940–41

Attends Long Beach Junior College (which becomes Long Beach City College). Joins a fraternity, for which he helps produce skits, and pursues radio announcing and public speaking.

1941

Works as a shipfitter on Terminal Island, near Long Beach.

1942–45

Corporal Wayne Thiebaud teaching a drawing class, Public Services Office, Army Air Force, 1942–43.

Serves in the U. S. Army Air Force, first at Mather Army Air Field (now Mather Air Force Base), near Sacramento. Assigned to the Special Services Department as an artist and cartoonist, he designs posters, creates a cartoon strip called "Aleck" for the base newspaper *Wing Tips,* works on murals, and designs set-ups for publicity photographs. In his last months of service, he is transferred to the First Air Force Motion Picture Unit, commanded by Ronald Reagan and temporarily housed in the Hal Roach Studios in Culver City, California. There he works on a project making map models to assist pilots in attacking Japan, and after V-J Day on documentary and training films.

1943

Marries Patricia Patterson.

Thiebaud working on *Aleck* cartoons, Mather Army Air Field, 1944.

1945

Daughter Twinka is born. WT included in *Kingsley Art Club 20th Annual Local Exhibit* at the E. B. Crocker Art Gallery (now Crocker Art Museum) in Sacramento.

1945–46

After his discharge from the army, works in Los Angeles and New York in a variety of commercial roles: free-lance cartoonist, illustrator, and layout designer. In New York, lives at the YMCA while trying to sell his cartoons, and spends time in the art department of Fairchild Publications, publisher of *Men's Wear* and *Women's Wear Daily*. After returning to Los Angeles, works for Universal-International Studios under art director Mischa Kallis, illustrating movie posters (*Killers, Dead of Night,* etc.) and designing sets for publicity photographs. A labor strike causes his departure.

1946–49

Works as a layout designer and cartoonist in the advertising department at Rexall Drug Company in Los Angeles. For the company magazine he creates the comic strip "Ferbus." Meets artist Robert Mallary, a co-worker at Rexall, who becomes an artistic and intellectual mentor. Mallary is a layout designer and sculptor and a well-read, self-taught intellectual with strong political convictions and a dominating

One of Thiebaud's "Ferbus" comic strips, created for the Rexall Drug Company magazine, ca. 1946–49.

commitment to art and art history that proves inspirational for WT. During these years, works seriously at painting for the first time. Earliest compositions show a combination of cubist and expressionist influences, with ideas drawn from such artists as John Marin, Lyonel Feininger, Rico LeBrun, and Eugene Berman. Mallary introduces him to a number of modernist artists living in Los Angeles, including LeBrun, Howard Warshaw, and William Brice.

1948

Participates in first major museum exhibition, *Artists of Los Angeles and Vicinity,* an annual sponsored by the Los Angeles County Museum (now Los Angeles County Museum of Art) and juried by Henry Lee McFee.

1949

Included in the other group shows *Artists under Thirty-three,* organized by the Los Angeles Art Association and selected by Lorser Feitelson, and the annual exhibition at the E. B. Crocker Art Gallery.

1949–50

Resigns from Rexall and, in order to obtain a teaching credential, enrolls at San Jose State College (now San Jose State University) in San Jose, California, on the GI Bill. Transfers in 1950 to California State College (now California State University) in Sacramento.

1950–53

At California State College, creates with instructor Paul Beckman a course in stage design and produces several set designs in an expressionistic style related to the theatrical designs of Eugene Berman. Receives bachelor of arts degree in 1951, master of arts in 1953, with an art major focused on art history, theory, and education. Exempts most of the mandatory studio courses, hence receiving little formal training in drawing and painting. Produces serigraphs and lithographs with Patrick Dullanty.

1951

First one-artist exhibition, *Influences on a Young Painter,* at the E. B. Crocker Art Gallery includes sixty works. The California State Library in Sacramento exhibits a selection of his graphics. Given first one-artist show in a commercial gallery at the Contemporary Gallery in Sausalito, California, near San Francisco. Watercolors are shown at the City of Paris department store's rotunda gallery in San Francisco.

1952

Daughter Mallary Ann is born.

1951–60

While still working toward his master of arts degree, WT is appointed instructor of art at Sacramento Junior College (now Sacramento City College). Serves as chairman of the art department, 1954–56 and 1958–60. Teaches both art and art history and institutes new courses in such fields as television production, film, and commercial art. During summers (1950–59), serves as exhibit designer for annual art exhibitions at the California State Fair and Exposition in Sacramento. Organizes shows of crafts, modern design, and fine art under the general direction of Grant Duggins and with the collaboration of fellow Sacramento artists Patrick Dullanty, Jack Ogden, and Mel Ramos. Also is active in the Sacramento area as a designer for theatrical events including such productions as the musical extravaganza *Embarcadero* (1951–53), for which he produces eight brightly colored sets in a Pointillist style, Jean Giraudoux's *The Madwoman of Chaillot* at the Eaglet Theatre in Sacramento in 1953, *The Dark of the Moon* at the Eaglet in 1958, and sets for the Sacramento City Unified School District annual

Thiebaud seen in profile in front of an outdoor mural he helped produce for the California State Fair and Exposition, 1957.

[ABOVE]
Set designed by Thiebaud for *Madwoman of Chaillot*, 1953.

[RIGHT]
Water at Play, a kinetic fountain designed by Thiebaud and Gerald McLaughlin in 1952.

CHRONOLOGY

Sacramento Municipal Utility District building with Thiebaud's mosaic mural *Water City,*
completed in 1957.

musical festival from 1953 to 1957. Receives several commissions for public works at the California State Fair (all later destroyed): a kinetic fountain created with Gerald McLaughlin entitled *Water at Play* in 1952, an outdoor mural in 1957, and a welded sculpture called *Angel of Art* in 1956. He is commissioned by the Sacramento Municipal Utility District in 1957 to create a large glass mosaic outdoor mural on one of their public buildings (completed 1959). Entitled *Water City,* the mural still survives. Enters numerous art shows in Sacramento and small nearby towns such as Auburn and Lodi, and continues to submit to the annuals sponsored by the E. B. Crocker Art Gallery, Oakland Art Museum (now the Oakland Museum of California), San Francisco Museum of Art (now San Francisco Museum of Modern Art), and the California Palace of the Legion of Honor in San Francisco.

1953

One-artist exhibition at the Zivile Gallery in Los Angeles, after which the gallery owner absconds with seventeen of his works (never recovered).

1954

One-artist exhibitions at Gump's Gallery, San Francisco, and the Pioneer Museum and Haggin Galleries, Stockton.

1954–59

Establishes a company called Patrician Films to produce educational art films, including *Color on a Stone* and *Modern Art Series,* which are distributed by Bailey Films in Hollywood. In 1956 his film *Space* wins the Chicago Golden Reel Award and first prize at the Art Film Festival, California State Fair. Initiates with Paul Beckman a series of tours for students, teachers, and artists during vacations to museums, galleries, and studios in New York, Washington, D.C., and Paris. Organizes a total of around eight trips during the fifties and visits, among others, Claes Oldenburg, Alex Katz, Richard Artschwager, and Elaine de Kooning.

1956–57

Takes a leave of absence from teaching to live in New York City. Frequents the Cedar Bar and Eighth Street Club and meets artists Elaine and Willem de Kooning, Franz Kline,

Barnett Newman, Philip Pearlstein, Milton Resnick, Lester Johnson, Wolf Kahn, and critics Harold Rosenberg and Thomas Hess, among others. Supports himself as an advertising art director, working at Deutsch and Shea Advertising Agency and Frederick A. Richardson Advertising Agency. Attends a memorial for Jackson Pollock at the Eighth Street Club on 30 November 1956. Paintings of everyday objects and storefront windows from this period often feature overlays of whiplash strokes in a manner reminiscent of Abstract Expressionism.

1957

Visits the groundbreaking exhibition *Contemporary Bay Area Figurative Painting* at the Oakland Art Museum, which publicly introduces the recent movement into figurative art by such painters as David Park, Elmer Bischoff, and Richard Diebenkorn. One-artist exhibition at the E.B. Crocker Art Gallery.

1958

During the summer, serves as guest instructor in printmaking at the California School of Fine Arts (now San Francisco Art Institute) in San Francisco, substituting for Nathan Oliveira. One of eighteen artists to cofound the Artists Cooperative Gallery (now Artists Contemporary Gallery) in Sacramento. Travels to Mexico and paints a series of watercolors of local scenes.

1959

Divorces Patricia. Marries Betty Jean Carr. Raises her son Matthew Bult. Receives an award in a national contest sponsored by Columbia Records for an album cover design for *Jazz Impressions of Eurasia* by Dave Brubeck.

1960

Appointed assistant professor in the Department of Art at the University of California, Davis. Subsequently appointed associate professor (1963–67), and professor (1967 until retirement at age 70). Now serves as professor emeritus.

1960–61

Begins his highly distinctive series of still-life paintings of foods and objects, with characteristically bright colors, strong light, and sternly ordered compositions.

1961

Receives University of California faculty fellowship, enabling him to travel to New York during the summer. Visits numerous galleries in an attempt to interest them in his work, but without success. Introduced by Robert Mallary to Allan Stone, who the previous year had opened a gallery dedicated to emerging artists. Stone at first does not know what to make of WT's work but decides to schedule an exhibition of food paintings the following year, thus initiating an artist/dealer relationship that continues to the present. One-artist exhibitions follow at the Allan Stone Gallery almost annually. Included in *1961 Northern California Painters' Annual* at the Oakland Art Museum and awarded a prize by artist/juror Richard Diebenkorn, whom he meets in 1964. His food paintings are shown at the Artists Cooperative Gallery in Sacramento, where one is purchased and donated to the E. B. Crocker Art Gallery, and in a one-artist exhibition at Arts Unlimited Gallery, San Francisco. Nothing sells from the latter show, but art critic Alfred Frankenstein mentions the show and quips that Thiebaud must be "the hungriest artist in California."

1962

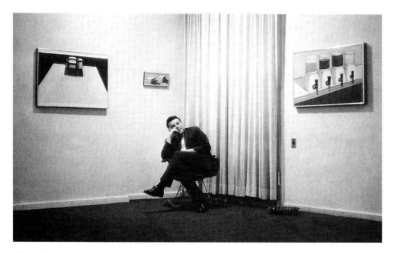

Allan Stone in his New York gallery at the time of Thiebaud's one-artist exhibition in 1962.

In April and May, has his first one-artist exhibition in New York, *Wayne Thiebaud: Recent Paintings,* at the Allan Stone Gallery. In July and August, given his first one-artist museum exhibition in San Francisco, *An Exhibition of Paintings by Wayne Thiebaud,* at the M. H. de Young Memorial Museum. The critical success of his work in New York is repeated in San Francisco. Included in October in the group exhibition *New Realists* at the Sidney Janis Gallery in New York. Articles and reviews discussing his work soon appear in such national publications as *Newsweek, Artforum, ARTnews, Arts Magazine, Nation, Art International, Time, New York Times,* and *Life.*

1963

Begins working on series of etchings with Kathan Brown at Crown Point Press, then located in Oakland and later moved to San Francisco. Takes first trip to Europe in conjunction with a two-artist exhibition shared with Stephen Durkee at the Galleria Schwarz in Milan.

1964–65

First meets Richard Diebenkorn while making prints at Crown Point Press. Receives creative research grant from U. C. Davis. Concentrates on painting the figure, resulting in the 1965 exhibition *Figures: Thiebaud* at the Stanford Art Museum, Stanford University.

1965

Portfolio of seventeen etchings, entitled *Delights,* published by Crown Point Press. One-artist survey of prints, drawings, and paintings at the San Francisco Museum of Art.

1967

Chosen to represent the United States in the São Paulo Bienal, Brazil. Receives the appointment of visiting lecturer and artist-in-residence at Cornell University, Ithaca, New York. In later years accepts similar positions at numerous schools, including the University of Victoria, British Columbia; Rice University, Houston; Colorado State University, Fort Collins; University of Utah, Salt Lake City; Stanford University, California; Skowhegan School of Painting and Sculpture, Maine; Laguna Beach School of Art, California; New York Studio School; Harvard University, Cambridge, Massachusetts; Yale University, New Haven, Connecticut; University of Wisconsin, Madison; University of New Mexico, Albuquerque; University of Virginia, Charlottesville; and Princeton University, New Jersey.

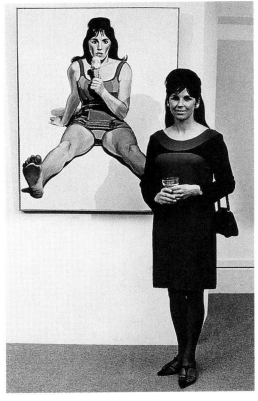

Betty Jean Thiebaud with *Girl with Ice Cream Cone*, for which she posed, at the Stanford Art Museum exhibition, 1965.

1968

Given one-artist exhibition at the Pasadena Art Museum (now Norton Simon Museum), California, which travels nationally; catalogue essay and interview by John Coplans. Commissioned by *Sports Illustrated* to paint Wimbledon Tennis Tournament, England, resulting in a group of still lifes and close-up figure studies reproduced in the June issue. Edition of his lithograph *Lollipops* published by Gemini G.E.L., Los Angeles.

1969–70

Teaches during the summer at the New York Studio School in Paris with Elaine de Kooning. Helps establish a visiting artist program at U. C. Davis. Invited artists include Robert Mallary, Joseph Raphael, Elaine de Kooning, Richard Artschwager, Robert Frank, John Cage, and William Wegman.

1970

Works on series of linocuts at the Arnera printshop in Vallauris, France.

1971

The exhibition *Wayne Thiebaud Graphics: 1964–1971,* organized by Parasol Press, appears at the Whitney Museum in New York then travels nationally and internationally. Two portfolios of prints, *Seven Still Lifes and a Rabbit* and *Seven Still Lifes and a Silver Landscape,* are published by Parasol Press.

1972

Thiebaud in his Potrero Hill Studio working on the painting *Girl in Striped Blouse,* ca. 1974–75.

Appointed thirty-first Faculty Research Lecturer and honored with the Golden Apple Award for distinguished teaching at U. C. Davis. Receives honorary doctorate at the California College of Arts and Crafts, Oakland. Establishes his second home and studio on Potrero Hill in San Francisco and begins to work more regularly on the enduringly important theme of San Francisco cityscapes, first taken up in 1971.

1975

Commissioned by the United States Department of the Interior to paint *Yosemite Ridge Line* for the bicentennial exhibition *America 1976.*

1976

Given a one-artist exhibition at the Phoenix Art Museum, Arizona, with catalogue essay by Gene Cooper (travels nationally). Begins weekly drawing sessions in San Francisco with a group of Bay Area artists including Mark Adams, Theophilus Brown, Gordon Cook, and Beth Van Hoesen.

Figure drawing group, San Francisco, ca. 1981. From the left: Gordon Cook, William Theophilus Brown, Beth Van Hoesen, Mark Adams, Thiebaud.

1978

Serves on the Prix de Rome award panel for painting. One-artist exhibition *Wayne Thiebaud: Recent Work* appears at the San Francisco Museum of Art.

1981

Receives citation from the College Art Association of America as Distinguished Art Studio Teacher of the Year for 1980–81.

1983

Receives an honorary doctorate from Dickinson College, Carlisle, Pennsylvania. Travels to Japan under the auspices of Crown Point Press to work with traditional Japanese woodblock printers.

1984

Presented a special recognition award by the National Association of Schools of Art and Design.

1985

Elected to the American Academy and Institute of Arts and Letters, New York. The major retrospective *Wayne Thiebaud* is organized by the San Francisco Museum of Modern Art and travels to the Newport Harbor Art Museum (now the Orange County Museum of

Art), California; Columbus Museum of Art, Ohio; and Nelson-Atkins Museum of Art, Kansas City, Missouri. The catalogue for this show, with essay by Karen Tsujimoto, remains for many years the standard reference work on Thiebaud.

1986

Elected as Associate of the National Academy of Design, New York. *Wayne Thiebaud: 25th Anniversary Exhibition* appears at the Allan Stone Gallery, New York.

1987

Advances to Academician in the National Academy of Design. Receives the Award of Honor for distinguished service in the arts from the San Francisco Arts Commission. Receives the Cyril Magnin Award for Outstanding Individual Achievement in the Arts from the San Francisco Chamber of Commerce. Acknowledged as annual honoree by the American Academy of Achievement. Designs sets and provides costume concepts for the Oakland Ballet production of *This Point in Time,* presented at the Paramount Theater, Oakland, California.

1988

Receives the Prize for Teaching and Scholarly Achievement from U. C. Davis. Elected as a fellow to the American Academy of Arts and Sciences, Boston. Awarded an honorary doctorate by the San Francisco Art Institute.

1990

Receives the Distinguished Service Award from California State University, Sacramento. Designs a native species stamp for the California Department of Fish and Game. The exhibition *Thiebaud at Seventy: A Retrospective Selection of Paintings, Drawings, Watercolors, and Prints, Including New Work* appears at the Hearst Art Gallery, Saint Mary's College, Moraga, California. In June, retires from full-time teaching at U. C. Davis, but continues to teach on an emeritus part-time basis. Provides the set and costume designs for the San Francisco Ballet's production of *Krazy Kat*.

Wayne Thiebaud, *Cliffs* (maquette for a stage design for *Krazy Kat* ballet), 1990, mixed media, 31 ¼ × 25 ½ in., Collection of the artist.

1991

Receives the Governor's Award for Lifetime Achievement in the Arts in a ceremony at Beverly Hills, California.

1993

Receives the Grumbacher Gold Medallion Award for Painting from the American Academy of Design, New York. Awarded a doctor of arts degree by the Art Institute of Southern California, Laguna Beach.

1994

The exhibition *Wayne Thiebaud at the Allan Stone Gallery: Celebrating 33 Years Together* appears at the Allan Stone Gallery, New York. Receives the National Medal for Arts Presidential Award from President Clinton. The Arion Press in San Francisco publishes *The Physiology of Taste* by Brillat-Savarin, illustrated with nine color lithographs by WT and reproductions of more than two hundred of his drawings. The exhibition *Wayne Thiebaud: Figurative Works, 1959–1994* at the Wiegand Gallery, College of Notre Dame, Belmont, California, provides the first survey focusing exclusively on the figurative paintings since 1965.

1995

Honored with the Distinguished Artistic Achievement Award by the California Society of Printmakers, Berkeley.

1997

The exhibition *Wayne Thiebaud: Landscapes* at the Campbell-Thiebaud Gallery, San Francisco, shows for the first time in depth the series commenced ca. 1995 depicting the Sacramento River Delta, featuring a new intensity of color and complex patterns.

1998

Receives the honorary degree of doctor of fine arts from California State University, Sacramento.

1999

The Arion Press in San Francisco publishes *Invisible Cities* by Italo Calvino (originally published 1972) with twelve illustrations and an etching by WT.

Selected Solo Exhibitions 1985–1999

Listings in Exhibitions and Bibliography begin in 1985. For earlier listings, see Tsujimoto, *Wayne Thiebaud.*

1985

Wayne Thiebaud, San Francisco Museum of Modern Art, 12 September–10 November 1985; Newport Harbor Art Museum, Newport Harbor, California, 19 December 1985–16 February 1986; Milwaukee Art Museum, Wisconsin, 11 April–1 June 1986; Columbus Museum of Art, Ohio, 19 July–31 August 1986; The Nelson-Atkins Museum of Art, Kansas City, Missouri, 27 September–9 November 1986

1986

Wayne Thiebaud: 25th Anniversary Exhibition, Allan Stone Gallery, New York, March 1986

Wayne Thiebaud, Crown Point Press, San Francisco, 16 November–28 December 1986

1987

Wayne Thiebaud: Works on Paper from the Collection of the Artist, Arts Club of Chicago, 15 April–24 June 1987; Georgia State University Art Gallery, Atlanta, 2 September–8 October 1987

1988

Wayne Thiebaud: Works on Paper, 1947–1987, Richard L. Nelson Gallery, University of California, Davis, 28 February–13 May 1988; Stanford University Museum of Art, California, 28 June–14 August 1988; Northern Arizona University Art Gallery, Flagstaff, 29 August–25 September 1988; University Art Gallery, University of California, Riverside, January–February 1989; Fresno Art Museum, California, April–August 1989; Museum of Art, University of Oklahoma, 30 August–30 September 1989; Fine Arts Gallery, University of California, Irvine, 7 October–9 November 1989; Institute for Contemporary Arts, University of Nevada, Las Vegas, 5 November 1989–15 January 1990

Wayne Thiebaud, Allan Stone Gallery, New York, November–December 1988

Wayne Thiebaud: Prints and Works on Paper, Rutgers Barclay Gallery, Santa Fe, New Mexico, 14 October–9 November 1988

Wayne Thiebaud: Prints, 1951–1988, Charles Campbell Gallery, San Francisco, 1–26 November 1988

1989

Wayne Thiebaud: Works on Paper, Mead Art Museum, Amherst College, Massachusetts, April 1989

Wayne Thiebaud, Marilyn Butler Gallery, Santa Monica, California, 9 June–3 July 1989

1990

Thiebaud at Seventy: A Retrospective Selection of Paintings, Drawings, Watercolors, and Prints, Including New Work, Hearst Art Gallery, Saint Mary's College, Moraga, California, 16 November–30 December 1990

Wayne Thiebaud: Prints and Hand-Coloured Etchings, Karsten Schubert, Ltd, London, 27 June–28 July 1990

Wayne Thiebaud: Sketchbook Selections, Rutgers Barclay Gallery, Santa Fe, New Mexico, 14 September–16 October 1990

1991

Wayne Thiebaud — Three Decades of Still Lifes, Associated American Artists, New York, 9 October–2 November 1991

Wayne Thiebaud: Monotypes, Crown Point Press, San Francisco, 24 October–23 November 1991

Wayne Thiebaud, Ahmanson Fine Arts Center, Pepperdine University, Malibu, California, 17 November–17 December 1991

Wayne Thiebaud, Carpenter Center for the Visual Arts, Harvard University, Cambridge, Massachusetts, 10 April–28 April 1991

1991–92

Vision and Revision: The Hand-Colored Prints of Wayne Thiebaud, California Palace of the Legion of Honor, San Francisco, 21 December 1991–8 March 1992; Modern Art Museum of Fort Worth, 12 July–20 September 1992; National Museum of American Art, Smithsonian Institution, Washington, D. C., 20 November 1992–15 February 1993; Norton Museum of Art, West Palm Beach, Florida, 27 March–23 May 1993

1992

Selections from the Collection/Wayne Thiebaud Prints, Richard L. Nelson Gallery and The Fine Arts Collection, University of California, Davis,

with *Wayne Thiebaud: Posters from the Collection of Gina Kelsch,* 30 September–12 December 1992

Wayne Thiebaud Still-Lifes, Graystone Gallery, San Francisco, 10 September–10 October 1992

1992–94

Wayne Thiebaud Prints, The American Federation of Arts, C. A. Johnson Memorial Gallery, Middlebury, Vermont, 10 October–5 December 1992; Schneider Museum of Art, Ashland, Oregon, 7 January–5 March 1993; Cheney Cowles Museum, Spokane, Washington, 2 April–9 May 1993; Heckscher Museum of Art, Huntington, New York, 19 June–5 August 1993; Colby College Museum of Art, Waterville, Maine, 11 September–6 November 1993; The Butler Institute of American Art, Youngstown, Ohio, 4 December 1993–29 January 1994; Huntington Museum of Art, West Virginia, 26 February–23 April 1994; Flint Institute of Arts, Michigan, 21 May–16 July 1994; Sheldon Memorial Art Gallery, Lincoln, Nebraska, fall 1994

1993

The Prints of Wayne Thiebaud, Schneider Museum of Art, Southern Oregon State College, Ashland, Oregon, 7 January–5 March 1993

Wayne Thiebaud: Figure Drawings, Campbell-Thiebaud Gallery, San Francisco, 5 January–6 February 1993

Wayne Thiebaud: Still Lifes and Landscapes, Associated American Artists, New York, 20 October–27 November 1993

Wayne Thiebaud: Cityscapes, Campbell-Thiebaud Gallery, San Francisco, 9 November–18 December 1993

1994

Wayne Thiebaud at The Allan Stone Gallery: Celebrating 33 Years Together, Allan Stone Gallery, New York, 6 May–30 June 1994

Wayne Thiebaud, National Academy of Design, New York, 8 April–4 September 1994

Wayne Thiebaud: Figurative Works, 1959–1994, Wiegand Gallery, College of Notre Dame, Belmont, California, 22 March–30 April 1994

Wayne Thiebaud Still Lifes, Crown Point Press, San Francisco, 24 March–30 April 1994

Wayne Thiebaud: Prints, 1970–1984, A. P. Giannini Gallery, Bank of America World Headquarters, San Francisco, 1 December 1994–1 February 1995

1995

Wayne Thiebaud's Landscapes and Foodscapes, Bobbie Greenfield Gallery, Santa Monica, California, November–December 1995

Wayne Thiebaud: The Physiology of Taste, 9 New Lithographs, Jim Kempner Fine Art, New York, 4 January–February 1995

Wayne Thiebaud: Objects of Desire–Selected Paintings, Works on Paper, and Prints, John Berggruen Gallery, San Francisco, 17 May–24 June 1995

1996

Thiebaud Selects Thiebaud: A Forty-Year Survey from Private Collections, Crocker Art Museum, Sacramento, California, 21 April–4 August 1996

Thiebaud: Original Graphics, 1971–1996, Van Stavern Fine Art, Sacramento, California, 13 April–4 May 1996

Wayne Thiebaud, Pasadena City College Art Gallery, Pasadena, California, 25 March–26 April 1996

1997

Wayne Thiebaud, Allan Stone Gallery, New York, 1 May–27 June 1997

Wayne Thiebaud: Landscapes, Campbell-Thiebaud Gallery, San Francisco, 11 November–20 December 1997

Wayne Thiebaud at Crown Point Press, 1964–1997, Crown Point Press, San Francisco, 3 October–8 November 1997

Wayne Thiebaud: Intimate Prints, Kemper Museum of Contemporary Art and Design, Kansas City, Missouri, 11 April–14 December 1997

1998

Wayne Thiebaud: Singular Vision/Multiple Views, The Robert and Mary Montgomery Armory Art Center, West Palm Beach, Florida, 22 January–21 February 1998

Wayne Thiebaud: Works on Paper from the Family Collections, 1955–1998, Springfield Art Museum, Missouri, 19 September–15 November 1998; Willard Arts Center, Idaho Falls, Idaho, 2 June–30 August 1999

1999

Wayne Thiebaud: Prints, Fairbanks Gallery, Oregon State University, Corvallis, 15 February–9 March 1999

Wayne Thiebaud: Simple Delights, Works on Paper, 1963–1979, Campbell-Thiebaud Gallery, Laguna Beach, California, 15 September–31 October 1999

Selected Group Exhibitions 1985–1999

1986

Life Drawings— 1980s: Seven San Francisco Artists, Charles Campbell Gallery, San Francisco, 7 January–1 February 1986

1987

Lots from California, Thomas Center Gallery, Gainesville, Florida, 28 February–25 March 1987

Made in the USA: An Americanization in Modern Art, the '50s and '60s, University Art Museum, University of California, Berkeley, 1 April–21 June 1987; Nelson-Atkins Museum of Art, Kansas City, Missouri, 25 July–6 September 1987; Virginia Museum of Fine Arts, Richmond, 7 October–7 December 1987

American Art Today: The Portrait, Florida International University Art Museum, Miami, 8 May–3 June 1987

Recent American Graphic Works: Prints, Monotypes, Multiples and Works in Paper Selected from the Collection of Mr. and Mrs. Harry W. Anderson, Stanford Art Museum, Stanford University, California, 29 September 1987–3 January 1988

The Artists of California: A Group Portrait in Mixed Media, Oakland Museum, California, 14 November 1987–10 January 1988; Crocker Art Museum, Sacramento, California, 1 April– 30 May 1988; The Laguna Art Museum, Laguna Beach, California, 19 May–24 July 1988

Contemporary Realism, Palo Alto Cultural Center, California, December 1987–February 1988

1988

California Light, Sert Gallery, Carpenter Center for the Visual Arts, Harvard University, Cambridge, Massachusetts, 22 April– 26 May 1988

Painting from the San Francisco Bay Area, North Carolina Museum of Art, Raleigh, 27 June– 4 September 1988; Paine Art Center and Arboretum, Oshkosh, Wisconsin, 25 September–20 November 1988

Contemporary Icons and Explorations: The Goldstrom Family Collection, Davenport Museum of Art, Iowa, 13 April–21 June 1988

1989

Artist-Educator: Albers, Hofmann, Lasansky, Thiebaud, Tworkov, Phyllis Rothman Gallery, Fairleigh Dickenson University, Madison, New Jersey, April 1989

An American Collection: Paintings and Sculptures from the National Academy of Design, National Academy of Design, New York, 14 April– 30 June 1989; Cheekwood Fine Arts Center, Nashville, 7 October 1989–7 January 1990; North Carolina Museum of Art, Raleigh, 4–24 April 1990; Michael C. Carlos Museum, Emory University, Atlanta, 30 May–15 July 1990; Triton Museum of Art, Santa Clara, California, 15 August–31 October 1990; Terra Museum of American Art, Chicago, 18 May–14 July 1991; Washington University Gallery of Art, Saint Louis, 6 September–3 November 1991; Denver Art Museum, November 1991–January 1992

At the Water's Edge: 19th and 20th Century American Beach Scenes, Tampa Museum of Art, Florida, 9 December 1989–February 1990; Center for the Arts, Vero Beach, Florida, 4 May–17 June 1990; Virginia Beach Center for the Arts, Virginia, 8 July–2 September 1990; Arkansas Art Center, Little Rock, 8 November 1990–6 January 1991

1990

Art What Thou Eat: Images of Food in American Art, Edith C. Blum Art Institute, Bard College, New York, 2 September–18 November 1990; The New-York Historical Society, New York, 18 December 1990–22 March 1991

Pop on Paper, James Goodman Gallery, New York, 4 May–15 June 1990

32 Years—And the Tradition Goes On, Artists Contemporary Gallery, Sacramento, California, 19 May–14 June 1990

Contemporary Realist Painting: Perception and Experience, Steven A. Oliver Art Center Institute for Exhibitions and Public Programs, California College of Arts and Crafts, Oakland, 30 May–21 July 1990

California A to Z, The Butler Institute of American Art, Youngstown, Ohio, 24 June–19 August 1990

Artists in Yosemite, California Academy of Sciences, San Francisco, 25 June 1990–15 January 1991

California, Fresno Metropolitan Museum, California, 12 September–24 November 1990

California Monoprints, Sewall Art Gallery, Rice University Art Gallery, Houston, Texas, 11 January–16 February 1991

Selections from the Mary and Crosby Kemper Collection of Kansas City Art Institute, The Inaugural Exhibition, Charlotte Crosby Kemper Gallery, Kansas City, Missouri, 13 January–10 February 1991

Large Scale Works on Paper, John Berggruen Gallery, San Francisco, 21 February–16 March 1991

Setting the Stage, Columbus Museum of Art, Ohio, 24 February–21 April 1991

Pop Prints - Aspects of Printmaking in Britain and the U. S. A., 1959–1982, Tate Gallery, London, 6 March–23 June 1991

Art for the Nation: Gifts in Honor of the 50th Anniversary of the National Gallery of Art, National Gallery of Art, Washington, D.C., 17 March–16 June 1991

Exit the Freeway, Security Pacific Gallery, San Francisco, 26 March–25 May 1991

Wayne Thiebaud and Richard Diebenkorn, Campbell-Thiebaud Gallery, San Francisco, 11 April–11 May 1991

Motion as Metaphor: The Automobile in Art, Virginia Beach Center for the Arts, Virginia, 13 April–16 June 1991

Contemporary Woodblock Prints from Crown Point Press, Edison Community College, Fort Myers, Florida, June 1991

California Cityscapes, San Diego Museum of Art, California, 1 June–18 August 1991

Small Format Works on Paper, John Berggruen Gallery, San Francisco, 26 June–3 August 1991

Pop Art, Royal Academy of Arts, London, 13 September–15 December 1991; Museum Ludwig, Cologne, 23 January–19 April 1992; Museo Nacional Centro de Arte Reina Sofia, Madrid, 16 June–14 September 1992

American Realism and Figurative Art: 1952–1990, Miyagi Museum of Art, Sendai, Japan, 1 November–23 December 1991; Sogo Museum of Art, Yokohama, Japan, 29 January–16 February 1992; Tokushima Modern Art Museum, Japan, 22 February–29 March 1992; Museum of Modern Art, Shiga, Japan, 4 April–17 May 1992; Museum of Art, Kochi, Japan, 23 May–17 June 1992

Transforming the Western Image in 20th Century American Art, Palm Springs Desert Museum, California, 21 February–26 April 1992; Boise Art Museum, Idaho, 23 May–12 July 1992; Tucson Museum of Art, Arizona, 7 August–4 October 1992; Rockwell Museum, Corning, New York, 25 October–20 December 1992

Dürer to Diebenkorn: Recent Acquisitions of Works on Paper, National Gallery of Art, Washington, D. C., 10 May–7 September 1992

A Feast for the Eyes: Prints, Drawings, and Paintings Celebrating the Pleasures of Food, Associated American Artists, New York, 3 June–3 July 1992

New American Figure Painting, Contemporary Realist Gallery, San Francisco, 10 September–28 October 1992

Directions in Bay Area Printmaking: Three Decades, Palo Alto Cultural Center, California, 20 September 1992–3 January 1993

Books and Portfolios, 1957–1992, Marlborough Graphics, New York, 29 September–28 November 1992

Pop Art, Montréal Museum of Fine Arts, Canada, 23 October 1992–24 January 1993

Hand-Painted Pop: American Art in Transition, 1955–62, Museum of Contemporary Art, Los Angeles, 6 December 1992–7 March 1993; Museum of Contemporary Art, Chicago, 3 April–20 June 1993; Whitney Museum of American Art, New York, 16 July–3 October 1993

Contemporary Artists of the California Landscape, John Natsoulas Gallery, Davis, California, 1–31 January 1993

American Color Woodcuts: Bounty from the Block, 1890s–1990s, Elvehjem Museum of Art, Madison, Wisconsin, 3 January–4 April 1993

Printed from Wood: Contemporary American Woodblock Prints, Joanne Chappell Gallery, San Francisco, 15 April–31 May 1993

35 Years: A Group Exhibition, Artists Contemporary Gallery, Sacramento, California, 16 April–13 May 1993

Bay Area Tradition: Robert Bechtle, Christopher Brown, Wayne Thiebaud, Crown Point Press, San Francisco, 22 April–5 June 1993

Still Life: 1963–1993, Gerald Peters Gallery, Santa Fe, New Mexico, 6 August–12 September 1993

The Collectors' Perspective: American and European Paintings and Drawings from Private Collections, John Berggruen Gallery, San Francisco, 14 September–9 October 1993

Picasso to Christo: The Evolution of a Collection, Santa Barbara Museum of Art, California, 4 December 1993–30 January 1994

1994

Sacramento Valley School: Landscapes and Still Lifes, John Natsoulas Gallery, Davis, California, 8 January–6 February 1994

Figures and Still Lifes, Graystone Gallery, San Francisco, 3 March–2 April 1994

The Still Life: Three Perspectives— Tony Cragg, Jose Maria Sicilia, Wayne Thiebaud, Crown Point Press, New York, 23 March–24 April 1994

The Pop Image: Prints and Multiples, Marlborough Graphics, New York, 9 November–3 December 1994

1995

American Art Today: Night Paintings, The Art Museum of Florida International University, Miami, 13 January–18 February 1995

Printmaking in America: Collaborative Prints and Presses, 1960–1990, Jane Voorhees Zimmerli Art Museum, Rutgers, New Brunswick, New Jersey, 23 April–18 June 1995; Mary and Leigh Block Gallery, Northwestern University, Evanston, Illinois, 22 September–3 December 1995; The Museum of Fine Arts, Houston, 23 January–2 April 1996; National Museum of American Art, Washington, D. C., 10 May–4 August 1996

Adding it Up: Print Acquisitions, 1970–1995, The Museum of Modern Art, New York, 27 May–5 September 1995

Martini Culture, Modernism Gallery, San Francisco, 8 June–19 August 1995

Facing Eden: 100 Years of Landscape Art in the Bay Area, M. H. de Young Memorial Museum, San Francisco, 25 June–10 September 1995

Art Works: The Paine Webber Collection of Contemporary Masters, The Museum of Fine Arts, Houston, 2 July–24 September 1995

XXV Years: An Exhibition Celebrating the 25th Anniversary of the John Berggruen Gallery, John Berggruen Gallery, San Francisco, 7 September–11 October 1995

Concept in Form: Artists' Sketchbooks and Maquettes, Palo Alto Cultural Center, California, 5 October 1995–7 January 1996

Wayne Thiebaud and the Gravure Group: Christopher Brown, Tom Marioni, Gay Outlaw, Edward Ruscha, Crown Point Press, San Francisco, 17 October–30 November 1995

Fifteen Profiles: Distinguished California Modernists, Fresno Art Museum, California, 7 November 1995–7 February 1996

A Bay Area Connection: Works from the Anderson Collection, 1954–1984, Triton Museum of Art, Santa Clara, California, 1 November 1995–28 January 1996

1996

Master Printers and Master Pieces, Kaohsiung Museum of Fine Arts, Taiwan, 16 February–2 June 1996

Feast for the Eyes, Austin Museum of Art, Texas, 17 February–7 April 1996

Certain Uncertainties: Chaos and the Human Experience, Bowdoin College Museum of Art, Brunswick, Maine, 17 April–2 June 1996

Diebenkorn, Francis, Frankenthaler, Motherwell & Thiebaud, Associated American Artists, New York, May 1996

California Visions: California State Fair Art Collection, 1948–1978, California State Capitol Museum, Sacramento, California, August 1996

Generations: The Lineage of Influence in Bay Area Art, Richmond Art Center, California, 21 September–16 November 1996

Selected Recent Acquisitions, Richard L. Nelson Gallery and The Fine Arts Collection, University of California, Davis, 24 September–25 October 1996; Shasta College Art Gallery, Redding, California, 30 October–12 December 1996

Concept in Form: Artists' Sketchbooks and Maquettes, Palo Alto Cultural Center, California, 5 October 1996–7 January 1997

California: One Hundred Forty Years of Art Produced in the State, Richard York Gallery, New York, 21 November 1996–10 January 1997

1997

20/20: CAF Looks Forward and Back, Santa Barbara Contemporary Arts Forum, California, 15 February–13 April 1997

Singular Impressions: The Monotype in America, National Museum of American Art, Washington, D. C., 4 April–3 August 1997

Drawings and Other Works on Paper from the Glenn C. Janss Collection, Richard York Gallery, New York, 1 May–13 June 1997

Crown Point Press Prints, Jane Haslem Gallery, Washington, D. C., 14 June–31 July 1997

A National Collection: Paintings Selected from the Collection of The National Academy, National Academy of Design Museum and School of Fine Arts, New York, 2 July–28 September 1997

Structures: Buildings in American Art, 1900–1997, John Berggruen Gallery, San Francisco, California, 10 July–13 September 1997

Tabletops: Morandi's Still Lifes to Maplethorpe's Flower Studies, California Center for the Arts Museum, Escondido, 21 September 1997– 21 January 1998

Twenty-Five Treasures, Campbell-Thiebaud Gallery, San Francisco, 2 September–4 October 1997

Thirty-Five Years at Crown Point Press: Making Prints, Doing Art, National Gallery of Art, Washington, D. C., 8 July–1 September 1997; California Palace of the Legion of Honor, San Francisco, 4 October 1997–4 January 1998

The Artist's Eye: Will Barnet Selects from the Collection, National Academy Museum and School of Fine Arts, New York, 8 October 1997– 4 January 1998

Bay Area Art from the Morgan Flagg Collection, M. H. de Young Memorial Museum, San Francisco, 18 October–4 January 1998

1998

Close Relations: Works of Art, Their Preparatory Studies and Alternative Versions, The Helene Druke Shaw Gallery, University of Utah, Salt Lake City, 11 January–5 April 1998

Still-Life Painting Today: An Invitational Exhibition, Jerald Melbery Gallery, Charlotte, North Carolina, 24 January–14 March 1998

Food for Thought: A Visual Banquet, DC Moore Gallery, New York, 15 June–12 August 1998

Beyond the Mountains: The Contemporary American Landscape, Asheville Art Museum, North Carolina, 19 March–24 May 1998

Artists' Contemporary Gallery 40th Anniversary Show, Artists' Contemporary Gallery, Sacramento, California, 26 April–3 June 1998

The Academy and American Art: History and Highlights, National Academy Museum and School of Fine Arts, New York, 15 July– 23 August 1998

Figuration/Abstraction, John Berggruen Gallery, San Francisco, 23 July–4 September 1998

New Works by Contemporary Artists, Gerald Peters Gallery, Santa Fe, New Mexico, 15 August– 10 October 1998

Figure Drawings, Danese Gallery, New York, 30 July–11 September 1998

From Exploration to Conservation: Picturing the Sierra Nevada, Nevada Museum of Art, Reno, 11 October 1998–10 January 1999

Gold Rush to Pop, Orange County Museum of Art, Newport Beach, California, 17 October 1998– 24 January 1999

1999

Innovation and Influence: The Art of Richard Diebenkorn and Wayne Thiebaud, Sun Valley Center for the Arts, Sun Valley, Idaho, 24 May– 3 July 1999

Diebenkorn & Thiebaud: Prints, Karen McCready Fine Art, New York, 19 July–3 September 1999

Silent Things, Secret Things: Still Life from Rembrandt to the Millennium, Albuquerque Museum, 19 September 1999–2 January 2000

The American Century: Art & Culture, 1900–2000; Part II, 1950–2000, Whitney Museum of American Art, New York, 26 September 1999– 13 February 2000

Picturing California's Other Landscape: The Great Central Valley, The Haggin Museum, Stockton, California, 17 October–31 December 1999

Still Life is Still Alive, Jan Krugier Gallery, New York, 12 November 1999–15 January 2000

Cityscape/Landscape, Karen McCready Fine Art, New York, 18 November 1999–2 January 2000

Curatorial

1994

The Artist's Eye: Wayne Thiebaud Selects Paintings from the Permanent Collection, National Academy of Design, New York, 8 April–4 September 1994

Lana International Art Competition, juried by Wayne Thiebaud, Campbell-Thiebaud Gallery, San Francisco, 21 June–30 July 1994

Selected Bibliography 1985–1999

Books And Exhibition Catalogues

Albright, Thomas. *Art in the San Francisco Bay Area.* Berkeley: University of California Press, 1985. (123–26 passim)

Arthur, John. *Spirit of Place: Contemporary Landscape Painting and the American Tradition.* Boston, Toronto, and London: Little, Brown and Company, 1989. (62–63)

Bahet, Kathleen. "Pictures in Motion." In *Wayne Thiebaud: Still Lifes and Landscapes,* 2–7. Exh. cat. New York: Associated American Artists, 1993.

Breuer, Karin, Ruth E. Fine, and Steven A. Nash. *Thirty-Five Years at Crown Point Press: Making Prints, Doing Art.* Exh. cat. San Francisco and Berkeley: Fine Arts Museums of San Francisco and University of California Press, 1997. (7–8, 47–48, 55, 58, 61–64)

Brown, Kathan. *Ink, Paper, Metal, Wood: Painters and Sculptors at Crown Point Press.* San Francisco: Chronicle Books, 1996. (33–38 passim)

Burgard, Timothy Anglin. *Bay Area Art from the Morgan Flagg Collection.* Exh. cat. San Francisco: M. H. de Young Memorial Museum, 1997. (12, 15–19, 42–43)

Castleman, Riva. *American Impressions: Prints Since Pollock.* New York: Alfred A. Knopf, 1985. (100)

Dalkey, Victoria. "Wayne Thiebaud's Rural Landscapes." In *Wayne Thiebaud: Landscapes,* n. p. Exh. cat. San Francisco: Campbell-Thiebaud Gallery, 1997.

Ferguson, R., ed. *Hand-Painted Pop, American Art in Transition, 1955–1962.* Exh. cat. Exhibition organized by Donna De Salvo and Paul Schimmel. Los Angeles and New York: The Museum of Contemporary Art and Rizzoli International Publications, 1993. (222–25)

Greenberg, Jan, and Sandra Jordan. *The Painter's Eye: Learning to Look at Contemporary American Art.* New York: Delacourte Press, 1991. (18–19 passim)

Gustafson, Donna, Nan A. Rothschild, Kendall Taylor, Gilbert T. Vincent, and Linda Weintraub. *Art What Thou Eat: Images of Food in American Art.* Exh. cat. Edited by Linda Weintraub. Annandale-on-Hudson, New York, and Mount Kisko, New York: The Edith C. Blum Art Institute, Bard College and Moyer Bell Limited, 1991. (71–72)

Holland, Katherine Church. "Wayne Thiebaud." In *San Francisco Museum of Modern Art: The Painting and Sculpture Collection.* New York: Hudson Hills Press, in association with the San Francisco Museum of Modern Art, 1985. (226–27)

Hopkins, Henry. *50 West Coast Artists: A Critical Selection of Painters and Sculptors Working in California.* San Francisco: Chronicle Books, 1986. (68–69)

———. "Wayne Thiebaud." In *California Painters: New Work,* 128–29. San Francisco: Chronicle Books, 1989.

Hughes, Robert. *American Visions: The Epic History of Art in America.* New York: Alfred A. Knopf, 1997. (532–34)

James, Jamie. *Pop Art.* London: Phaidon, 1996. (46–47)

Jones, Harvey L. *San Francisco: The Painted City.* Salt Lake City: Gibbs Smith, 1993. (82–83)

Kimmelman, Michael. "Wayne Thiebaud." In *Portraits: Talking with Artists at the Met, the Modern, the Louvre, and Elsewhere,* 157–73. New York: Random House, 1998.

Livingstone, Marco. *Pop: A Continuing History.* New York: Harry N. Abrams, 1990. (71–72, 234, 253)

———, ed. *Pop Art.* Exh. cat. London: Royal Academy of Arts and Weidenfeld & Nicolson, 1991. (36–39, 58, 90, 120, 291–92)

Lucie-Smith, Edward. *American Realism.* London: Thames and Hudson, 1994. (174–77)

Madoff, Steven Henry, ed. *Pop Art: A Critical History.* Berkeley, Los Angeles, and London: University of California Press, 1997. (341–44 passim)

Moritz, Charles, ed. "Wayne Thiebaud." In *Current Biography Yearbook, 1987,* 566–70. New York: H. W. Wilson Company, 1987.

Moser, Joann. *Singular Impressions: The Monotype in America.* Exh. cat. Washington and London: Smithsonian Institution Press for the National Museum of American Art, 1997. (154–55)

Nash, Steven A. , ed. *Facing Eden: 100 Years of Landscape Art in the Bay Area.* Exh. cat. San Francisco: Fine Arts Museums of California, 1995: Essays by Steven A. Nash and Bill Berkson. (xvi, xix, 102, 104, 106, 107, 113, 138, 148–50, 178, 207)

Neubert, George. "Wayne Thiebaud." In *The American Painting Collection of The Sheldon Memorial Art Gallery,* 184–85. Compiled and edited by Norman A. Geske and Karen O. Janovy. Lincoln and London: The University of Nebraska Press, 1988.

Nixon, Mignon. "Wayne Thiebaud." In *The Pop Image: Prints and Multiples.* Edited by Judith Goldman. Exh. cat. New York: Marlborough Graphics, 1994. (70)

Poole, Kristin. "The Art of Richard Diebenkorn and Wayne Thiebaud." In *Innovation and Influence: The Art of Richard Diebenkorn and Wayne Thiebaud.* Exh. brochure. Sun Valley, Idaho: Sun Valley Center for the Arts, 1999.

Shone, Richard. "Wayne Thiebaud: Objects and Cityscapes." In *Wayne Thiebaud: Prints and Hand-Coloured Etchings,* n. p. Exh. cat. London: Karsten Schubert, 1990.

Skolnick, Arnold, ed. *Paintings of California.* Berkeley, Los Angeles, and London: University of California Press. (100, 101, 119)

Stich, Sidra. *Made in USA: An Americanization in Modern Art, the '50s and '60s.* Exh. cat. Berkeley: University Art Museum, University of California, and University of California Press, 1987. (76–78, 84–87, 126–27 passim)

Tallman, Susan. *The Contemporary Print from Pre-Pop to Postmodern.* London and New York: Thames and Hudson, 1996. (49, 52–53, 55, 143, 186, 280)

Tsujimoto, Karen. *Wayne Thiebaud.* Exh. cat. San Francisco and Seattle: San Francisco Museum of Modern Art and University of Washington Press, 1985.

Vision and Revision, Hand-Colored Prints by Wayne Thiebaud. Introduction by Wayne Thiebaud. Exh. cat. San Francisco: Chronicle Books, 1991. Essays by Bill Berkson and Robert Flynn Johnson.

Wayne Thiebaud: Private Drawings — The Artist's Sketchbook. Selected and edited by Constance Glenn and Jack Glenn. New York: Harry F. Abrams, 1987.

Interviews

Baker, Kenneth. "A Conversation with Wayne Thiebaud." *San Francisco Chronicle,* 15 January 1995, *Datebook.*

Berkson, Bill. "Thiebaud on the Figure." In *Wayne Thiebaud: Figurative Works, 1959–1994,* n. p. Exh. cat. Belmont, California: The Wiegand Gallery, College of Notre Dame, 1994.

Denison, D. C. "The Interview: Wayne Thiebaud." *Boston Globe Magazine,* 14 April 1991.

Lewallen, Constance. "Interview with Wayne Thiebaud, August, 1989." *View* [San Francisco] 6, no. 6 (Winter 1990).

Maréchal-Workman, Andrée. "Wayne Thiebaud: Beyond the Cityscapes." *Smithsonian Studies in American Art* 1, no. 2 (Fall 1987): 34–51.

McGough, Stephen C. "An Interview with Wayne Thiebaud." In *Thiebaud Selects Thiebaud: A Forty-Year Survey from Private Collections,* 7–15. Edited by Stephen C. McGough. Exh. cat. Sacramento: Crocker Art Museum, 1996.

———. "Thiebaud on Thiebaud." *ARTnews* 97, no. 4 (April 1998) : 118–20.

Tromble, Meredith. "A Conversation with Wayne Thiebaud." *Art Week* 29, no. 1 (January 1998): 15.

Wollheim, Richard. "On Thiebaud and Diebenkorn: Richard Wollheim Talks to Wayne Thiebaud." *Modern Painters* 4, no. 3 (Autumn 1991): 64–86.

———. "An Interview with Wayne Thiebaud." In *Wayne Thiebaud: Cityscapes,* n. p. Exh. cat. San Francisco: Campbell-Thiebaud Gallery, 1993.

———. "Matisse at MOMA: Richard Wollheim Talks to Wayne Thiebaud." *Modern Painters* 6, no. 3 (Autumn 1993): 56–61.

Articles and Reviews

Baker, Kenneth. "The Ambiguities of Thiebaud." *San Francisco Chronicle,* 15 September 1985.

———. "Facing Realism's Paradoxes: Retrospective of Thiebaud Paintings at St. Mary's Takes a Long Look." *San Francisco Chronicle,* 8 December 1990.

———. "The Finishing Touches: Thiebaud Show of Hand Colored Prints at the Legion." *San Francisco Chronicle,* 4 January 1992, Datebook. 3

———. "Thiebaud's Dreamy Vision of the Urban Landscape." *San Francisco Chronicle,* 11 December 1993.

———. "Thiebaud Shows His Struggle." *San Francisco Chronicle,* 21 April 1994.

———. "Thiebaud Wins National Medal of Arts." *San Francisco Chronicle,* 13 October 1994.

———. "Thiebaud Stakes Out His Territory: Late Landscapes Show Freedom, Maturity." *San Francisco Chronicle,* 13 November 1997, Datebook.

Bass, Ruth. "Wayne Thiebaud, David Beck." *ARTnews* 93, no. 9 (November 1994): 156–57.

Berkson, Bill. "Thiebaud's Vanities." *Art in America* 73, no. 12 (December 1985): 110–21.

———. "Objects of Affection: Wayne Thiebaud." *Vogue* 184, no. 5 (May 1994): 164, 166.

———. "Wayne's World." *Modern Painters* 11, no. 2 (Summer 1998):18–19.

Binstock, Jonathan P. "Wayne Thiebaud's Jackpot Machine." *American Art* 10, no. 2 (Summer 1996): 78–82.

Bonetti, David. "Thiebaud's Art is Proof Positive." *San Francisco Examiner,* 3 January 1992.

———. "Two Who Savor Paint: Thiebaud and Simpson in their Late Style." *San Francisco Examiner,* 18 December 1997.

Bourdon, David. "Can He Paint a Cherry Pie?" *Vogue* 175, no. 9 (September 1985): 114.

Conrad, Barnaby, III. "Wayne Thiebaud." *Horizon* 29, no. 1 (January–February 1986): 6–16.

Curtis, Cathy. "Thiebaud: Changer of the Mundane into the Surreal." *Los Angeles Times,* 15 October 1989, Calendar.

Dalkey, Victoria. "Wayne Thiebaud: Portrait of the Artist at 70." *Sacramento Bee,* 11 November 1990, Encore.

———. "Thiebaud on Thiebaud." *Sacramento Bee,* 21 April 1996.

———. "Gallery Illustrates Success." *Sacramento Bee,* 26 April 1998.

DeWeese-Wehen, Joy. "Wayne Thiebaud: Simple Lessons in Realism." *Art & Antiques* 17, no. 9 (November 1994): 112.

Diehl, Carol. "Wayne Thiebaud." *ARTnews* 96, no. 9 (October 1997): 160.

Duncan, Michael. "Painterly Pop." *Art in America* 81, no. 7 (July 1993): 89, 117.

Falaschi, Susan. "Thiebaud: A Study of Realism in Art." *Country Almanac,* 20 July 1988, 26, 28.

Glueck, Grace. "Thiebaud's Paintings for Dessert." *New York Observer* 8, no. 23 (13 June 1994): 17.

Gopnik, Adam. "Window Gazing." *New Yorker* 67, no. 10 (29 April 1991): 78–80.

Hoving, Thomas. "Time for Thiebaud, America's Best Overlooked Painter." *Connoisseur* 215, no. 884 (September 1985): 76–79.

Hughes, Robert. "A Rich, Feisty Eventfulness; California's Wayne Thiebaud Emerges as a Leading U.S. Realist." *Time* 126, no. 17 (28 October 1985): 101.

———. "Wallowing in the Mass Media Sea." *Time* 138, no. 17 (28 October 1991): 102–103.

Hurwitz, Laurie S. "Wayne Thiebaud's Studied Sensuality." *American Artist* 57, no. 615 (October 1993): 26–33, 77–9.

Kimmelman, Michael. "Even with 2 Shows (or 3), Not the Usual Star." *New York Times,* 27 May 1994.

———. "A Little Weirdness Can Help an Artist." *New York Times,* 23 August 1996.

———. "Wayne Thiebaud." *New York Times,* 23 May 1997.

Klein, Michael. "Wayne Thiebaud at Allan Stone." *Art in America* 85, no. 12 (December 1997): 99.

Kramer, Hilton. "National Academy Paintings: Modernism Is Not Our Foe." *New York Observer* 8, no. 18 (9 May 1994): 1, 21.

Lifton, Norma. "Wayne Thiebaud." *New Art Examiner* 15, no. 1 (September 1987): 42–43.

Maréchal-Workman, Andrée. "Wayne Thiebaud: Beyond the Cityscapes," *Smithsonian Studies in American Art* 1, no. 2 (Fall 1987): 35–37.

Moorman, Margaret. "Wayne Thiebaud." *ARTnews* 85, no. 6 (Summer 1986): 142–43.

Nadaner, Dan. "A World of Specific Things." *Art Week* 16, no. 34 (19 October 1985): 1.

Nixon, Bruce. "Wayne Thiebaud." *Artweek* 21, no. 42 (13 December 1990): 15.

Plagens, Peter. "Post-Pop Master." *Vanity Fair* 48, no. 9 (September 1985): 78–79.

Poutello, J. M. "A Cityscape Challenge." *Southwest Art* 18 (September 1988): 21.

Richard, Paul. "Luscious Realism: Thiebaud, Making the Mouth Water." *Washington Post,* 16 December 1992.

Rowlands, Penelope. "A Sense of Taste." *ARTnews* 94, no. 2 (February 1995): 27.

Segal, Lewis. "Dance Reviews; San Francisco's 'Krazy Kat': Better Scenery than Ballet." *Los Angeles Times,* 24 March 1990, Calendar.

Stein, Ruthe. "Artist Designs Sets for 'Krazy Kat' Ballet." *San Francisco Chronicle,* 23 January 1990.

Steinberg, Steven. "Wayne Thiebaud: The Concept of Realism, The Notion of Inquiry." *Southwest Art* 15 (February 1986): 50–56.

Stevens, Mark. "Wayne Thiebaud." *New York* 30, no. 22 (9 June 1997): 81.

Sylva, Bob. "Thiebaud's Treasures." *Sacramento Bee,* 4 December 1995.

Tarshis, Jerome. "Not Just Pie in the Sky." *San Francisco Focus* 32, no. 9 (September 1985): 24–29.

———. "City Streets that Plunge and Curve." *Christian Science Monitor,* 4 April 1989, Home Forum.

———. "Local Hero: Wayne Thiebaud Takes Brush and Canvas to the Streets of San Francisco." *San Francisco Magazine* 27, no. 9 (November 1989): 90–93.

Tsujimoto, Karen. "Wayne Thiebaud: Exploring Realism's Abstract Energy." *Art Today* (Fall 1986): 18-20.

Wallin, Leland. "Toys Take a Holiday, Play the Theater, and Travel Through Time." *Arts Magazine* 16, no. 7 (March 1987): 44–47.

Winter, David. "Wayne Thiebaud." *ARTNews* 84, no. 10 (December 1985): 93.

Wollheim, Richard. "Wayne Thiebaud: *Green River Lands, 1998.*" *Artforum* 38, no. 2 (October 1999): 134–35.

———. "A Painter's Alchemy." *Modern Painters* 11, no. 2 (Summer 1998): 20–24.

Writings by Thiebaud

Thiebaud, Wayne. Foreword to *Mark Adams,* by Robert Flynn Johnson, Paul Mills, and Lorna Price. San Francisco: Chronicle Books and John Berggruen Gallery, 1985.

———. Foreword to *Drawn to Excellence: Masters of Cartoon Art.* Exh. cat. San Francisco: Cartoon Art Museum, 1988.

———. Foreword to *On Art and Artists: Essays by Thomas Albright,* edited by Beverly Hennessey; afterword by Lawrence Ferlinghetti. San Francisco: Chronicle Books, 1989.

———. "Forum: Balthus's Study for 'The Guitar Lesson.'" *Drawing* 16, no. 1 (May/June 1994): 9–10.

Books Illustrated by Thiebaud

Bates, Katharine Lee. *O Beautiful for Spacious Skies.* San Francisco: Chronicle Books, 1994.

Brillat-Savarin, Jean Anthelme. *The Physiology of Taste, or, Meditations on Transcendental Gastronomy.* Translated by M. F. K. Fisher. San Francisco: The Arion Press, 1994.

Calvino, Italo. *Invisible Cities.* Translated and introduced by William Weaver. San Francisco: The Arion Press, 1999.

Olmsted, Frederick Law. *Yosemite and the Mariposa Grove: A Preliminary Report,* 1865. Yosemite National Park, California: Yosemite Association, 1993.

Shere, Lindsey Remolif. *Chez Panisse Desserts.* New York: Random House, 1985.

Index to Illustrations of Wayne Thiebaud's Works

Photo Credits

Photographs of works of art reproduced in this volume have been provided by the lenders unless otherwise noted.

Joseph McDonald 10, 78, 89, 90, 91, 102, 106, 120, 123, 126, 130, 140, 150, 155, 157

Steven A. Nash, 1999 figs. 20, 22

Greg Heins 38, 99, 110

Lee Fatherree 83

Hickey-Robertson 84

Lyle Peterzell 97 and cover © Board of Trustees, National Gallery of Art, Washington, 1963

Lee Stalsworth 103

Michael Bodycomb 118

Michael Tropea 119

Malcolm Kimberlin 138

© The Nelson Gallery Foundation. All Reproduction Rights Reserved 143

Courtesy of Wayne Thiebaud 192–94, 196, 201, 202

Comic strip courtesy of Gegory Kondos 194

Set design courtesy of Eaglet Theatre, Sacramento 196

Allan Stone Gallery, New York 197, 199, 200

PRODUCED BY THE PUBLICATIONS DEPARTMENT OF THE FINE ARTS MUSEUMS OF SAN FRANCISCO:
ANN HEATH KARLSTROM, DIRECTOR OF PUBLICATIONS AND GRAPHIC DESIGN; KAREN KEVORKIAN, EDITOR.

BOOK AND COVER DESIGN BY MICHAEL SUMNER.
TYPESET IN GRANJON AT BURNING BOOKS, SANTA FE, NEW MEXICO.
ASSISTANCE BY MELODY SUMNER CARNAHAN.

PRINTED AT SNOECK, DUCAJU & ZOON, GHENT.